C'est mon plaisir.

 — ISABELLA STEWART GARDNER, 1902

 — LA ROUCHEFOUCAULD, CA. 1665

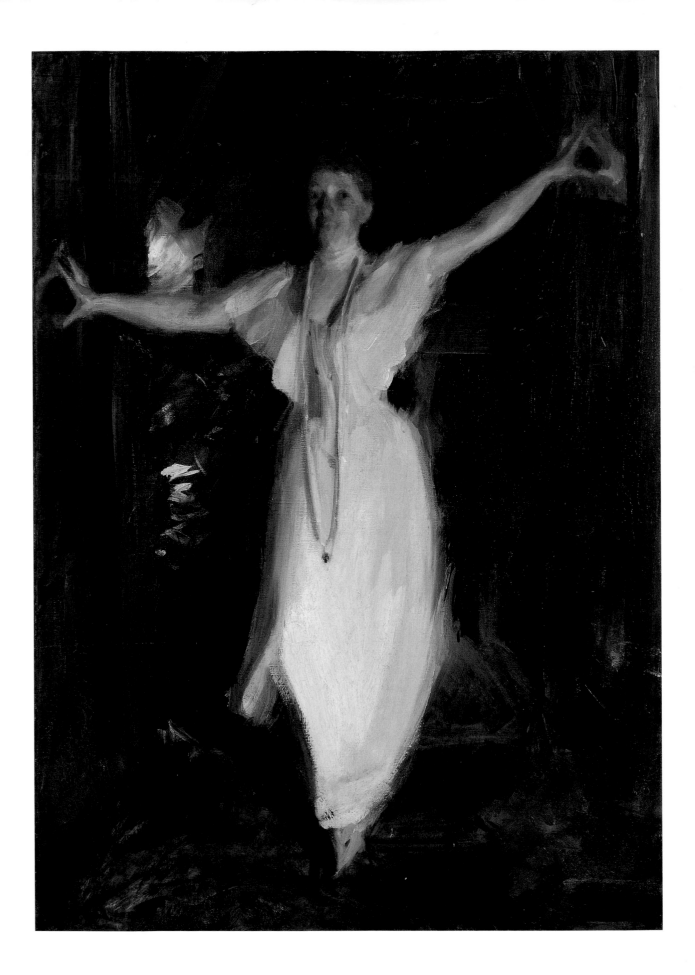

Eye
of
the
Beholder

Masterpieces from the

ISABELLA
STEWART
GARDNER
MUSEUM

Edited by

ALAN CHONG RICHARD LINGNER CARL ZAHN

ISABELLA STEWART GARDNER MUSEUM

BOSTON, MASSACHUSETTS

in association with

BEACON PRESS

BOSTON, MASSACHUSETTS

PUBLISHED IN ASSOCIATION WITH BEACON PRESS
25 BEACON STREET, BOSTON, MASSACHUSETTS, 02108-2892
WWW.BEACON.ORG
BEACON PRESS BOOKS ARE PUBLISHED UNDER THE AUSPICES OF THE
UNITARIAN UNIVERSALIST ASSOCIATION OF CONGREGATIONS.

LIBRARY OF CONGRESS CATALOGUE CARD NO. 2002115911
ISBN 0-807-6612-5

THIS PUBLICATION WAS MADE POSSIBLE BY A GENEROUS GRANT
FROM THE RICHARD C. VON HESS FOUNDATION.
ADDITIONAL SUPPORT WAS PROVIDED BY THE GETTY GRANT PROGRAM
AND BY PETER AND LAURIE THOMSEN.

NEW PHOTOGRAPHY BY THOMAS LINGNER

PRODUCTION BY MUSEUM PUBLISHING PARTNERS,
CAMBRIDGE, MASSACHUSETTS
EDITOR: CYNTHIA PURVIS DESIGNER: CARL ZAHN

TYPE SET IN MINION AND TRAJAN
BY CARL ZAHN AND FRAN PRESTI-FAZIO

THE CREST ON THE COVER WAS DESIGNED IN 1900 BY
MRS. GARDNER'S FRIEND SARAH WYMAN WHITMAN.
THE WOODCUT ON THE TITLE PAGE IS FROM FRANCESCO COLONNA,
HYPNEROTOMACHIA POLIPHILI (VENICE: ALDINE, 1499), A BOOK
THAT MRS. GARDNER OWNED. THE DEVICE APPEARS IN HER PRINTED
CATALOGUES OF 1906 AND 1922 (BOSTON: MERRYMOUNT PRESS).

PRINTED AND BOUND IN SINGAPORE BY CS GRAPHICS

FRONTISPIECE:
ANDERS ZORN, ISABELLA STEWART GARDNER IN VENICE, 1894, p. 214

～ Contents

Foreword VII

Introduction IX

Mrs. Gardner's Palace on the Fenway XXI

The Courtyard 2

Ancient Art 4

Medieval Art 17

The Early Renaissance 34

The High Renaissance 74

The Art of Venice 94

Textiles 113

Decorative Arts 125

The Art of Northern Europe 131

Spanish Art 151

Islamic Art 161

Asian Art 173

The Nineteenth Century 189

Coda: Contemporary Art 226

Chronology 230

Contributors 231

Sources 233

Index 238

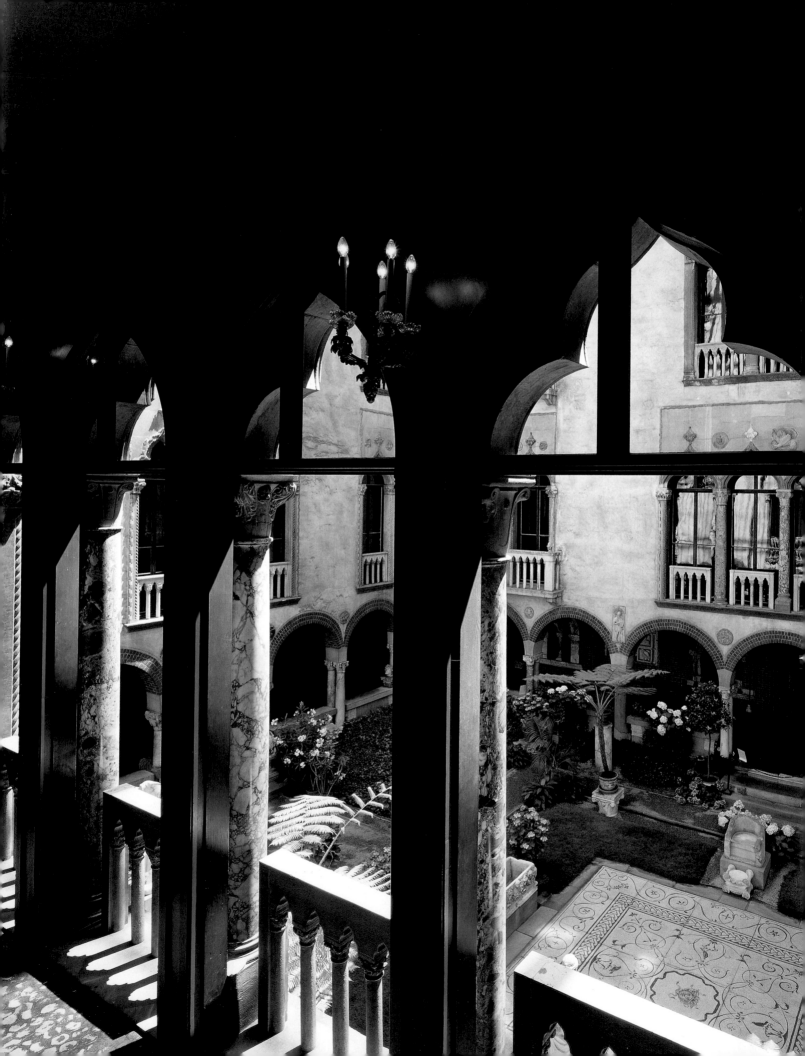

❧ Foreword

The Gardner Museum has always been a particular favorite of mine. My grandfather, John Fitzgerald, knew Mrs. Gardner and was proud to have her as a friend. He loved to regale me with the story of the benefit performance they sponsored together for Carney Hospital one evening in 1906 when Grampa was Boston's mayor. At the suggestion of Mrs. Gardner, the performance featured Ruth St. Denis, a legendary dancer of the time, and it turned out to be a major cultural event for our growing city in those years. It was part of a larger plan by Mrs. Gardner to develop a cultural life in Boston equal to its renown in commerce and education. It's no surprise that our family has always supported the museum. Grampa often took us to see the wonderful house that Mrs. Gardner built to display her famous masterpieces, and I've loved every visit ever since.

— SENATOR EDWARD M. KENNEDY,
2002

ISABELLA Stewart Gardner's museum creates an experience like no other. Atmospheric and personal, it displays great works of art in a beautiful setting. Since its opening in 1903, Fenway Court has enchanted and inspired generations of visitors. We celebrate the centennial of the Isabella Stewart Gardner Museum by publishing this book, which not only surveys Mrs. Gardner's collection, but also captures some of the varied responses to it. The voices of original creators can be heard: Vasari, Michelangelo, Titian, Cellini, as well as Whistler and Sargent. We also witness a rich tradition of criticism and commentary in the writings of Bernard Berenson, Henry James, Edith Wharton, John La Farge, Roger Fry, Okakura Kakuzō, and Isabella Stewart Gardner herself. More recent writers and artists have advanced challenging new interpretations of the collection. Appropriately, the book's title *Eye of the Beholder* is taken from the Gardner Museum's distinguished lecture series, excerpts from which appear throughout the volume.

Isabella Stewart Gardner surrounded herself with creative individuals – musicians, dancers, writers, scholars, and painters. During her lifetime, Fenway Court was a venue for concerts and performances, a studio for artists, and a gathering place for thinkers. Today, the museum furthers Mrs. Gardner's legacy through a residency program which invites artists of all types and in all media to live and work at the museum. Special exhibitions of these contemporary responses, and of historic art, enhance our understanding of the museum.

Alan Chong and Richard Lingner, curator and assistant curator of the collection, compiled the quotations, commissioned new entries, and added their own insightful comments along the way. Carl Zahn participated fully in the conceptualization of the text and designed the book. Thomas Lingner made excellent new photographs of objects and galleries. I am grateful to all the contributors to this volume.

It is our fervent hope that readers – and visitors – will continue to be inspired by Isabella Stewart Gardner's singular museum.

ANNE HAWLEY
Norma Jean Calderwood Director

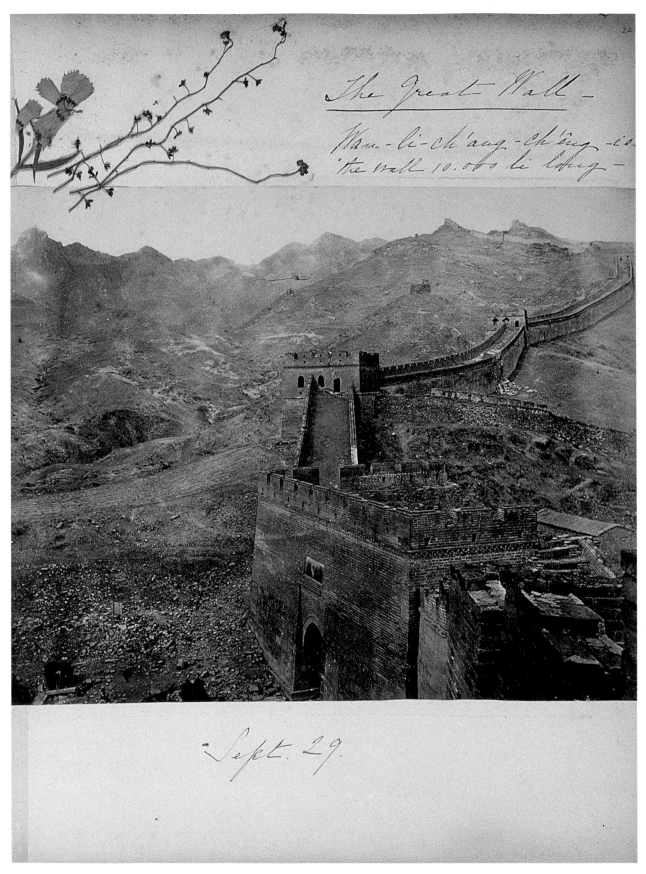

Mrs. Gardner's travel album: The Great Wall, China, September 1883

❧ Introduction

Years ago, I decided that the greatest need in our Country was Art. We were largely developing the other sides. We were a young country & had very few opportunities of seeing beautiful things, works of art etc. So I determined to make it my life work if I could. Therefore, ever since my parents died I spent every cent I inherited (for that was my money) in bringing about the object of my life. So, you see for my personal needs I cannot possibly sell any work of art. I economize as much as possible with the income of Mr. Gardner's money left to me. The principal I shall never touch. I economize with the income because what I save goes to the upkeep of my ideal project.

— ISABELLA STEWART GARDNER,
1917

For the education and enjoyment of the public forever.

— Isabella Stewart Gardner's will

Isabella Stewart Gardner's museum is an extraordinary achievement. Studded with works of major significance, the collection ranges over many cultures and periods. Moreover, it was acquired in a remarkably short period – mostly between 1892 and 1901. While wealthy, Isabella did not possess the vast resources of American collectors like J. P. Morgan, Henry Clay Frick, and Peter Widener, who spent many times more on art than she did. Her taste and intelligence engendered a very personal collection, replete with masterpieces but also with delightful eccentricities. And, while advisors helped her with acquisitions, the display and presentation of the collection were entirely her own. Mrs. Gardner left no manifesto for her museum, and seems to have deliberately disguised her intentions, leaving visitors to create their own poetic narratives based on the works of art as installed in her galleries.

Little in the background of Isabella Stewart, either before or after her marriage to John Lowell Gardner Jr. in 1860, seemed to predict that she would become a sophisticated collector. In the fashion of wealthy American women, she had received a short formal education in New York and Paris. As a girl of sixteen, she traveled with her parents through Europe where she was greatly impressed by private museums.

After her marriage, Isabella Stewart Gardner emerged as a flamboyant figure in Boston society. Like other members of her class, she gave grand parties, supported charities, hosted famous musicians, and decorated her house with art objects. More remarkable, she began an extended process of self-education in music, literature, and art. Beginning in 1878, she attended Harvard classes given by Charles Eliot Norton, who lectured on Dante and art history.

Travel shaped Mrs. Gardner's taste and personality in significant ways. In 1883 to 1884, the Gardners traveled around the world. Her experiences in Japan, China, Cambodia, India, and the Near East encouraged a deep fascination with other cultures. Thereafter, she and her husband traveled to Europe every other year, usually settling in for an extended sojourn in her beloved Venice. Until the mid-1890s, Gardner did not buy anything more than a few souvenirs and trinkets on her journeys. Instead she collected photographs – commercially produced tourist images of art and architecture – which she annotated and carefully pasted into albums. These albums, which are sometimes also adorned

with her own watercolors, document a voracious curiosity about art. She also seems to have been impressed by the private museums then being formed, the Musée Jacquemart-André in Paris, the Museo Poldi Pezzoli in Milan, and the Wallace Collection in London.

The first works of art that Mrs. Gardner bought were typical of her class and time: a few Barbizon landscapes and some tapestries; more unusual were several important stained glass panels which she acquired in Nuremberg in 1875. Her first serious interest as a collector was for books. Encouraged by Charles Eliot Norton, in the 1880s she bought many rare books and manuscripts, including several early editions of Dante. At about this time, she met writers like Henry James and painters such as James McNeill Whistler, John Singer Sargent, Ralph Curtis, and Denis Miller Bunker. These friendships prepared the way for her wider collecting ambitions.

Great collectors need money. On the death of her father in 1891, Isabella inherited $1.6 million, which she and her husband agreed she would spend on art. Unguided, Isabella began to buy paintings. The incredible good fortune in securing a painting by Vermeer in 1892 turned her into a passionate collector. Shortly after, Bernard Berenson arrived on the scene to offer expert advice, and soon she was spending extremely large sums on paintings. Gardner clearly determined the shape of her collection: after experimenting with British and Dutch pictures, she focused on the Italian Renaissance and later on Spanish art. She also collected ancient and medieval sculpture extensively, and sought important pieces of Italian furniture – a highly unusual field of collecting. In 1902, she decided to buy an important group of old master drawings at a single auction, and did not return to the field. She greatly treasured textiles of all types, but avoided such popular categories as bronzes, maiolica, or armor.

PENSE MOULT,
PARLE PEU,
ECRIS RIEN.

No impression of the "new" Boston can feel itself hang together without remembrance of what it owes to that rare exhibition of the living spirit lately achieved, in the interest of the fine arts, and of all that is noblest in them, by the unaided and quite heroic genius of a private citizen. To attempt to tell the story of the wonderfully-gathered and splendidly-lodged Gardner Collection would be to displace a little the line that separates private from public property; and yet to find no discreet word for it is to appear to fail of feeling for the complexity of conditions amid which so undaunted a devotion to a great idea (undaunted by the battle to fight, losing, alas, with State Protection of native art, and with other scarce less uncanny things) has been able consummately to flower. It is in presence of the results magnificently attained, the energy triumphant over everything, that one feels the fine old disinterested tradition of Boston least broken.
— HENRY JAMES, 1907

I also remember what you said to me (you were I think about 16 years old), namely, that if ever you inherited any money that it was yours to dispose of, you would have a house, a house like the one in Milan (the Poldi Pezzoli) filled with beautiful pictures & objects of Art, for people to come & enjoy. And you have carried out the dream of your youth & given great happiness to hundreds of people. And how grateful we are to you for it, dear Mrs. Gardner!
— IDA AGASSIZ HIGGINSON to
GARDNER, 1923

Think much, speak little, write nothing.
— tile in Mrs. Gardner's bathroom

I have not one cent and Mr. Gardner (who has a New England conscience) won't let me borrow even one more! I have borrowed so much already. He says it is disgraceful. I suppose the picture-habit (which I seem to have) is as bad as the morphine or the whiskey one—and it does cost. So this morning I simply wept when I saw the photograph of the Rembrandt! I want it so much.

— GARDNER TO BERENSON, 1896

Europa and Philip and Van Dyck have drowned me in a Sea of debt. You would laugh to see me. I haven't had but one new frock for a year!

— GARDNER TO BERENSON, 1897

Shan't you and I have fun with my Museum?

— GARDNER TO BERENSON, 1896

"*Bernhard Berenson as I first saw him. I.S.G.,*" ca. 1887

Isabella Stewart Gardner met Bernard Berenson while he was a Harvard undergraduate, and in 1887, helped support several years of his study in Europe. Berenson assisted Edward P. Warren, a connoisseur from Boston who had settled in England, and who acted as art advisor for several American museums. In 1894, Berenson began a friendly correspondence with Mrs. Gardner, and soon offered to help her acquire Botticelli's *Tragedy of Lucretia*. He wrote, "If you cared about it, I could I dare say, help you in getting the best terms. It would be a pleasure to me to be able in some sort to repay you for your kindness on an occasion when I needed help." In the 1890s, Gardner became one of the top collectors in the world. Berenson found for her Titian's *Europa* and works by Rembrandt, Fra Angelico, Botticelli, Giotto, Cellini, and Degas. Later, he helped her with Islamic miniatures and Chinese antiquities. Not surprisingly, there also were a few expensive mistakes: the portrait by Anguissola was bought as a Titian, a portrait of Innocent X was erroneously thought to be by Velázquez.

If Berenson was instrumental in forming Mrs. Gardner's collection, she in turn made Berenson's reputation as a connoisseur who could expertly guide a collector. He needed her perhaps even more than she needed him. In 1894, Berenson had little experience in the art market and relied almost exclusively on the London firm of Colnaghi. Berenson was normally paid five percent of a purchase price by Mrs. Gardner, but was also given a substantial commission by the dealer. Berenson took great pains to disguise this arrangement, claiming to have discovered unknown pictures with old families and in dusty palaces. In fact, most of the paintings offered Mrs. Gardner were owned by Colnaghi, and had been marked up considerably. Reports of Berenson's arrangement slowly leaked out, and Jack Gardner became deeply suspicious. Mrs. Gardner confronted Berenson about this, and Mary Berenson recorded that he "felt at times almost suicidal." Richard Norton, Charles Eliot Norton's son who had become Gardner's agent for ancient sculpture, attacked Berenson as an unscrupulous dealer. (Later, Norton's own reputation was clouded by rumors that he received secret commissions from dealers.) In the end, she continued to trust Berenson, probably realizing that the arrangement – whatever the shady dealings – were in her favor.

Berenson's legacy is controversial. Most of Gardner's important paintings came from Colnaghi, who paid him secretly. Was Berenson therefore just a fancy salesman? Some of his letters are excruciatingly sycophantic, and he was not above inventing elaborate tales to make second-rate pictures seem attractive, or warning her that other buyers were waiting to pounce. However, Mrs. Gardner clearly enjoyed this courtly correspondence and the intrigue of the market; like Lucretia Borgia, she jokingly asked Berenson to kill the owners of Giorgione's *Tempest*. Berenson typically sent black and white photographs of paintings for sale, and she cabled back her response. More often than not, she accepted his advice, and even confessed to once buying a picture just to make him happy! But she also asked him to seek out things she had seen or heard of, and sometimes insisted on acquiring things he did not feel appropriate.

By what standards can we judge Berenson's ethics and abilities? Berenson himself was clearly worried about his lack of truthfulness with the Gardners. On the other hand, there is no doubt that Berenson performed an enormous service to Gardner by offering her the first chance to buy rarities from Colnaghi, who was one of the top dealers. The art market was not entirely open, and Berenson ensured that the very best things made their way into Mrs. Gardner's hands. The overpriced mediocrities were a small price to pay for the great things. If Colnaghi and Berenson took huge profits on the pictures by Rembrandt, Botticelli, and Titian, this was not at all unusual. In any case, the sums would seem absurdly small even ten years later, when the market for paintings rose to astronomical heights. It is obvious too that Berenson truly relished the task of building a collection for Gardner, and knew that he would be judged by the quality of her pictures. In 1896, he wrote, "in my Platonic idea of your gallery a Bellini must be there." And Berenson remained loyal: even in 1917, when Mrs. Gardner's resources had dwindled, he offered her the chance to buy the *Feast of the Gods* by Titian and Bellini (now in the National Gallery of Art, Washington).

Berenson will not be allowed to see the picture for the simple reason that he is dishonest. He is as you must know a dealer. Well, there are only one or two honest Fine Art dealers in the world & Berenson is not one of those.

— RICHARD NORTON to
GARDNER, 1898

Tell me exactly what you paid for the Holbeins. I have a most singular letter from the former owners. I am afraid something is wrong in the transaction. I never liked the Colnaghis, and…. I absolutely did not want to have anything to do with them… It looks as if it might be a question for the Law Courts.

— GARDNER to BERENSON, 1899

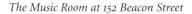

The Music Room at 152 Beacon Street

Fenway Court was not only planned by its owner: in a way, she was an actual builder of the house to an extent probably unprecedented in association with the execution of plans of such magnitude and scope. Virtually Mrs. Gardner was her own architect.

— SYLVESTER BAXTER, 1903

The Prado has such wonders. They seem better and better, and worse and worse installed and cared for. My fingers itched to be made Director.

— GARDNER to BERENSON, 1906

Construction of Fenway Court, with the placement of a stylobate lion, 1900

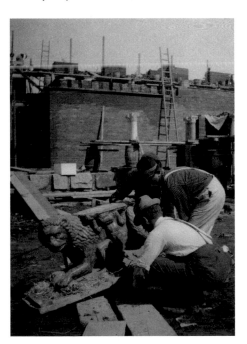

1896 marked a turning point in Gardner's collecting, for in that year she secured paintings by Rembrandt and Titian. The collection was now significant enough to constitute a museum. The Gardner house on Beacon Street, though large, was already very crowded and could not properly display the growing collection. In September 1896, Mrs. Gardner asked the architect Willard Sears to draw up plans for a new museum building that would entirely replace her double house on Beacon Street; an apartment for the Gardners would be included on the top floor. "She wanted me to keep the matter secret from everybody," Sears noted. The Gardners spent much of 1897 in Europe buying objects to furnish their new museum, but sadly, in December 1898, Jack Gardner suddenly died.

Just two weeks later, Sears was asked to finalize the plans so that construction could begin immediately. This suggests that Jack and Isabella had thoroughly conceived plans for a museum, and that Isabella now felt the pressure of time. (On the other hand, the Gardner Museum lacks any explicit memorial to Jack Gardner, and it is somewhat surprising that the building bears Mrs. Gardner's name only.) One day after Willard Sears was asked to complete his plans, Mrs. Gardner announced that she had acquired a new piece of land on the Fens, an empty tract that had just been filled and subdivided. New plans were drawn up for the museum, which would now include a theater and a large courtyard. Ground was broken in June 1899 and the basic structure was finished in late 1901. Isabella spent the following year installing the museum.

The Philadelphia Press, *17 March 1901*

Music Room, Fenway Court, 1903

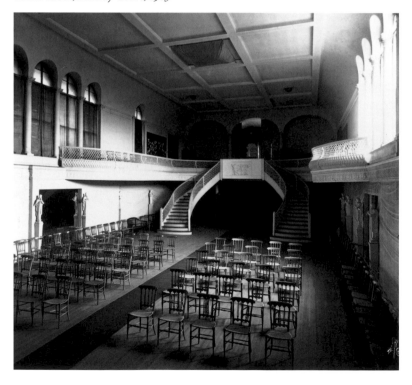

John Evans called today with the drawing for the stone doorway of Mrs. Gardner's house, and said that he would have nothing further to do with her work owing to her pitching into his men yesterday. He would not be bothered by her any further.

Sullivan said she called him a liar and he would not do any more work for her, but after a while I prevailed on him to keep on.

Mrs. Gardner changed her mind in regard to the arrangement of the triple arch windows at the west end of the Gothic Room today after they had been built part way up, and had them rebuilt.

She insisted one of the wood panels had been placed bottom end up, but later said it was all right. She wanted me to discharge all of the plasterers and hire new men. She repudiated all of the plumbing fixtures, saying that they were not at all what she had selected and that she would not have them.

The electric light wiring men objected to entering the conduit on the Worthington St. side of the house and she told them she would not have it elsewhere, that she would use candles.

She said that she had directed Mr. Letson to discharge the floor layers for mimicking her when she spoke to them for not working.

I told her that I had not obtained a permit from the City [for the carriage shed], that I was afraid that the City would not give one if asked for. She said, "Go ahead and build it without a permit, if the City stops me I will not open my museum to the public."

— WILLARD SEARS, *diary, 1900–1901*

❧ The Opening

I am building a new house on the Fenway. I made the plans myself and it has been and is a great pleasure and interest. But within the last fortnight the complications have become so great that I live at the end of a telegraph wire, and find myself called to Boston every other day; and lately I have spent the night there to insure being on the spot early enough to guard against anything going wrong. It is very critical and I simply don't dare being more than an hour away.

— GARDNER, 1901

I still go daily, dinner pail in hand to my Fenway Court work.

— GARDNER, 1902

Do you remember how I once expressed to you my belief that you were the unifying and vivifying essence of Fenway Court? You cannot separate the arts without destroying them, or, at least, reducing them to the condition of investigation. My feeling is that the museum of the past was found in the church, and the museum of the future must consist of a combination of all branches of art. You cannot enjoy music without pictures, and you cannot enjoy pictures without music, and so on. Your collections are less tedious because your presence animates them with life. Withdraw, and science stalks unrobed as a ghost that may never be laid. We are a long way from the Museum of the Future, but when it comes with its orchestra and gardens and so forth, our present efforts will be smiled at by a thankless generation of descendants.

— MATTHEW PRICHARD to
GARDNER, 1908

Having cut such an extravagant social figure, Mrs. Gardner attracted even more rumor and speculation as her museum was being built. Newspapers around the world reported on the progress of the structure that would house her famed pictures. On the evening of 1 January 1903, Isabella Stewart Gardner opened her museum to a group of 300 friends. Guests entered the Music Room (the space now occupied by the Spanish Cloister and Tapestry Room), then paraded up a flight of stairs to be welcomed by Mrs. Gardner on the balcony. At 9:30 p.m., players from the Boston Symphony Orchestra performed a short concert of Bach, Mozart, Chausson, and Schumann. As the last notes were sounding, a mirrored door was rolled back to reveal the lush courtyard illuminated by Japanese paper lanterns. The astonished guests walked through the garden into the galleries of the museum – lit only by candles – before gathering for a light supper in the Dutch Room.

This carefully staged revealing of the museum typifies Gardner's dramatic approach to art. The first guests entered the museum in the dead of winter, and initially encountered rooms decorated in contemporary fashion. Only on passing over a threshold into the courtyard did they encounter a magical historical world: a Venetian court laden with ancient sculpture, and galleries unlike any other in America.

Fenway Court was first opened to the public on 23 February 1903. Tickets were $1 and were sold at an agency downtown; attendance was limited to 200 a day. Mrs. Gardner monitored the proceedings, sometimes following the crowds through the rooms, sometimes watching from the upper balconies. During her lifetime, the museum was opened for several weeks each spring and autumn.

Modernist critics, not surprisingly, were uncomfortable with Mrs. Gardner's intensely personal museum. Lewis Mumford chided Gardner for her "pillaging" of Europe. Similarly, Henry James, Henry Adams, and George Santayana were faulted for failing to support the "virile" forces of American modernism, preferring instead European culture. However, Mrs. Gardner made an important contribution to the cultural debate in America by her fervent support of the original work of art. At a time when many American museums were debating whether it was worth acquiring genuine historical objects, she advocated that the Museum of Fine Arts abandon its practice of buying plaster reproductions of canonical works.

... and of course have seen Palazzo Gardner. Her collection is marvelous, & looks beautifully in its new setting, but a spirit of opposition roused in me when I am told "there is nothing like it in Europe" especially when this is applied to houses!

— EDITH WHARTON
 to SARA ISELIN, 1903

The Dutch Room

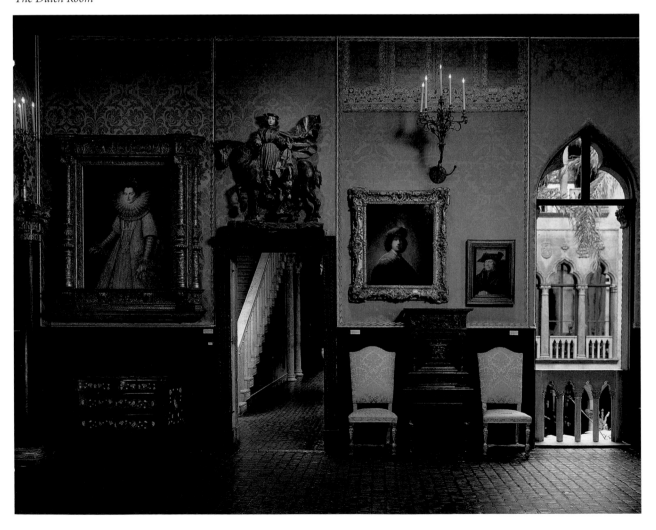

She seized scattered objects; lugged them to Boston; and enthroned them in a building which was – one hardly knows which to call it – a home and a museum. As a home, it became a pattern for the homes of rich people in America for a whole generation.... That is what the Gilded Age called "culture;" and this is what they dreamed of. Mrs. Jack Gardner's palace was the Platonic pattern which earlier houses anticipated, and later ones struggled bravely towards. Was it any wonder that Henry James, William James, Charles Eliot Norton, Henry Adams sat more or less obediently at her feet?

— LEWIS MUMFORD, 1925

... a house which seemed to have grown from a demented fancy... the house was laid out in a jumble of Gothic passages, erratically placed steps, and doorless chambers, and had then been filled with the spoils of Mrs. Gardner's travels abroad.

— CHARLES MERRILL MOUNT, 1955

The task is to find and create a humane milieu for works of art, a humane environment for all art which will not repel mankind but attract him.

— MATTHEW PRICHARD to GARDNER, 1908

We went out to see Mrs. Gardner today. She will soon die, and she must know it, but she is unchanged in her egotism, her malice, her attachment to detail, to nonsensical things. All this, in the days of her vitality, when it seemed as if she couldn't grow old and die, were actually part of her charm. But now it is purely pathetic, and a little ugly.... But the worst of all is that her great Palace, in spite of the marvellous pictures in it, looks to our now enlightened eyes like a junk shop. There is something horrible in these American collections, in snatching this and that away from its real home and hanging it on a wall of priceless damask made for somewhere else, above furniture higgledipiggled from other places, strewn with objets d'art ravished from still other realms, Chinese, Japanese, Persian, Indian objects, that seem as if they were bleeding to death in those dreary super-museums.... But this is not a gospel I can even allude to here, under the circumstances!! Where should we be?

— MARY BERENSON, 1920

When we enter Mrs. Gardner's space, we enter an inverted building. What should be public facades – palazzi fronting the Grand Canal in Venice – are now interior walls. At the time, homosexuality itself was being conceptualized as sexual inversion. Furthermore, gays and lesbians have, for a century, been required to carefully sequester their emotional and sexual lives from the public gaze. The spacious, majestic courtyard of the Gardner Museum strikes me as a kind of closet, amply furnished and turned into a simulation of an exterior. The outside of the building is rather plain; only when we enter Gardner's secret world do we see her flamboyance.

For centuries, expatriation has been a necessity for many privileged gays and lesbians. Gertrude Stein, André Gide, Paul Bowles, and James Baldwin searched for other locales where they might find the liberty to pursue their desires. Mrs. Gardner's appropriation of Venice – her gesture of bringing Venice back to Boston – seems connected to the gay urge to make of foreign ports sexual wonderlands, and to escape the confinements of home by reinventing home as a simulacrum of abroad.

— WAYNE KOESTENBAUM, 1996

This fresh and spontaneous portrait links three close friends: Isabella Stewart Gardner, John Singer Sargent, and the sitter, Charles Loeffler (1861–1935), who was a composer and violinist. A month after Fenway Court opened, Gardner invited Sargent to use the Gothic Room as a studio. Sargent painted Loeffler's portrait there in less than three hours, and then presented it to Mrs. Gardner on her birthday. Born in France, Loeffler immigrated to the United States in 1881. He was joint first violinist of the Boston Symphony Orchestra, but left to devote himself to composing. A few days after receiving this portrait, Gardner presented a concert of Loeffler's compositions at Fenway Court, including the premiere of his *Pagan Poem*.

Jack and Isabella Gardner's house at 152 Beacon Street had been the venue for concerts by such luminaries as Ignace Paderewski and Jean de Reske, and music and performance were also an integral part of the new museum. The celebrated Australian soprano Nellie Melba gave a concert in 1905, and the modern dancer Ruth St. Denis performed the following year.

After the museum opened, Mrs. Gardner continued to buy new works and rearrange rooms. After 1909, she published a small pamphlet every year or so that listed the principal objects on view. During the last phase of Mrs. Gardner's collecting, her interests shifted to Spanish, Islamic, and Chinese art. By 1914, there were so many new objects that the entire east wing of Fenway Court was rebuilt. The old Music Room was carved into new galleries: a Spanish Cloister (which displays Sargent's *El Jaleo*) and a Tapestry Room, the setting for two tapestry cycles from the Barberini collection.

Other galleries were re-organized. The old Chinese Room of 1903 had been a typically Victorian mixture of Japanese screens, Chinese silks, Italian furniture, and modern paintings. In 1915, the room was changed into the Room of Early Italian Pictures, a more academic presentation of gold ground paintings, although a few works linking Italy with the East were retained.

— ALAN CHONG, 2002

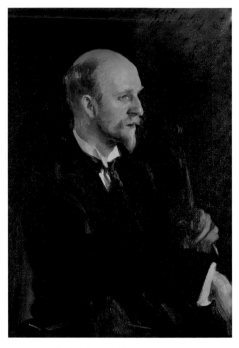

Portrait of Charles Loeffler, 1903
John Singer Sargent. Oil on canvas, 87 x 62 cm, signed at top: To Mrs. Gardner, con buone feste / from her friend John S. Sargent.

John Singer Sargent at work in the Gothic Room, February 1903

Notes to the reader

*Buddhist teachers try to make us under-
stand that the looks of the people who
gazed upon the work of art have added to
its power. For this the work of art must
live by itself as a part of the temple or the
house, must be removed from the gaze of
the common or the analyzing eye. It must
be seen accidentally, in poor lights as well
as good—as it were, never on purpose.*

— JOHN LA FARGE, 1907

The texts in this book have been culled from many sources, from articles and books, to unpublished diaries and letters, as well as lectures given at the Gardner Museum. Many essays have been specially written for the volume. We hope that the reader will find these rich and varied responses of interest.

We would like to thank those who have written insightful new comments: Cristelle Baskins, Marietta Cambareri, Robert Campbell, Stephen Campbell, Rachel Jacoff, Deborah Kahn, Eloy Koldewij, Jane Langton, Robert Maxwell, Anne McCauley, Mary McWilliams, Noriko Murai, Midori Oka, Myra Orth, James Saslow, Susan Spinale, Aileen Tsui, Evan Turner, Eugene Wang, Michelle Wang, Barbara Weinberg, and Michael Zell. Others have kindly revised their earlier texts and approved their use. Tom Lingner made new photographs of sometimes difficult to reach objects.

The illustrated here are meant to survey the most significant works in the collection, while representing Mrs. Gardner's major collecting interests and also including a few less familiar objects. We have been advised in this selection by many of the authors and by Laurence Kanter, Everett Fahy, David Alan Brown, Trevor Fairbrother, Eleonor Garvey, Fausto Calderai, Bet McLeod, Tracey Albainy, and Madeline Caviness. Staff members Valentine Talland, Kathy Francis, Bonnie Halvorson, Anne Hawley, Giovanna de Appolonia, and Pieranna Cavalchini wrote entries and provided much valuable advice. Warm thanks also to Chris Aldrich, Cynthia Purvis, Gianfranco Pocobene, Sunil Sharma, Matthew Smith, Lindsy Parrott, Dacey Sartor, Kristin Parker, Peter Campbell, Mario Pereira, and the staff of Beacon Press.

Locations are not given for books, works on paper, or most textiles. Sources for texts and quotes, as well as identifying information on the contributors, can be found at the end of the book.

— AC, RL, CZ

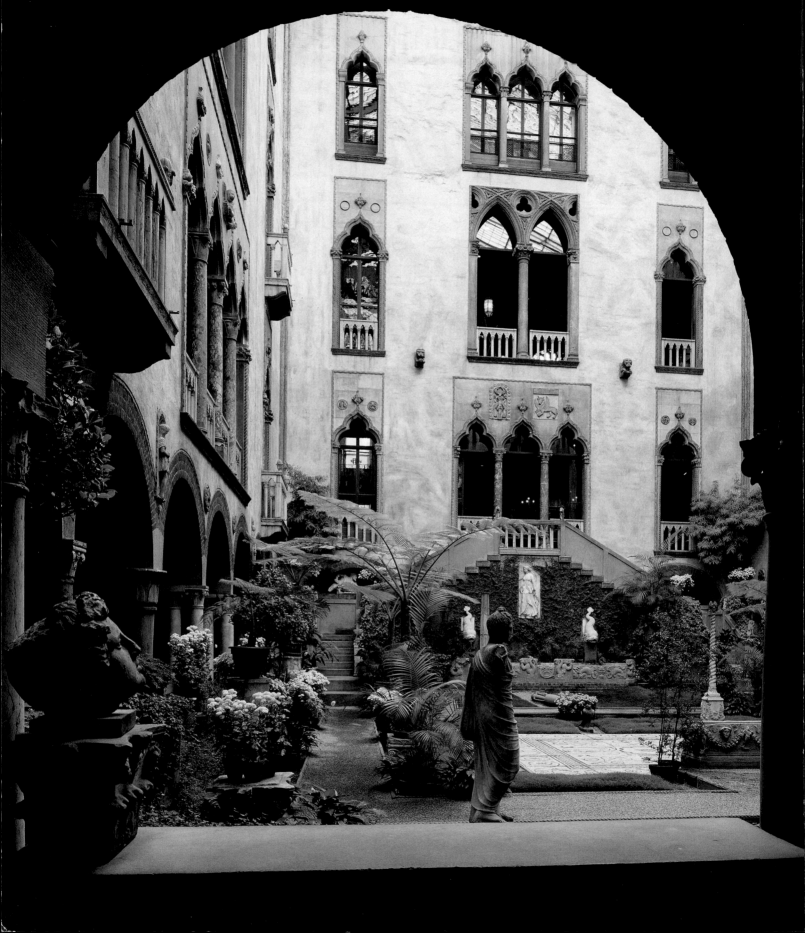

Mrs. Gardner's Palace on the Fenway

IN EVERY CITY people say, to their visiting friends and relatives, "There is one place you must see before you leave." In Boston, for me, that place has always been the Gardner Museum. There is nothing like it, nothing even remotely like it, anywhere else on earth.

I made my first visit shortly after arriving in Boston as a student. I remember it vividly. The blankness of the exterior of the building, like the plain brown wrapper around a forbidden delight. The low, dark, slightly claustrophobic entry that seems to compress you. And then the great upward explosion of light and color and space as you emerge into the atrium. You feel like a star football player trotting out of a tunnel into a cheering stadium. Light plays on the varying shades of pink of the stucco. When you see another person looking into the atrium from one of its windows, that person is framed by the window like a work of art. I wandered around in a daze of delight. The paintings are wonderful, but for me the art of the architecture is what is most wonderful about the Gardner.

We live today in a world of media screens, in which only one of our five senses, the sense of sight, is fully engaged. The Gardner reminds us that we have others. We smell the fragrance of flowers and old wood. We hear, perhaps, a string quartet in the distance. We may stroll out to the Monks Garden and taste a glass of wine in the open air.

Most art museums foreground the art to the exclusion of all else, perhaps placing a painting or sculpture against a white wall beneath a spotlight. A work of art, seen that way, looks like the slide on a screen in an art history lecture. The Gardner, by contrast, tells us that art cannot be isolated. It integrates art into the fullness of life. A painting is not celebrated or shoved in our faces, but takes its place among the rooms and flowers as simply one part of a well-furnished life.

Part of the magic, although it can also be an irritation, is the fact that often the artworks aren't terribly well lighted, and they usually lack informative captions. But it's the lack of spotlighting and captioning that makes us feel that we are Mrs. Gardner's guests, rather than tourists. We feel we are merely wandering through the rooms of her remarkable house for a few minutes before she calls us in to dinner. We're not here to study, but to live.

It's partly because of the lack of captions, too, that frequent visitors tend to become inside dopesters of the collection. We take

pride in knowing what and where things are. We revisit favorite artworks like old friends. I don't know why, but I always make a point of checking out the wonderful small portrait by Uccello of a "Young Lady of Fashion." It's like being greeted by a familiar and loved face. On the other hand, there is never a visit to the Gardner in which we don't discover something we'd never noticed before.

Attributed to Paolo Uccello, *A Young Lady of Fashion*, 1460s, p. 51

When she was setting her museum up, this country was filled with Beaux-Arts museums. Now, these are grand museums, with great big halls in which directors and curators can have fun moving things around. But Mrs. Gardner did something quite different. She created rooms specific to artists or to periods, so that, for example, the Veronese Room is exactly the kind of room that suggests the voluptuous textures of Veronese, while the Dutch Room has the intellectual austerity coupled with a grandeur typical of that period. When you enter any room at the Gardner Museum, you are subtly directed towards art, and are given subliminal signals that alert you to the character of what you are about to see.

— SISTER WENDY BECKETT, 1998

If Fenway Court were not a palace, it would still be a fine museum of art. But, then, museums of art are unartistic, and this, it must be added, is artistic to the point of genius.

The Outlook, 1903

The great court inside this perfectly plain building, which has the look of secrecy that we remember in many foreign treasure houses, is pierced with Venetian windows and balustrades, opening on many stories. Each of these, and the arcaded galleries, has its own character, its own reminder of different pasts.

— JOHN LA FARGE, 1907

The Gardner isn't a building that makes it into the architectural history books. The architect, Willard Sears, produced in the building's details a fairly conventional imitation of the private palaces of Venice. But the Gardner is more remarkable than it looks at first. This is a palace that has been turned inside out. The rich ornament and detail that would, in Venice, be part of a facade overlooking a canal is, at the Gardner, brought indoors. The Gardner's real facades are the four sides of the atrium. That's why the building exterior is bland. The architectural billboards are inside. And these mottled indoor facades are washed by sunlight that is modulated, by the glass roof, in such a way that it often resembles light reflected off water, as it would be in Venice. As we look, we hear the sound of water falling over ancient fragments.

If you prowl the museum with a guidebook, there are other architectural pleasures. Much of the building has been assembled, rather than constructed. The floor of the atrium is a mosaic from an ancient villa in Rome. Balustrades at the balconies once graced the famed Ca' d'Oro in Venice. The list is endless. The house is itself a collection, almost as much as is the art. The Gardner blurs the distinction between art and architecture. Is this carved column to be thought of as an independent work of art, or is it an integral part of the architecture? At the Gardner, you're never quite sure, and you realize it doesn't matter. The effect is to make everything begin to feel like art, from table settings to paintings to column capitals to the atrium walls themselves. In such a setting, you start to feel like an artwork yourself.

Like William Randolph Hearst in California, Isabella Stewart Gardner attempted to pack up Europe and bring it to America. Both of them embodied a typical American attitude that has now disappeared. This was the assumption that America was the natural inheritor of all the cultures of the past. Europe was the past and we were the future, and it felt natural for us to take possession of the heirlooms.

We are the lucky beneficiaries of the pilfering urge of such people. Architecture is the art of making places, and the Isabella Stewart Gardner Museum is simply the most amazing, and the most improbable place in the Boston area. As it moves into its second century, we can only be grateful for the vision of the woman who created it, and whose spirit is a presence in the air of every room.

— ROBERT CAMPBELL, 2002

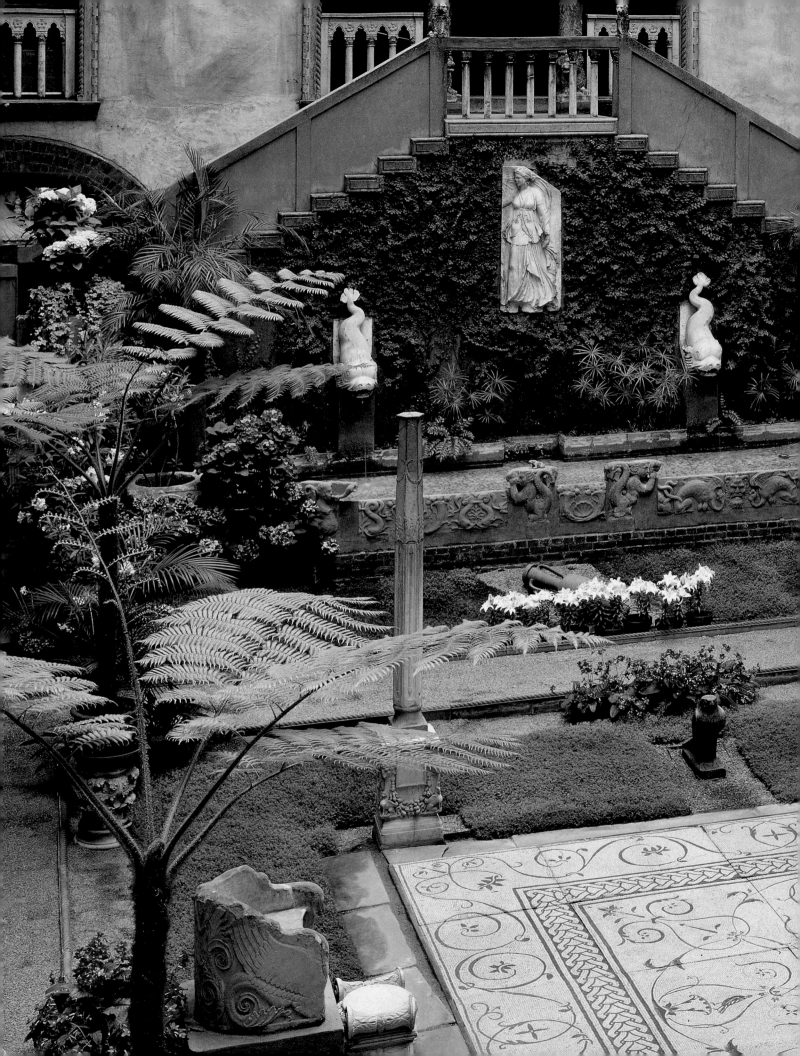

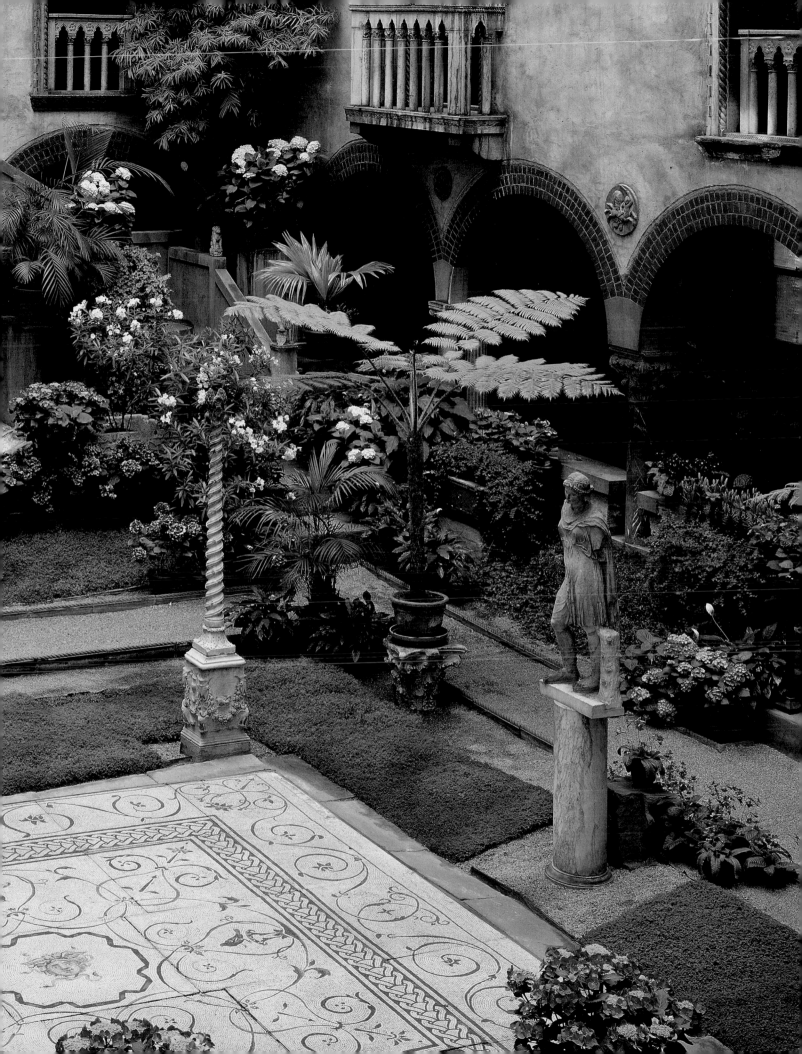

❧ The Courtyard

MANY ASPECTS of the Gardner Museum recall universal female traits: maternal love, matriarchal power, and erotic passion. Isabella Stewart Gardner arranged the objects in her fertile garden courtyard to suggest an intensely personal narrative. The Roman mosaic floor depicting the snake-encircled head of Medusa was specifically chosen by her; she then carefully positioned it at the center of the garden. Medusa is perhaps the ultimate embodiment of female power, while the encircling birds and flowers symbolize regenerative nature. By placing Medusa at the heart of her museum, Gardner clearly established the space as a locus of female power.

Mrs. Gardner often liked to sit on the ancient marble throne that faces the mosaic. There, she could gaze directly at a statue of Diana, goddess of the hunt, and eternal virgin, who was never possessed by another. Similarly, Gardner remained independent and true to her own vision. On the front edge of the mosaic is a small garlanded sarcophagus decorated with the bust of a young child – this inevitably recalls Gardner's own beloved son Jackie, who died in 1865 at the age of two. At the far end of the court, over the fountain, is a relief depicting a maenad (illus.), a female follower of Bacchus who participated in orgiastic rituals devoted to the god. Caught in motion as she dances, this extravagant figure decorated a monument dedicated to Bacchus. Gardner thus captured the wild side of her gender – the erotic power of woman. All of these roles – virgin, mother, sybarite – find echoes throughout the museum. And since all the galleries have balconies overlooking the courtyard, visitors are constantly reminded of these connections as they are drawn back to the vital, feminine space of the garden.

— ANNE HAWLEY, 1999

Mrs. Gardner's Sunken Garden

How very appropriate that this courtyard, this sunken garden, should be presided over by the Egyptian sky god, Horus. It seems as if this figure – African if indeed not black – presides over the central mosaic the way Egyptian culture might be said to have presided over its younger sibling, ancient Greece. Even in the very center of Western culture, the figure of the Other appears: the half-acknowledged emblem of all that is non-Western. Horus is the uniter of Rome and Egypt, of Europe and Africa, of a multicultural present and a multicultural past.

Medusa, depicted in the mosaic, was one of the three Gorgons whom Herodotus places in a region he calls Libya, adjoining the land of darkness. Alone of her sisters, Medusa was mortal and, initially, a beautiful maiden, until Athena turned her hair into serpents, because she had slept with Poseidon. And where I come from, in my culture, that hair would be known as bad or kinky hair.

So, at the heart of this museum, staring us in our faces as we gaze upon Mrs. Gardner's garden, our primal Egyptian god stands guard over a first-century Roman mosaic pavement, at the center of which is a dredlocked head of a woman from north Africa. I think of this garden as the sunken garden of Western civilization. And I think of it as a metaphor for the construction of our idea of Western culture itself, as well as of the place of the African presence in it.

— HENRY LOUIS GATES, JR., 1993

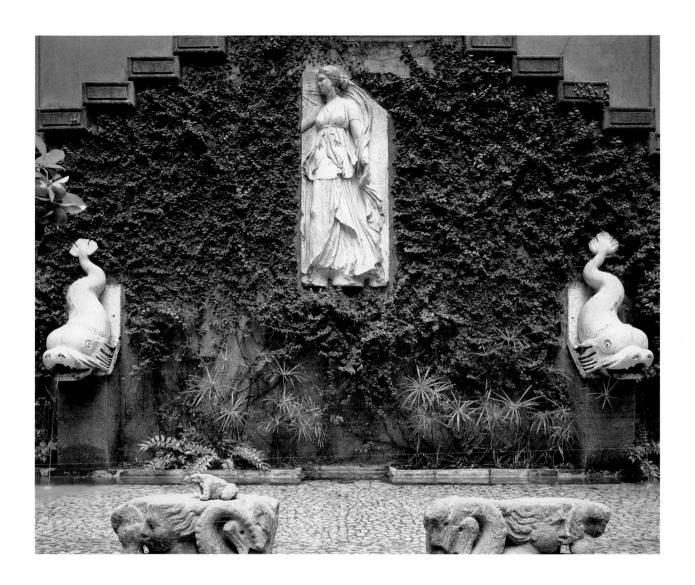

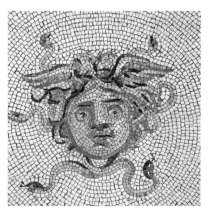

❧ Ancient Art

The first ancient object that Isabella Stewart Gardner purchased is also one of the collection's very oldest – the Egyptian Horus that now peers over the mosaic in the courtyard was bought in 1895. Once she had decided to create a museum of significant works of art, Mrs. Gardner began to buy ancient sculpture, a field she had earlier ignored. Classical statuary was of course a requirement of any encyclopedic museum, and Mrs. Gardner needed no special coaching to embark in this field. Bernard Berenson, who helped her acquire many important paintings, played no role, but Richard Norton, son of the Harvard professor Charles Eliot Norton, began to suggest possible acquisitions. She was adamant that genuine ancient statues and sarcophagi be acquired, and vigorously objected to the policy at the Boston Museum of Fine Arts of acquiring plaster casts.

It is startling to realize how many canonical pieces of ancient art were for sale around 1900. Mrs. Gardner began at the very top. When it was suggested that the celebrated Ludovisi Throne and the Farnese Sarcophagus were available for the right price, Mrs. Gardner snapped up the sarcophagus, although the throne remained elusive. In late 1898 negotiations began in earnest, with strong competition from the Italian government and the Museum of Fine Arts. Richard Norton and Gardner thought they were very close to clinching a deal, but in the end the government acquired the entire Ludovisi collection in 1905. Gardner also attempted to buy the Lancellotti Discobolos and the Girl of Anzio (both now in the Museo Nazionale Romano, Rome). Marble statuary most strongly interested Gardner, almost certainly because of the strong echoes to be seen in her Renaissance paintings.

The heart of the classical collection is also the heart of the museum: the courtyard. Around the mosaic depicting Medusa is arranged a throne, decorative shafts, the Horus, and a child's sarcophagus. On the perimeter are the prize pieces: a maenad relief, standing goddesses, Odysseus, and the great Farnese Sarcophagus. Important ancient works can also be found scattered through the galleries.

∽ *Odysseus*

Roman, ca. 25 BC or ca. AD 125, in Greek Archaic style of 490 BC
Marble, 65 x 113 cm
Purchased in 1898 from Giuseppe Spithoever, Rome, through
Richard Norton. Courtyard

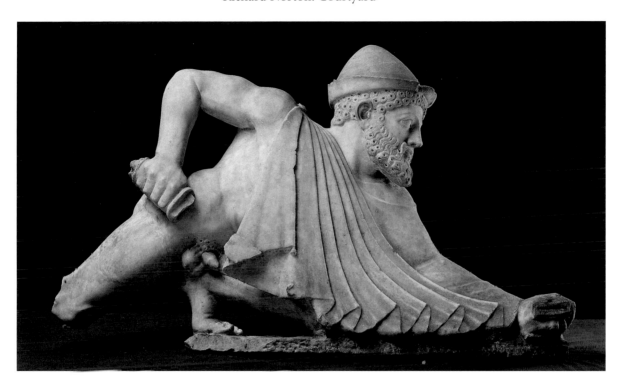

"The Billiard Player"
— HAROLD PARSONS

Odysseus creeping towards an unseen object or adversary has long been a magnificent mythological sight at Fenway Court. The crafty Greek hero assumed this unusual posture on several occasions during the ten-year siege of Troy. Near the end of the war, he crept into the city on a spying mission. Odysseus also entered the city with Diomedes to steal the sacred image of Athena, the Palladium. Some sources say that Odysseus did the stealing. Others say he became jealous of Diomedes' success in this endeavor and crouched just outside the city to ambush his accomplice returning over the walls with the small icon. The glint of moonlight on Odysseus' drawn sword is what saved Diomedes from death.

This Odysseus is a Roman pedimental figure, meant to be seen in the setting of a wide triangle on a small building such as a shrine in the Gardens of Sallust in Rome, where the statue was found in 1885. The complete composition might have shown the Palladium on an altar or pedestal in the center, with Diomedes creeping up from the other side. Or perhaps Athena herself stood in the middle of the pediment, as was often the case in Archaic Greek sculpture, helping the thieves to hasten Troy's fall.

— CORNELIUS C. VERMEULE, 1984

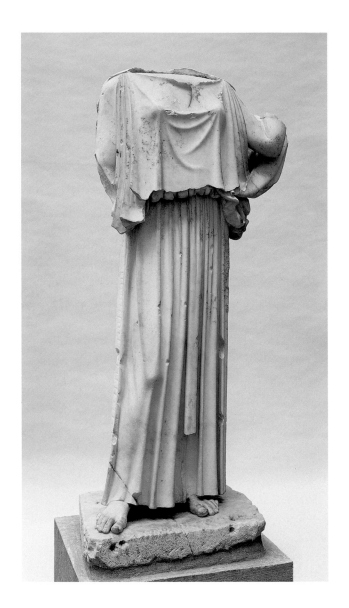
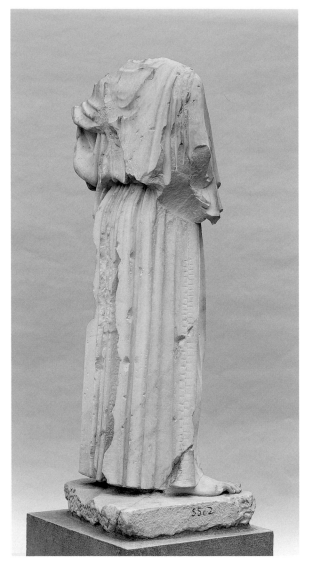

❧ A Goddess (Peplophoros)

Roman, early 1st century, after a Greek bronze of ca. 455 BC
Marble, 148 cm high
Purchased in 1901 from the Sisters of San Giuseppe, through
Richard Norton. Courtyard

The most famous statue at Fenway Court is probably the
Peplophoros, a representation of a youthful goddess such as
Persephone, made at the time of Julius Caesar or Augustus after
an original of about 455 BC. The smooth finish of the surfaces and
the translucent qualities of the Greek island marble make this a
very attractive modernization of a bronze from the so-called
Severe Style that led to the golden age of Phidias and the
Parthenon in Athens. The goddess, or perhaps a noble mortal,
wears a high-girt Doric chiton with an ample overfold. The chi-
ton is represented as sewn at the right side, where a long wavy
seam with horizontal stitches has been carefully copied in marble
from the bronze original. Mrs. Gardner's treasure of Greek female
dignity was discovered in March 1901, on the site of the famous
Gardens of Sallust, on the property of the Sisters of San Giuseppe
on the Pincian Hill. Mrs. Gardner never saw the statue in Boston.
It was a showpiece of the American Academy in Rome from 1901
until 1936, when the Italian government authorized its export.

 — CORNELIUS C. VERMEULE, 1978

*Please consider the feet of the Greek lady whose photograph I send.
For their sake alone she ought to be Pope!*

 — RICHARD NORTON, 1901

❧ A Goddess (Persephone)

Greek, ca. 20 BC–AD 50, after a work of ca. 340 BC
Marble, 151.1 cm high
Purchased in 1901 in Rome, through Richard Norton. Courtyard

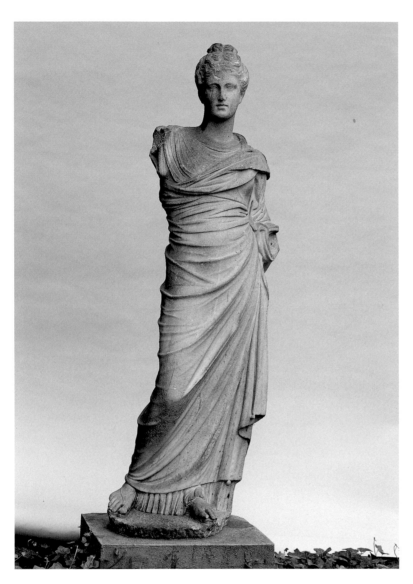

*It was Praxitelean draped beauty which appealed to Mrs.
Gardner's tastes and standards in Greek sculpture. The Praxitelean
goddess or lady of fashion brought to Boston at the outset of the
Edwardian decade suited these aspirations to classical perfection.*

— CORNELIUS C. VERMEULE, 1978

✺ A Maenad

Roman, ca. AD 100, after a model of ca. 300 BC
Marble, 143.5 x 58.4 cm
Purchased in 1897 from Antonio and Alessandro Jandolo, Rome.
Courtyard

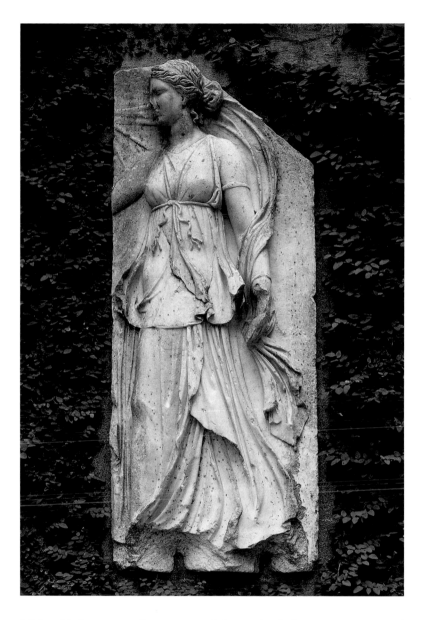

This relief, set over the courtyard fountain, belongs to a series of eight maenads (the seven others were unearthed separately in Rome in 1908 and are now in the Museo Nazionale Romano, Rome). Together, they formed a cylindrical frieze of exuberantly dancing women that was probably the base of a tripod dedicated to Bacchus. Maenads were female followers of Bacchus who danced themselves into orgiastic frenzies.

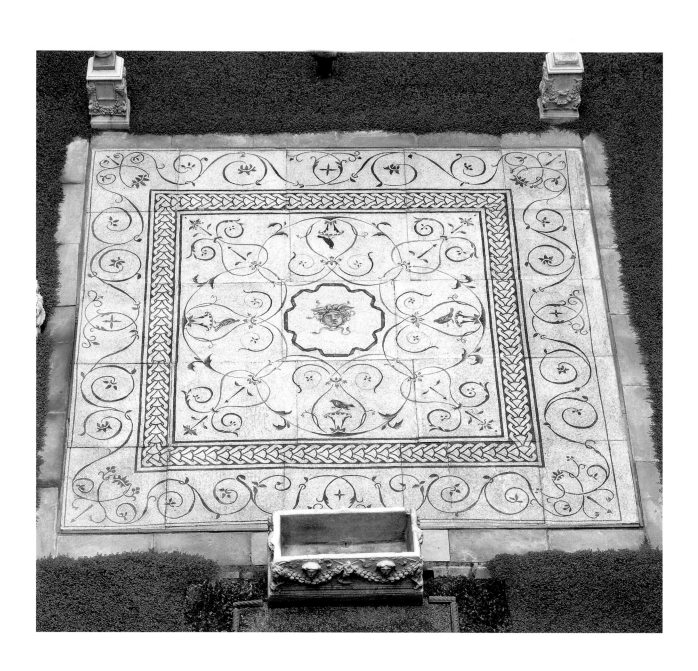

Mosaic Floor: Medusa

Roman (near Rome), AD 117–138
Mosaic, 500.4 x 495.3 cm
Purchased in 1892. Courtyard

*The saga of Mrs. Gardner's Greek and Roman antiquities can
begin and end with this mosaic, for the marble sculpture at Fenway
Court were set, with considerable taste and thought, to be patterns
in a larger scene.*

 — CORNELIUS C. VERMEULE, 1978

In 1892 an ancient villa was discovered just north of Rome, near
the villa of Augustus's wife Livia. Several well-preserved mosaic
floors adorned the baths of the villa. A second mosaic from the
villa, showing two figures in Egyptian style, is now in the
Metropolitan Museum of Art. Jack and Isabella Gardner inspect-
ed the mosaics in 1895 and purchased this floor in 1897. The deli-
cate tracery of this mosaic resembles those made in Pompei
around 25 AD (the late second or third style), but brick stamps
indicate that it was laid a century later, during the reign of
Emperor Hadrian.

The Muse as Medusa

I saw you once, Medusa; we were alone.
I looked you straight in the cold eye, cold.
I was not punished, was not turned to stone—

How to believe the legends I am told?

I came as naked as any little fish,
Prepared to be hooked, gutted, caught;
But I saw you, Medusa, made my wish,
And when I left you I was clothed in thought.

....

I turn your face around! It is my face.
That frozen rage is what I must explore—
Oh secret, self-enclosed, and ravaged place!
This is the gift I thank Medusa for.

 — MAY SARTON, 1967

Sarcophagus: Revelers Gathering Grapes

Roman, ca. 225
Marble, 105.5 x 224 x 101.5 cm
Purchased in 1898 from the Sciarra collection, Rome, through
Richard Norton. West Cloister

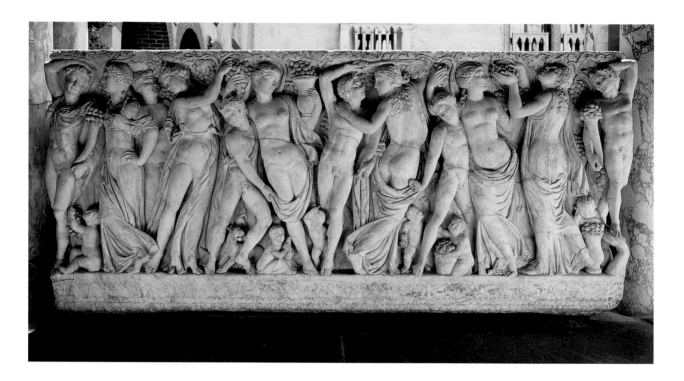

In terms of antiquarian fame – marbles copied in sketchbooks, paintings, or sculptures from the Renaissance on – the most important work of art in the Gardner collection, and perhaps of its type in America, is the sarcophagus with satyrs and maenads gathering grapes. This large, rectangular coffin of Pentelic marble with one long side and both ends elaborately carved and polished (the second long side left in a less finished state because it stood against a wall in the funerary chamber), was exported from Athens to the area of Rome in the late Severan period, between circa AD 222 to 235. The occupants of the monument are unknown, since the lid was lost or destroyed some time around 1500. The groups of reveling couples on all sides, combined with the type of lid found on other examples of this Attic imperial sarcophagus, suggest a husband and wife were shown on top, as if reclining at a symposium on an elaborate couch.

The art-historical diarist and cicerone of the mid-cinque-cento, Ulisse Aldrovandi, reported that the sarcophagus came

For a sarcophagus, it is unusually fine. Naturally the work is not as refined as the work on the Parthenon frieze, but this slightly hasty character of the work is characteristic of sarcophagi. It is really very lovely and I do not think even Boston would object to its frank but slight sensuality.

– RICHARD NORTON
TO GARDNER, 1897

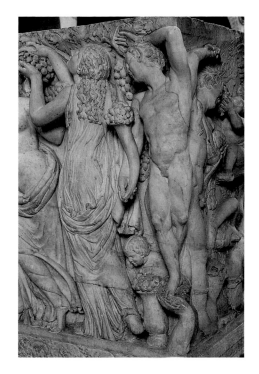

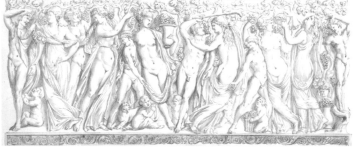

This copy of the sarcophagus was drawn around 1620 by an unknown Italian artist. The sheet is mounted in Cassiano dal Pozzo's album of drawings after ancient sculpture (Royal Library, Windsor Castle). The variety of sensuous poses found on the sarcophagus must have appealed greatly to Baroque artists in Rome.

Detail of right corner

from Tivoli and was first to be seen in Rome in the Villa Farnesina in the 1550s. For over a quarter of a millennium the monument ornamented the courtyard of the Palazzo Farnese in the heart of the city, passing finally to the Villa Sciarra. In 1898 it was purchased from the Sciarra collection, through Richard Norton. The carving of the satyrs and maenads was especially suited to the artistic tastes of Mannerist and Baroque Rome, providing one of the most elegant examples of Greek imperial optic elongation to have survived from ancient times. The Farnese-Gardner Sarcophagus can be considered one of the latest expressions of monumental pagan sculpture used for non-historical and decorative funerary purposes. As such it makes a perfect transition through the sculptures of the Middle Ages at Fenway Court to the cinquecento paintings with antiquarian flavor, like Titian's *Europa*, in the rooms upstairs.

— CORNELIUS C. VERMEULE, 1978

Torso of Dionysos

Roman (Italy), ca. AD 140–190, after a Greek type of ca. 340 BC
Marble, 92 cm high
Chinese Loggia

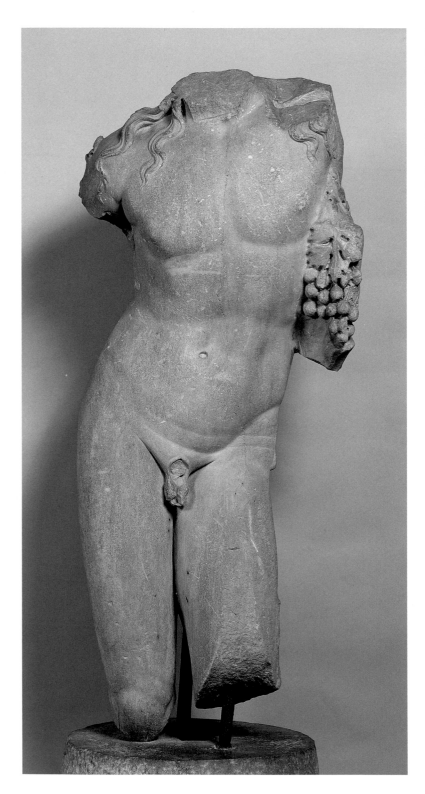

The languid pose of the figure – hip jutting out as he leans against a vine stump – is derived ultimately from the celebrated works of Praxiteles. The most famous example of the pose was the Apollo Sauroktonos (Lizard-Slayer), known through numerous Roman marble copies of the lost bronze. The use of the drill in defining the leaves and grapes suggests that this work was carved in the Antonine period of the Roman Empire.

Cinerarium (Grave Altar)

Roman, ca. 100
Marble, 78 x 62.5 x 47.5 cm
Acquired through Richard Norton in 1901. Long Gallery

Heart ache is very difficult to still;
I do not know how many Vermeers,
Or what quality of Velasquez would be
needed
For the loss of a lover or husband;
And would it take more to still
The cry for an only child – or none at all?
The little Raphael, the Giorgione,
or the Fra?

Here she dropped the pen and glanced
Into Saint Ingrazia's eyes.
Here she stepped to the other table
Where Innocent may be examined –
More critically than in life most women
dared, I wager!

Wander from room to room, and round
the Court –
You may almost catch a shade
That searches your face
As in life it did –
Seeking what, I wonder,
With all this glory of alleviation!

 – AUGUSTA S. TAVENDER,
 ca. 1925

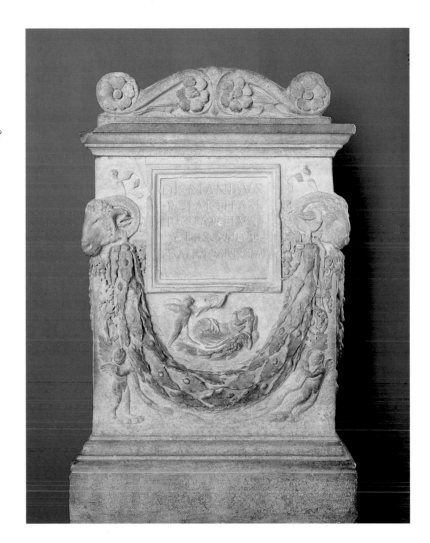

Many sarcophagi and cinerary urns decorate the Gardner Museum. In this well-preserved example, two rams' heads anchor a garland. Below the inscription Cupid approaches the sleeping Psyche, a subject that suggests that dead souls could be reawakened through love. This cinerarium was found near S. Paolo fuori le mura in Rome. Other grave markers found nearby indicate that the deceased was from a family of freed Greek slaves from Asia Minor.

TO THE GODS AND SHADES, TO PUBLIUS CIARTIUS LASUS. PUBLIUS CIARTUS ALEXANDER, TO HIS DEAREST BROTHER.
 – inscription on the cinerarium

Then if you want to know what in the retrospect makes me weep each time I think upon it – you will smile to know that it is the sight of the long table before the fireplace in the Gothic Room on which are some iron boxes & to me, well, it has to me the simple note of perfection – and so you see, entails these tears!

— SARAH WHITMAN, 1902

Medieval Art

Among Isabella Stewart Gardner's earliest art acquisitions were small medieval objects, which she began to buy in Nuremberg and Venice on her regular trips to Europe. In 1897, when she and Jack Gardner decided to create a true museum, she acquired architectural elements and sculpture to create evocative chapels and cloisters at the new Fenway Court.

Gardner did not buy objects simply as decoration, but chose individual works with great care and affection. She seems to have been drawn to specific categories of medieval art, and to works possessed of deep religious expression. Romanesque sculpture, with its severe and simple pathos, continually stirred her interest and constitutes perhaps the most significant part of the medieval collection. She also collected stained glass with some seriousness. The collection contains numerous processional crosses, a handful of illuminated prayer books, and a great deal of wrought iron. She avoided such genres as ivories, enamels, and manuscript illumination, which collectors like J. P. Morgan bought in large quantities.

Mrs. Gardner's installation strategies were sophisticated and powerful. The Gothic Room forms the centerpiece of the medieval collection. Much of the French Gothic furniture is arranged here, along with sculpture and stained glass. Appropriately, she displayed paintings by Giotto and Simone Martini here. The gallery is not a historicist "period room" nor a recreation of a chapel or cloister. Indeed, in an entirely unorthodox (even sacrilegious) manner, the Gothic Room is dominated by Gardner's own portrait by Sargent. Madonna-like, she remains a luminous and audacious presence.

Nearby are other medieval objects: a chapel is adorned with the huge window from Soissons, while an adjacent hallway contains important religious sculpture. The courtyard is lined with secular architectural reliefs, while its cloisters display important Romanesque carvings. Mrs. Gardner's palace had considerable influence on American museums, which began to collect medieval sculpture and architectural elements. George Gray Barnard's Cloisters in New York (1914, rebuilt in 1934) is a far more archeological and extensive reconstruction of medieval Europe, but it owes a real debt to Mrs. Gardner's museum.

❧ Altar Frontal Relief

Italian (around Rome), mid-800s
Marble, 76.2 x 181.6 cm
Purchased in 1899 from Francesco Dorigo, Venice.
Stairway to the second floor

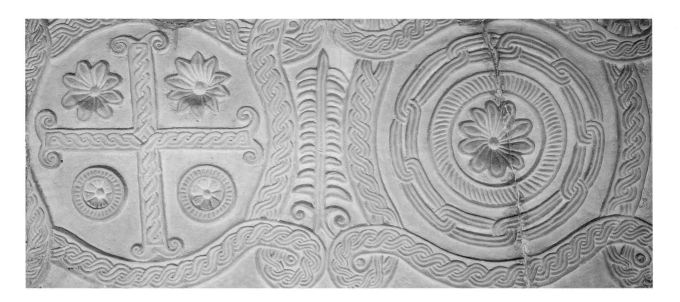

Full of twisting, looped, and repeating forms, this relief displays an elaborately carved cross and a rosette. The carving varies considerably in depth, which lends greater interest to the object. The patterns are typical of Italian ornamental reliefs of the ninth and tenth centuries, while the distinctive chain motif is closely related to altar frontals made in or around Rome.

The design is organized around two large circles formed by twisted bands with looped corners. This relief, which originally had ornamental borders on all sides or a base, probably formed an altar frontal. A slab of similar design is in the Museo Nazionale Romano, Rome.

— GIOVANNA DE APPOLONIA, 2002

❧ *Crucifix*

French or German, mid-1100s
Bronze with iron pin, 35 x 19.8 cm (overall); corpus: 17.3 x 17.2 cm
Probably purchased in 1897 in Venice. Long Gallery

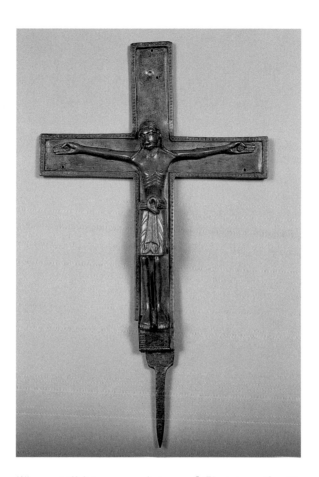

This small bronze sculpture of Christ on the Cross was made to be placed on the altar during Mass. The crucifix was originally completely gilded and would have appeared as a glimmering, if diminutive, precious object. This type of crucifix became common in the eleventh and twelfth centuries in response to changes in liturgy that encouraged the placement of crosses on altars. Religious texts of around 1100 state that a cross acts as a focus for prayer, a visual reminder of Christ's suffering, and an encouragement to the congregation.

Isabella Stewart Gardner was drawn to religious art and acquired a significant number of crosses and crucifixes. This is the first complete bronze Romanesque crucifix to enter an American museum. The body of Christ is still attached to its cross, and at the bottom is the original iron pin that allowed the cross to be inserted into a base or a slot in the altar.

— ALAN CHONG, 2002

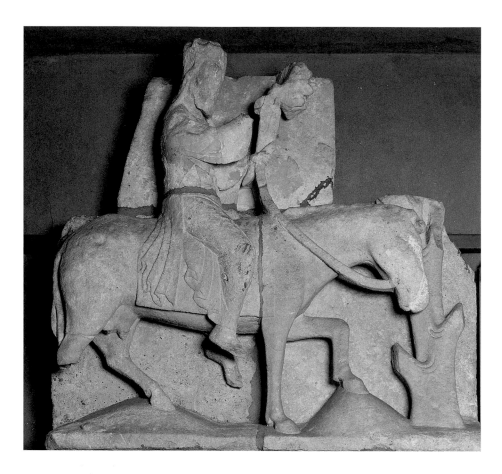

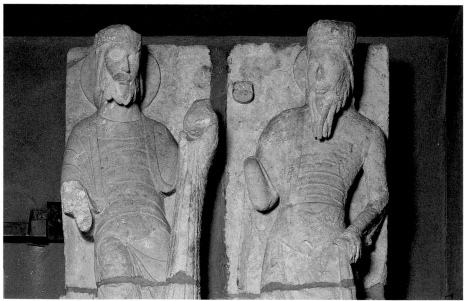

Christ Entering Jerusalem
Two Elders of the Apocalypse

French (Parthenay), mid-1100s
Limestone, 124.5 x 134.5 x 20.5 cm; and 77.4 x 99 x 25.9 cm
Purchased in 1916 from Georges Demotte, Paris, through Berenson.
Spanish Cloister

Medieval art occupied only the margins of American collecting taste at the turn of the nineteenth century. When Mrs. Gardner acquired these three sculptures in 1916, they were among the most impressive examples of monumental medieval sculpture yet seen in America. The acquisition helped establish Gardner at the forefront of medieval collecting, blazing a trail that William Randolph Hearst, Raymond Pitcairn, and John D. Rockefeller Jr. would soon follow.

Often compared to statues at Chartres, these sculptures from Parthenay (a town in Poitou) possess qualities that define twelfth-century religious art. Static yet vividly compelling, the monumental figures express the timelessness of Christian theology while evoking the realism of everyday life. Facial expressions are minimized, lending an imposing, otherworldly allure, yet the soft modeling of the lips, eyebrows, and curling locks of hair suggests real human qualities. Their stately character befits the crowned personages portrayed: Christ, on his triumphant entry into Jerusalem, and the Elders witnessing the Revelations of the Apocalypse.

Controversy, too, lent the sculptures a certain notoriety. All came from the facade of a feudal lord's courtly church, Notre-Dame-de-la-Couldre, a site long important to French patrimony. Their acquisition by no less a connoisseur than Mrs. Gardner launched a frenzy of interest in Romanesque Parthenay. Soon more sculptures flooded the market, including several removed illegally as well as some outright forgeries. Mrs. Gardner's own dealer, Georges Demotte, was pursued in the Paris courts, where eventually a sculptor in Demotte's service admitted embellishing several unspecified statues. Before the affair could be resolved, the sculptor was found dead, the victim of an apparent suicide; soon afterward, Demotte, too, was mysteriously killed in a hunting accident. These bizarre episodes caused suspicions about the Gardner sculptures to linger until the 1940s, when scientific analysis finally demonstrated that the lower halves of the Elders were forgeries, while the magnificent busts and the entire Entry into Jerusalem relief were authentic. Today there is no hesitation in counting these works among the most important Romanesque sculptures in America. They speak as much to the excellence of medieval carvers as to modern passions for the art of the Middle Ages.

— ROBERT MAXWELL, 2002

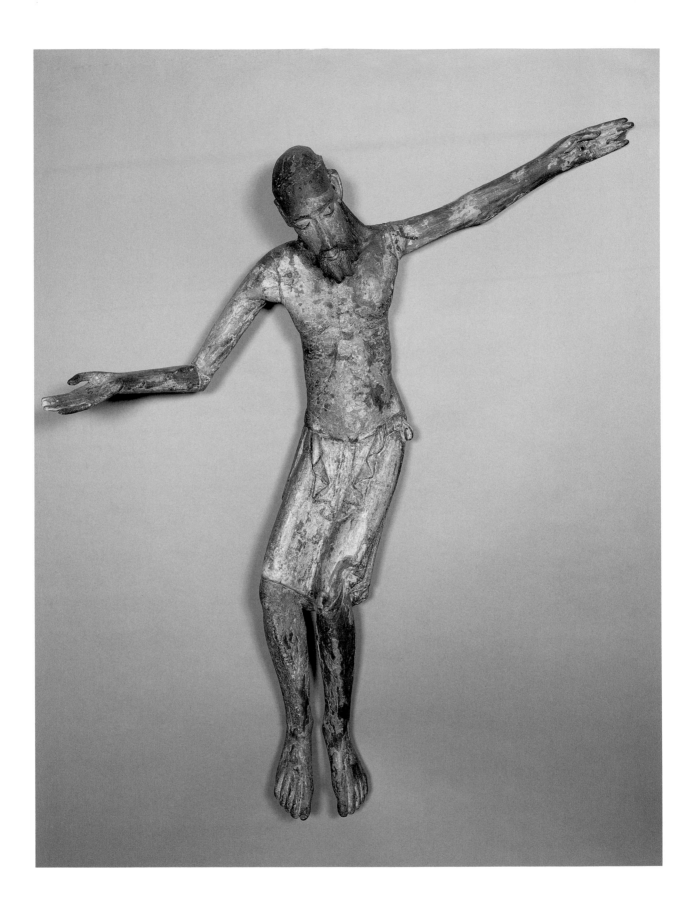

❧ *Crucified Christ*

Spanish (Catalonia), ca. 1150
Painted wood, 111 x 94 cm
Purchased in 1917 from Joseph Brummer, New York.
Third Floor Stair Hall

This immensely moving image, with remnants of original pigment visible in the beard, eyes, and loin cloth, has taken on even greater pathos through centuries of wear and damage, which echo Christ's suffering on the cross.

The sculpture was originally part of a much larger ensemble that depicted the body of the dead Christ being lowered from the cross. A large number of such sculptural groups were produced in small hill towns in Catalonia, to the north of Barcelona. It appears that the creativity of a few sculptural workshops in the region encouraged the production of these dramatic depictions.

While nothing is known of the ensemble to which this figure belonged, similar groups were made to be displayed over the high altar of local community churches. With nearly life-size, naturalistically painted figures, such depictions – almost re-enactments – of Christ's removal from the cross provided dramatic narratives for congregations.

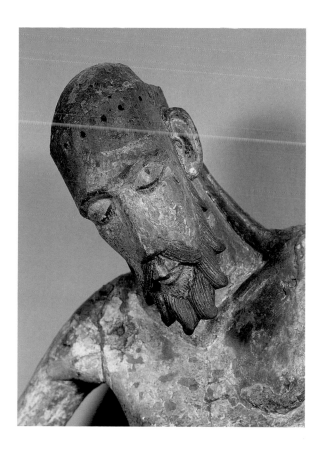

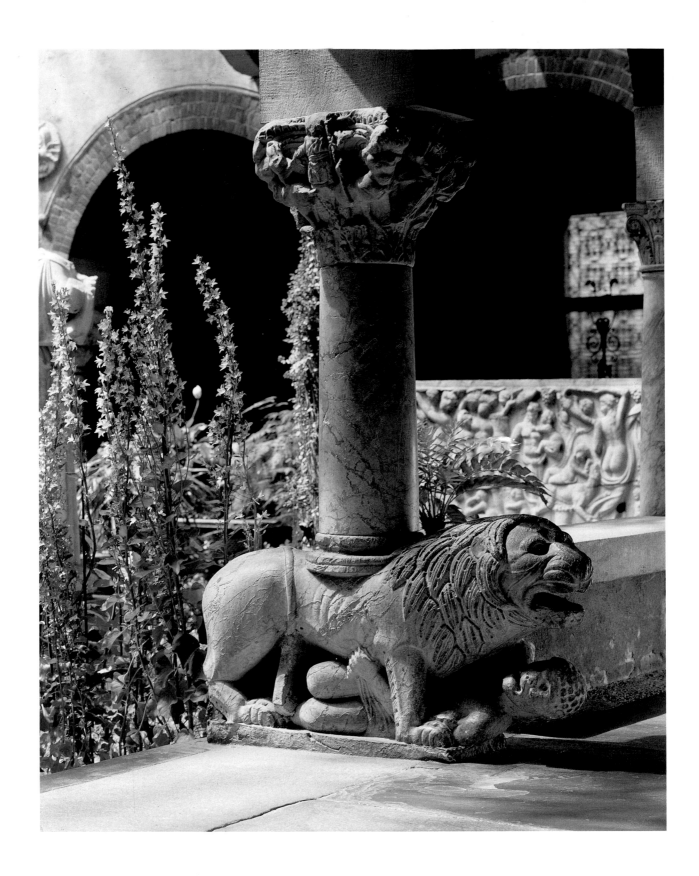

❧ *Stylobate Lion*

Italian (central or southern), ca. 1200
Marble, 63 x 119.5 x 35.5 cm
Purchased in 1897 from Stefano Bardini, Florence. Courtyard

This column with its lion base is typical of church portals throughout Italy in the late Romanesque period. However, they were rarely used elsewhere in Europe except under Italian influence. The weathering of the marble indicates that it was originally placed on an outside door. The deep drill marks on the mane and face suggest that it was made in southern or central Italy where Roman carving techniques were revived and imitated with great precision. The drill work enhances the impression of the lion's ferocity as does the agonized position of the man pinned beneath its paws. The prostrate captive in turn stabs the lion. The portal lions of San Giovanni Fuorcivatas in the town of Pistoia have a similar subject.

The symbolism of the lion in twelfth-century art varies considerably. Inscriptions suggest that the lion sometimes represented a diabolical force, but that it could also be given a positive meaning, as in Proverbs (30.30) where the lion is called "the strongest of all animals." The *Physiologus* (a Greek natural history text of ca. 150) describes the lion as sleeping with its eyes open and never relaxing its guard. In this sense it may have stood as a symbol for Christ who never relaxed his vigilance in looking after his flock.

— DEBORAH KAHN, 2002

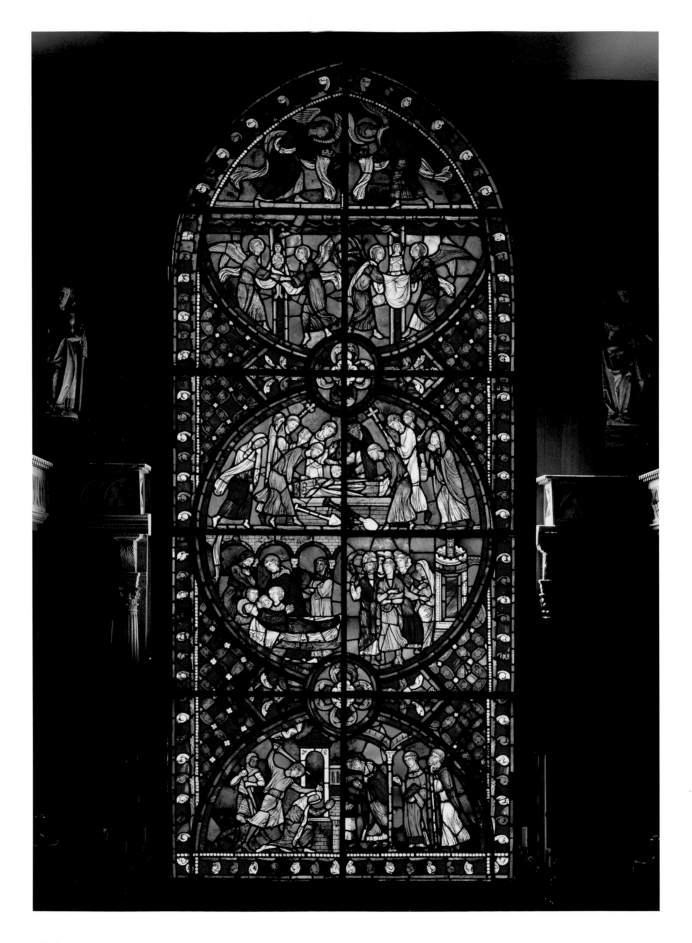

Window: Scenes from the Lives of Saint Nicasius and Saint Eutropia

French (Soissons), ca. 1205
Stained glass, 366 x 157 cm
Purchased in 1906 from F. Bacri, Paris. Long Gallery Chapel

This window is not only the finest example of early thirteenth-century French stained glass in America, it also occupies a pivotal position in the history of early Gothic painting. It was made for Soissons Cathedral, the earliest of the great High Gothic cathedrals, located some sixty miles northeast of Paris. The window at the Gardner Museum is now about forty percent of its original height; the remainder of the window was bought by the Louvre, Paris, at the same time Mrs. Gardner acquired her pieces. The upper three registers are in their original positions, while the two lower right sections come from other parts of the window. The two sections at the lower left are made up from various fragments.

The window narrates the story of Nicasius, archbishop of Reims, and his sister Eutropia, who were martyred by the Vandals in 403. The two saints had great local significance in Soissons. One of the most imposing scenes, in the center of the Gardner window, shows the entombment of Saint Nicasius (detail below), who is surrounded by mourners gracefully bending over his body. The classicizing style of the window may well have been produced under Nivelon de Chérizy, the bishop of Soissons (from 1176 to 1205), or commissioned in his memory.

The stained glass of Soissons suffered greatly over the years. In the 1800s, many of the windows were taken to Paris for restoration and were later sold to collectors.

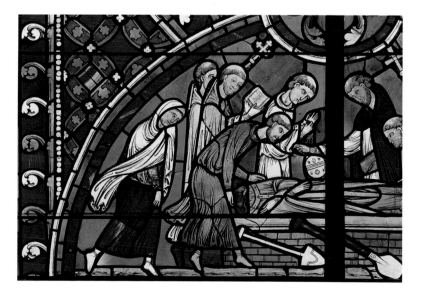

French (southern Champagne or northern Burgundy), ca. 1425
Limestone, 78.7 x 274.3 x 21.6 cm
Purchased in 1899 from the Emile Peyre collection, Paris.
North Cloister

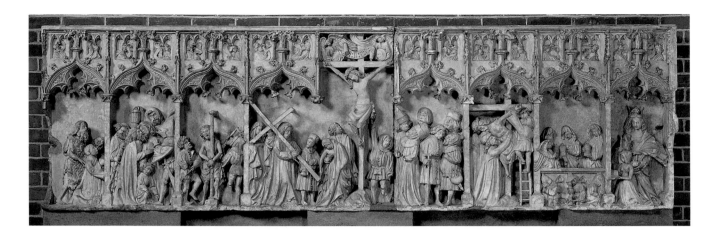

This large, finely carved relief is composed of two limestone blocks. The carving, with its hard-edged lines, elegantly detailed hair, feline eyes, and flowing drapery, is of very high quality and refinement. The Crucifixion dominates the composition; it is flanked on either side by four arches. Kneeling donors and their patron saints fill the two arches at the ends, while the intermediate arches are filled with scenes from the Passion. The scenes read from left to right: a donor with John the Baptist, the Kiss of Judas, the Flagellation, Christ Carrying the Cross, the Crucifixion, the Deposition, the Three Marys at the Tomb, a donor with Saint Catherine. Above these scenes is a row of trompe l'oeil windows with prophets holding scrolls (which may originally have had painted inscriptions) looking out.

The form of the altar is modeled on the retable at Bessey-lès-Cîteaux carved by Claus de Werve in the late fourteenth century. Its design is closer still to that in the chapel of Saint Barbara in Vignory (Haute-Marne). Even the donors – identified by their coats of arms – are the same, Guillaume de Bouvenot and his spouse Gudelette.

— DEBORAH KAHN, 2002

❧ Decorative Roundels

Italian (Venice), ca. 1200
Marble
Purchased in 1897 from Moisè dalla Torre and Dino Barozzi, Venice.
Courtyard

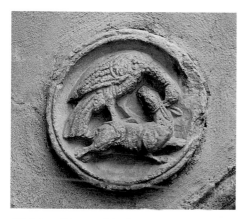

Bird Attacking a Rabbit (30.5 cm diameter)

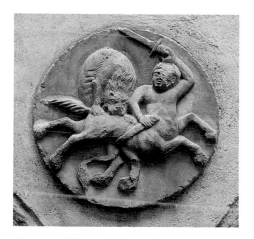

Centaur with a Raised Sword and a Lion in Combat (43.2 cm diameter)

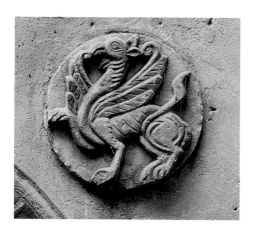

Griffin (35.5 cm diameter)

The roundels illustrated here are part of a group of twenty-eight that Isabella Stewart Gardner bought in 1897 during her search for architectural elements and decorative sculpture for her new museum. They were installed in the courtyard of Fenway Court. This is entirely appropriate to their original purpose since such roundels (called *patere* in the Venetian dialect) were most often used to decorate domestic Venetian facades. They derive from a longstanding classical tradition and from continued use in the religious buildings of Byzantium. Venice, of course, had close trade ties with Byzantium, which led to abundant artistic exchange during the Middle Ages. In the area around Venice, such roundels were first used in the facade of the great abbey church of Pomposa (ca. 1026), and then in the northern facade of San Marco (late 1000s). They subsequently appear in the Doges' Palace (1172–78), and their use continued as late as the fourteenth century.

The subjects represented on these roundels are rarely religious. Most depict animals, grotesques, or scenes of combat. The sculptures in the Gardner Museum beautifully illustrate the ability of medieval sculptors to arrange and contort their subjects so that they fit within a confined architectural frame.

— DEBORAH KAHN, 2002

The Trinity with Saint Catherine and a Bishop Saint

German (northern), ca. 1500
Wood, 152.5 x 128.5 cm (overall)
Purchased in 1897 from the dealer Hermann Einstein, Munich.
Gothic Room

This highly accomplished monumental work was carved by an unknown sculptor active in northern Germany or Denmark. A sculpture by the same artist, which displays the same voluminous but organized curls in the hair and beard, comes from Tjustrup near Copenhagen (Nationalmuseet, Copenhagen). The sculptor may have been based in Lübeck in northern Germany, which was an important artistic center at this period.

Representations of the Trinity – God the Father, Christ, and the Holy Ghost symbolized by a dove – became popular in northern Europe beginning in the twelfth century. This sculpture depicts the specific theme known as the Seat of Mercy or the Throne of Grace (in German, *Gnadenstuhl*), in which God the Father holds the body of the crucified Christ on his lap. Here, Christ opens his hand to display his wound, and gestures to his side, as the enthroned God embraces him.

On the left, Saint Catherine looks at a book and holds the spoke of a wheel, instrument of her martyrdom. At her feet is a tiny figure of Maxentius, her tormentor. On the right, a bishop saint, perhaps Nicholas, makes a sign of benediction. Although now set in a nineteenth-century frame, these figures would have formed the original center section of an altarpiece, probably accompanied by wings with smaller figures.

 – ALAN CHONG, 2002

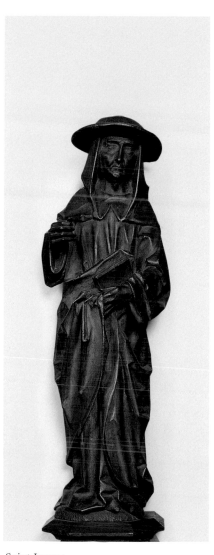

Saint Jerome
German (upper Rhine), ca. 1500
Wood, 62.2 cm high

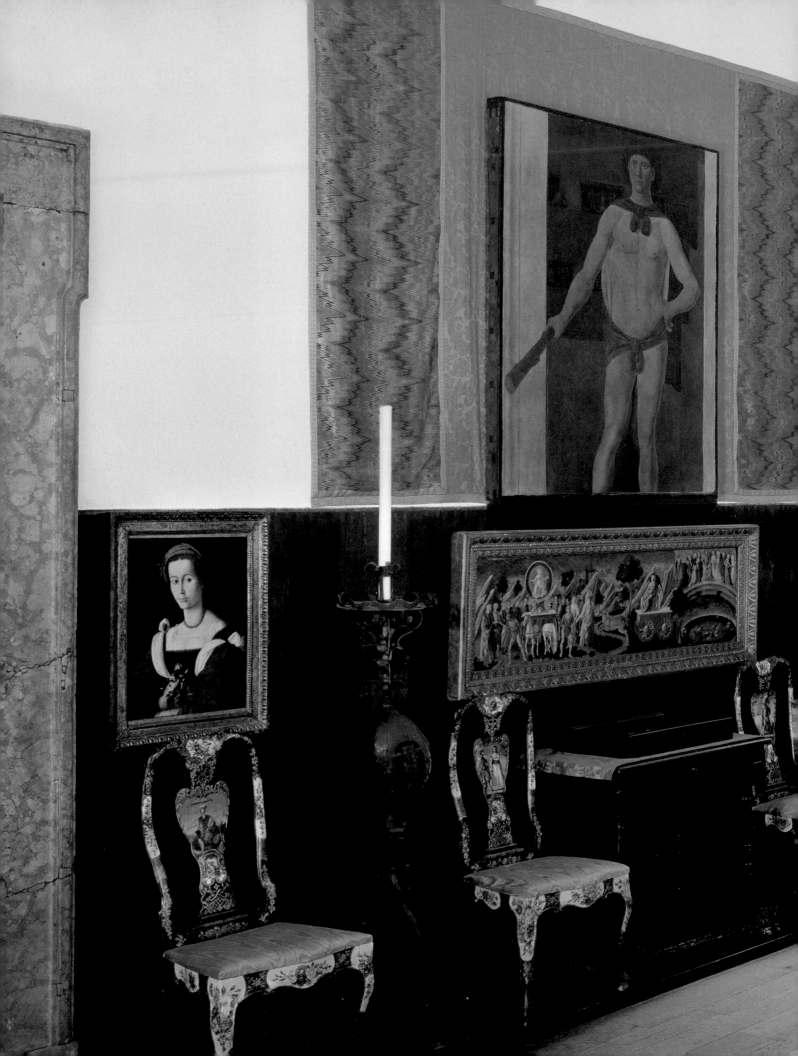

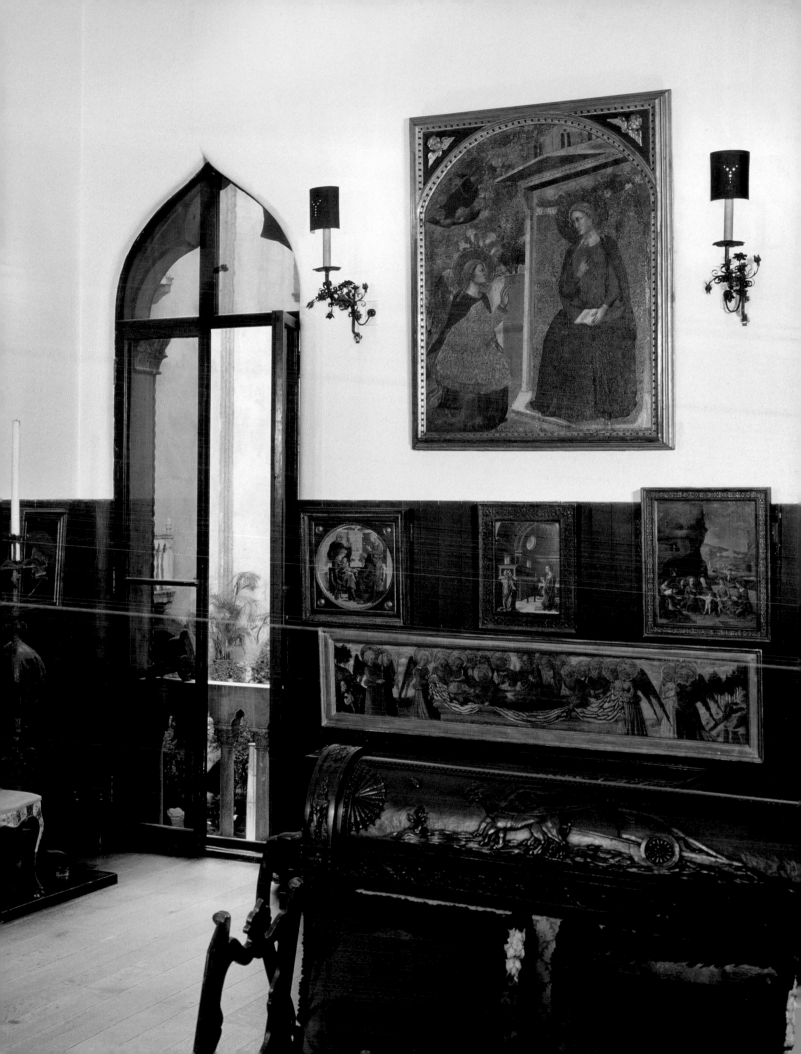

᧱ The Early Renaissance

ITALY was Isabella Stewart Gardner's true love, and the Italian Renaissance forms the core of her collection. In the 1870s she discovered the wonders of Dante through the Harvard lectures given by Charles Eliot Norton, who encouraged her to collect historic editions of Dante's works. She learned to read and speak Italian. And in the 1880s and 1890s, she spent considerable periods in Italy, mainly at the Palazzo Barbaro in Venice, where she hosted artists, writers, and connoisseurs.

In 1892, Gardner began to collect Italian paintings seriously. She had toyed with British and Dutch art, but by 1896 had decided to dedicate her full energies – and financial resources – to pursuing important Italian Renaissance pictures. In this she was guided principally by the young connoisseur Bernard Berenson, although she also accepted advice from others and always made her own decisions about what was worthy of inclusion in her collection.

When Fenway Court first opened in 1903, the Italian Renaissance pictures were scattered through several rooms, periods and cultures being intermingled in typical Victorian fashion. As the collection grew, and important paintings such as the Piero della Francesca were bought, Mrs. Gardner concentrated the Renaissance pictures and objects in a few rooms, and began to arrange them in groups. In 1915, a new gallery, called the Room of Early Italian Pictures, was created where the majority of the gold ground and quattrocento paintings were displayed. Medals by Pisanello and iron objects were also placed in the gallery. Earlier works by Giotto and Lippo Memmi were, defensibly, left in the Gothic Room. The Raphael Room contained not only works by that artist, but also numerous cassoni – pieces of wedding furniture that seem to have especially interested Gardner. Draped over these objects and pinned to the walls were Renaissance velvets and damasks, which completed the museum's presentation of the Renaissance.

Isabella Stewart Gardner's establishment of a museum containing Italian Renaissance pictures was preceded in America by two collectors, Thomas Jefferson Bryan (1803–1870) and James Jackson Jarves (1818–1888). In the 1850s and 1860s, both tried, and failed, to found public museums. Bryan collected early Italian and seventeenth-century Dutch painting (later adding some American works), and in 1852, opened Bryan's Gallery of

My foremost desire always is for a Filippino Lippi; and a Velásquez very good – and Tintoretto. Only very good need apply!

– GARDNER to BERENSON, 1895

Ever since I have been buying for you at all I have been looking out for a Fra Filippo, a Filippino, and a Fra Angelico.

– BERENSON to GARDNER, 1898

So let us aim for a Raphael Madonna [and] an A No. 1 Perugino.

– GARDNER to BERENSON, 1902

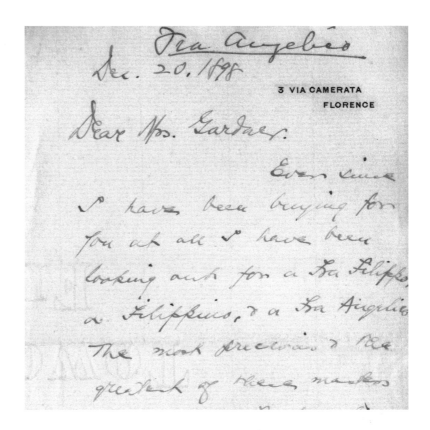

Letter from Bernard Berenson to Mrs. Gardner, 20 December 1898

Christian Art in New York. The effort quickly failed and the collection was given to the New-York Historical Society. Unfortunately nearly all of Bryan's paintings have now been sold.

Bryan's pioneering attempt was soon repeated by Jarves, who had amassed a large collection of Italian pictures, including important gold ground works, while living in Florence in the 1850s. After attempting to sell the collection to the Boston Athenaeum and various New York institutions, Jarves lent it to Yale College, which eventually bought the collection. Now at the Yale University Art Gallery, the 119 Jarves paintings are the closest American precedent to Mrs. Gardner's Italian collection. The differences however are striking: Jarves bought large numbers of pictures at extremely low prices, while Gardner carefully selected each piece and often paid record amounts. Jarves himself believed that his collection consisted of "representative" examples rather than masterpieces, but there are treasures at Yale unduplicated at Fenway Court, including thirteenth-century paintings and works by Antonio Pollaiuolo, Sassetta, and Signorelli.

Mrs. Gardner was fully aware of both her predecessors and her own position in American museum history. In 1904, after her museum had been open a year, she ventured to Yale to see the Jarves collection for herself. Her copy of the catalogue is carefully annotated with changes in attribution and stars that rate the paintings.

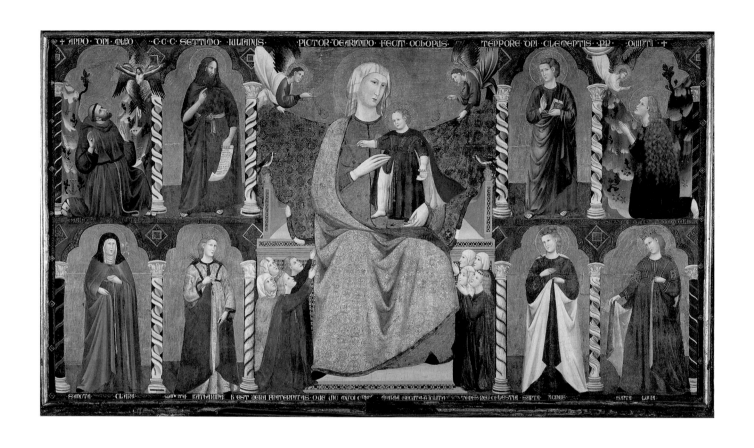

❧ *Virgin and Child Enthroned with Saints,* 1307

GIULIANO DA RIMINI, Italian, active 1307, d. before 1346
Tempera and gold on wood, 179 x 320 cm
Purchased in 1903 in London through Joseph Lindon Smith.
Long Gallery

[I have found] a fine large "primitive" Italian picture, which I have just bought for you here in London…. I happened along and snapped it up. It is as large as a grand piano – splendid in color – Madonna and child with saints around her, full of strong individual character…. You will be delighted with it I am sure. It is signed Justvannio da Rimini, an unknown man to me. I bought it simply on the strength of its powerful character, and dignity – feeling – and great beauty of color.

— JOSEPH LINDON SMITH, 1903

The large panel by Giuliano da Rimini exemplifies the horizontal dossals that were common during Giotto's youth. At the top an inscription with the artist's name and the date '1307' establish the dossal as the earliest signed work by a Riminese artist. During the first half of the fourteenth century, Rimini was the center of a prolific school of painters who drew their inspiration from the Byzantine tradition and the innovations of Giotto. The Gardner dossal is an unusually well-preserved and decorative specimen of this provincial school.

— EVERETT FAHY, 1978

A.D. 1307, Giuliano, painter from Rimini, made this work during the time of the Pope Clement V. This is a true fraternity that conquers the world's sins. Following the glorious Mary, you will obtain the kingdom of heaven.
– inscription on the painting

This altarpiece was made for a religious order of nuns, and the painter specifically tailored its imagery to devout women. It was commissioned by the Order of Clares for the church of S. Giovanni Decollato in Urbania, a small town near Urbino. The order had been co-founded by Saint Clare (1194–1263), who is depicted at the lower left. She was a close follower of Saint Francis, who is shown above her. Three other female saints – Catherine, Agnes, and Lucy – are seen on the lower arcade, while Mary Magdalene (detail) is depicted opposite Saint Francis. Clustered around the Virgin's throne are devout women: some wear habits, one wears a crown. These supplicants represent the order that commissioned the painting, and some of them may be portraits of the wealthy donors. The inscription directly describes the "true" confraternity and the intercessory power of the Virgin.

— ALAN CHONG 2002

ᔓ *The Presentation of the Christ Child in the Temple,* ca. 1320

GIOTTO, Italian, 1267–1337

Tempera and gold on wood, 45.2 x 43.6 cm
Purchased in 1900 from J. P. Richter, through Berenson.
Gothic Room

At first glance the small painting of *The Presentation of the Christ Child in the Temple* looks like a self-contained object. It has a balanced composition: two pairs of standing figures flank a dainty ciborium that symbolizes the Temple of Jerusalem. Following the gospel of Luke, the artist has illustrated the dramatic moment when Simeon and the prophetess Anna recognize the Christ Child as the savior.

Ever since the early nineteenth century, the *Presentation* has been known to be one of a series of seven paintings of the life of Christ (the others are in Munich, London, and New York). Although some scholars have questioned the traditional attribution of the series to Giotto, all the scenes are devised with such imagination and executed with such depth of feeling that only he could have painted them. There is nothing stereotyped about the compositions: each action is expressive, each face is individual. Thus, in the *Presentation*, the child struggles to get back in his mother's arms. None of Giotto's followers made such telling observations of human behavior.

> — EVERETT FAHY, 1978

The Gothic Room is dominated by John Singer Sargent's portrait of our hostess, Isabella Stewart Gardner. She is a queenly presence, standing high and splendid among her saints and madonnas and tapestries, her lips parted as if to say something clever. Pearls and rubies adorn her black gown, but there is a brighter jewel in this charming assemblage of precious things, one that outshines them all, Giotto's panel painting, *The Presentation of the Christ Child in the Temple*. The majesty of this small rectangle with its blank gold background and childlike perspective is charged with powerful human feeling: Anna lifts an awestruck hand, the priest Simeon gazes at Mary with intensity, mother and child reach for each other with ardor.

Giotto was inspired by something we don't have anymore, faith unshadowed by doubt. I love our doubt and can't imagine doing without it, but it will never produce works of art like these.

> — JANE LANGTON, 2002

Virgin and Child with Saints, ca. 1320

SIMONE MARTINI, Italian (Siena), ca. 1284–1344

Tempera and gold on wood (5 components), center: 99 x 60.7 cm,
side panels each: ca. 86.3 x 42.5 cm
Purchased in 1899 from the Mazzocchi family, Orvieto.
Early Italian Room

This altarpiece was originally in the Chiesa dei Servi di Maria in
Orvieto, and is the artist's only known commission from the
Order of the Servites of Mary. Surrounding the center image are
the saints (from left) Paul, Lucy, Catherine, and John the Baptist.
Each saint is surmounted by an angel, while above the center
panel Christ displays his wounds.

In 1899, Mrs. Gardner paid a mere £500 for the altarpiece, in
an arrangement brokered by Bernard Berenson.

*The Isabella Stewart Gardner Museum's polyptych… has been rel-
atively underestimated, perhaps for psychological rather than sub-
stantive reasons. The panel was evidently still in Italy not so long
ago… Perhaps this has prompted a certain tendency to accentuate
its poor condition rather than the high quality of the altarpiece.
When I first saw the painting twenty years ago, unaware of any
question of provenance, I was greatly impressed; I was convinced
that it was a splendid work by Simone himself, as I believe every-
one now agrees that the painting has been cleaned.*

 — GIOVANNI PREVITALI, 1988

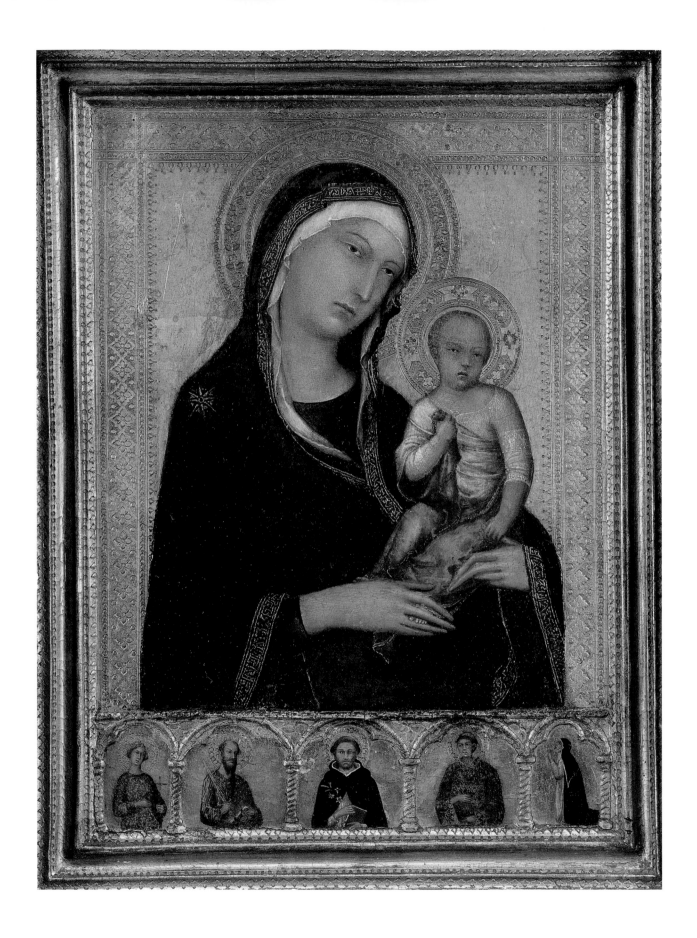

∽ *Virgin and Child,* ca. 1325

SIMONE MARTINI, Italian (Siena), ca. 1284–1344
Tempera and gold on wood, 28.4 x 20.1 cm
Purchased (as Lippo Memmi) in 1897 from the dealer Stefano
Bardini, Florence. Gothic Room

Under the Virgin and Child are five small arches with figures.
These are, from the left, a crowned female saint holding a cross,
Saint Paul, Saint Dominic, a male saint, and a kneeling nun. This
last figure, presented in a different scale, is the donor of the paint-
ing. This is one of the earliest surviving examples of a small, inde-
pendent panel containing a predella. The original engaged frame
shows that the painting is a complete devotional image, not part
of a larger ensemble.

*For nearly its entire known history, this unusually refined panel
has been considered a typical work of Simone Martini's brother-in-
law and sometime collaborator, Lippo Memmi (act. 1317–1357).
Distinguishing between the hands of Simone Martini and Lippo
Memmi in their collaborative and imitative efforts has long been
and remains one of the most contentious topics in the study of
early Italian paintings. Miklós Boskovits has suggested that two
paintings universally attributed to Lippo Memmi (this panel and a
related image in Kansas City) actually share all the features of con-
ception and handling that he individuated in the personality of
Simone Martini. Not only do these two panels share the refinement
of execution typical of Simone Martini's best work, but also their
figure types are directly related to those in Simone's mature altar-
pieces and not to any of Lippo Memmi's more solid, carefully
drawn examples.*
　　－ LAURENCE KANTER, 1998

The Death and Assumption of the Virgin, ca. 1432

FRA ANGELICO, Italian (Florence), 1390/95–1455

Tempera and gold on wood, 61.8 x 38.5 cm
Purchased in 1899 from Colnaghi, London, through Berenson.
Early Italian Room

Wherever one may have seen a painting by the blessed Fra Angelico in a museum, the first sensation is that of the unfitness of the place. Here the "Dormition and Assumption of the Virgin" by Fra Angelico, placed alone in the recess of a window, keeps its look of being a manner of reliquary.

 – JOHN LA FARGE, 1907

Possessed of great delicacy, this little painting also compels attention through its complexity. In the lower scene, enclosed by a wall, the body of the Virgin lies on a bier draped with sumptuous gold textiles. She is surrounded by Christ's disciples, who miraculously appeared as she lay dying. Four of them prepare to lift the body and carry it to the tomb. In the center of the composition, Christ too has appeared to accept the Virgin's soul, represented by the infant he holds in his arms.

The Assumption of the Virgin is seen above. Three days after her burial, she ascended into heaven. Fra Angelico depicts the Virgin rising upwards, surrounded by a chorus of musical angels. At the top, Christ, garbed in intense blue robes, opens his arms to embrace his mother.

Fra Angelico was highly prized in the nineteenth century for his blues, which here range from delicate pale tints to saturated ultramarine. Equally remarkable is the handling of the gold surface, which has been punched, decorated, and in some areas coated with glaze. The idealized mysticism of the painting is balanced by naturalistic, observed details such as the faces and poses of the disciples.

This small image was probably originally surrounded by an ornate carved frame embedded with star-shaped chambers holding relics. It was one of four reliquary paintings devoted to the Virgin that were placed on the high altar of the church of Santa Maria Novella in Florence on special celebrations. They were commissioned by the church's sacristan, Giovanni Masi. The other three painted reliquaries (which preserve parts of their original frames) are in the Museo di San Marco, Florence.

 – ALAN CHONG, 2002

❧ *Christ Disputing in the Temple,* late 1450s

GIOVANNI DI PAOLO, Italian (Siena), active 1417, d. 1482

Tempera on wood, 26.7 x 23.6 cm
Purchased in 1908 from Agnew's, London. Early Italian Room

The painting depicts a passage from Luke in which Mary and Joseph, having journeyed to Jerusalem for Passover, realize that the young Jesus is not with them: "After three days they found him in the temple, sitting with the teachers, listening to them, and asking them questions; and all who heard him were amazed at his understanding and his answers." Giovanni di Paolo gives his narrative scenes imaginative variation and rich detail. He shows the young Christ grandly enthroned, holding a scroll, and raising a hand in rhetorical argument. The four learned theologians seated below him are each given individual gestures and characterizations. At the left, another elder shows Joseph in as the Virgin Mary hurries up the steps to her son, seeming to interrupt the proceedings.

Together with works now in the Fogg Art Museum, Cambridge, and the Metropolitan Museum of Art, New York, this painting originally formed part of the predella of an altarpiece. The main panel of the altarpiece was probably the *Presentation of the Christ Child in the Temple* (Pinacoteca Nazionale, Siena), which presents a more elaborate version of the architecture seen here.

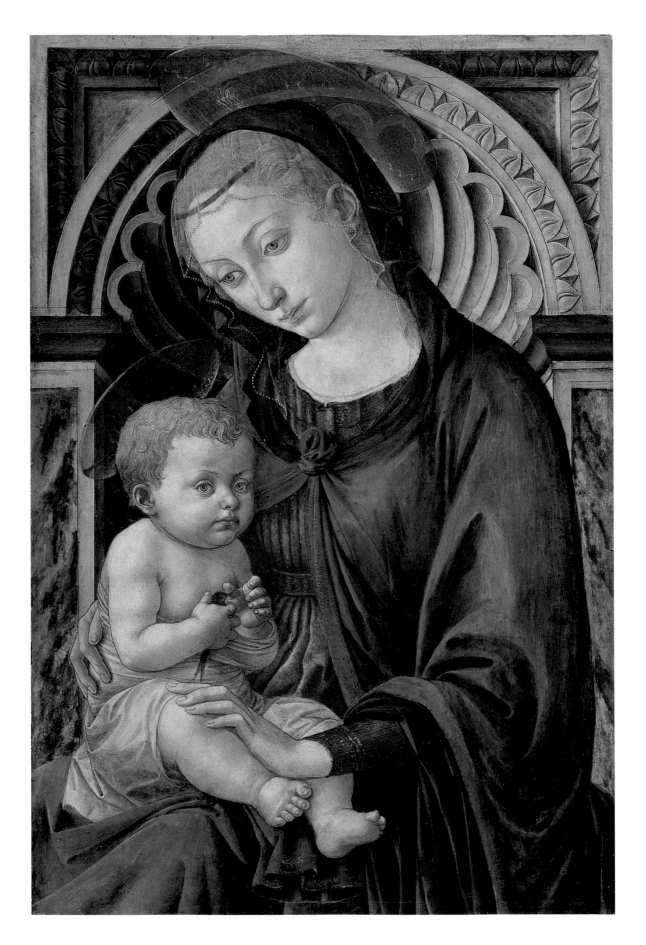

❧ *Virgin and Child with a Swallow,* mid-1450s

FRANCESCO PESELLINO, Italian (Florence), 1422–1457
Tempera on wood, 59.7 x 39.5 cm
Purchased (as Filippo Lippi) in 1892 at the auction of Frederick
Leyland, London. Raphael Room

This accomplished *Virgin and Child* by Francesco Pesellino, dating from the mid-1450s, was one of the most reproduced paintings in fifteenth-century Florence. It was a pivotal work in an unusual and prolific copying enterprise. From the 1450s to the mid-1490s, the composition appeared in thirty-eight panel paintings executed by a workshop close to Pesellino and Filippo Lippi. These copies and variants were produced using a mechanical transfer method – stencil-like pounced cartoons, possibly generated from a tracing taken from the Gardner panel, rubbed over with charcoal dust. A very similar painting in Esztergom, Hungary, is probably also an autograph work by Pesellino. The Gardner panel, however, is clearly the prototype and a more accomplished work. The modeling is very delicate and the brushwork fluid. Underdrawing is visible through the transparent paint film and shows that changes were made in the drapery and body contours of both the Virgin and the Christ Child.

The Gardner Museum's *Virgin and Child* is an important work within the small body of paintings attributed to Pesellino, a celebrated, but little-studied fifteenth-century Florentine master whose paintings were collected by the Medici family. Made at a time when painted and sculpted half-length Virgin and Child images were becoming standard features in middle- and upper-class Florentine homes, Pesellino's painting has much in common with the work of the most successful Madonna manufacturers of the day – Filippo Lippi, Donatello, and Luca della Robbia. There is tension between the sacred and the profane within the picture. The holy protagonists are positioned close to the picture plane, creating a sense of intimacy and accessibility. The Christ Child – appealingly childlike – meets the eye of the beholder. In contrast, the Virgin refuses visual engagement: she asserts decorum and distance; her physical grace and beauty are designated sacred, not of this world.

— MEGAN HOLMES, 2002

❧ *A Young Lady of Fashion,* early 1460s

Attributed to Paolo Uccello, Italian (Florence), 1397–1475
Oil on wood, 44.1 x 31.8 cm
Purchased (as Domenico Veneziano) in 1914 from Böhler and
Steinmeyer, New York. Long Gallery

The portrait has a highly decorative quality in which costume and ornament play a major role. The rather flatly modeled face is placed on an insubstantial bust set against a uniform blue background. The woman is portrayed both according to literary notions of female pulchritude, which called for fair skin and blonde hair, and the dictates of contemporary fashion. Costly brocaded fabrics, pearls, and precious stones serve not only to display the sitter's familial wealth and status but also to enhance her physical appearance – in art, as in life. In addition to a red and gold brocade sleeve and a sleeveless overdress, the woman wears a head brooch, a pearl choker with jeweled pendant, and a white cap ornamented with pearls.

This fashionable beauty looks impassive, immobile, and immutable, as if she were outside space and time. Her portrait image has a static, stereotyped character, in which the sitter's individuality is almost entirely suppressed in favor of the social ideals for which she stands.

Bought as a work by Domenico Veneziano, the portrait has also been attributed to Paolo Uccello and the so-called Master of the Castello Nativity.

— DAVID ALAN BROWN, 2002

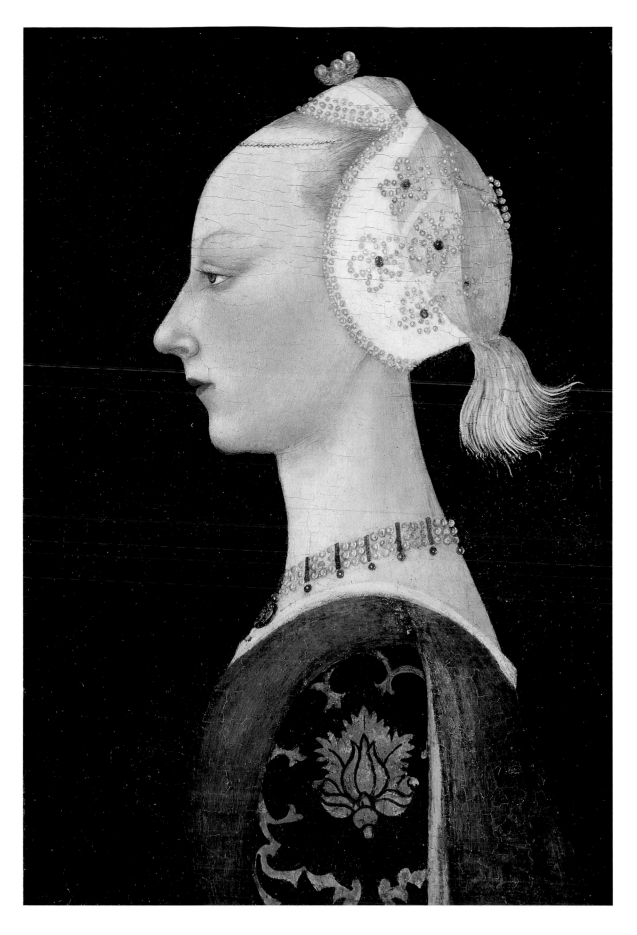

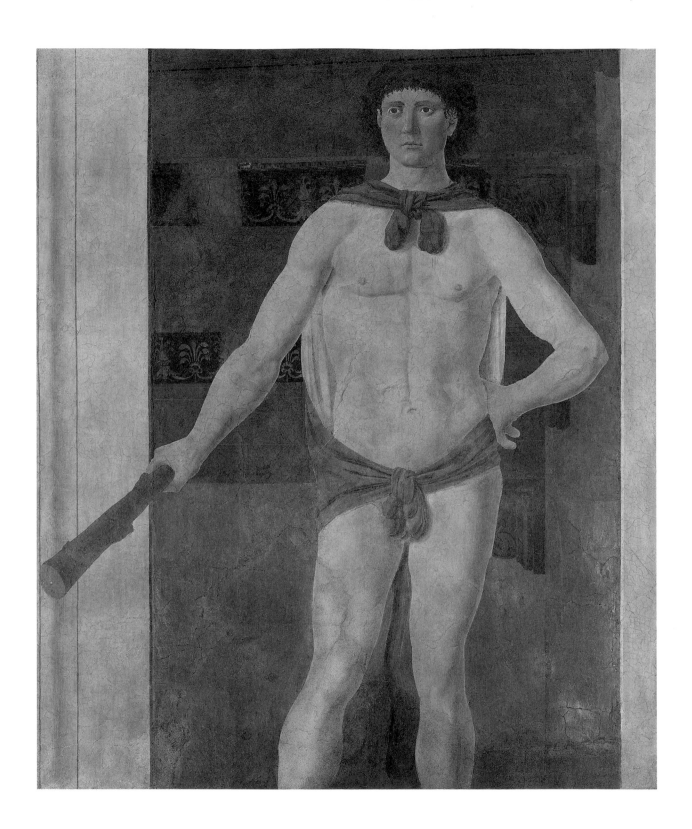

PIERO DELLA FRANCESCA, Italian, 1416–1492

Fresco, 151 x 126 cm
Purchased in 1903 from the Florentine dealer Elia Volpi, through
Joseph Lindon Smith. Early Italian Room

Piero della Francesca was an artist who, when I was young nearly sixty years ago, was not even mentioned. He had fallen through the cracks; paradoxically, our noisy and agitated century has discovered a wonderful artist whose message is silence and stillness. This is a very great painting by Piero, especially since he did not paint many mythological figures. Many artists who have painted Hercules have painted him acting vigorously, bashing about with his cudgel, killing lions, and pursuing people. Not Piero. His Hercules is a young man with a grave face. He holds his club almost like a judge's wand; you only know he is Hercules because of the lion's skin around his waist. It is the face of a young, wise judge – all that potential violence directed towards good. Then of course there is the poignant fact that after 500 years, some wretched owner decided he wanted a door in a wall, so Hercules was cut from the shins down. I can never see this without a pang of distress. Somehow it makes the painting even more moving, that he's not allowed now to stand on his own two feet.

— SISTER WENDY BECKETT, 1998

This fresco once adorned Piero della Francesca's house in Borgo Sansepolcro. The painting was originally positioned in the upper corner of a room, with its right edge bordering a wall, which helps explain the steep perspective of the image. Hercules stands at a threshold. Beyond, we can see a ceiling with wooden beams decorated with foliage. There is no evidence that the room was decorated with other gods or heroes, as might be expected. Further, Piero della Francesca chose to portray Hercules as a youth, rather than as the bearded, muscle-bound figure familiar in ancient sculpture. Certainly the ideal nude was a central theme of the Italian Renaissance. However, it remains a mystery what this image of the young Hercules might signify in the painter's private dwelling, although the hero was commonly associated with civic virtue and goodness. Perhaps the painting of a classical nude in unusually steep perspective was a compelling artistic challenge for Piero.

Mrs. Gardner's effort to acquire the fresco was also Herculean. The fresco had been detached from the wall in the 1860s and in 1903 it was sold to Gardner by the Florentine dealer Elia Volpi, with the assistance of Joseph Lindon Smith. However, the Italian government delayed the work's export until 1908, and when it arrived in America, it was seized by customs officials for payment of duty and fines. At Fenway Court, it became the centerpiece of a new gallery of early Italian pictures where it was displayed in front of a flame-stitched embroidery.

— ALAN CHONG, 2002

The Circumcision, 1470s

Cosmè Tura, Italian (Ferrara), 1451–1495
Oil on wood, 38.6 cm diameter
Purchased in 1901 from Contessa Passeri, Rome, through Richard
Norton. Early Italian Room

Tura was the great painter of fifteenth-century Ferrara; in his life-
time, his stature was equal to that of Mantegna in Mantua and
Botticelli in Florence. His reputation has suffered considerably
because almost all of his significant works were damaged or
destroyed after his death in 1495. Much of what survives is frag-
mentary, such as this tondo that Gardner acquired in 1901. The
work exhibits Tura's wiry outlines and hard, metallic drapery.

The Gardner Museum's panel is generally thought to have
come from a large polyptych commissioned by the Roverella fam-
ily, made in the 1470s for the church of San Giorgio in Ferrara,
and dismembered following the bombardment of the church in
1709. Other surviving portions include two round panels of sim-
ilar format in the Fogg Art Museum and the Metropolitan
Museum of Art, along with a fragment showing the head of Saint
George (Museum of Fine Arts, San Diego). The largest portions
include the central panel showing the Virgin and Child enthroned
with angels (National Gallery, London), a side panel with
Cardinal Bartolomeo Roverella being presented by his patron
saints (Colonna Collection, Rome), and a crowning lunette
depicting the lamentation over the dead Christ (Louvre, Paris).

This reconstruction can be supported not only from the fact
that the three tondi are of the correct dimensions to serve as the
central parts of a predella for the altarpiece, but also because of
thematic and iconographic links with the panels known to have
come from the altarpiece. The Circumcision was normally inter-
preted (especially by the preachers of the Papal Curia, to which
the Roverella were strongly attached) as a termination and fulfill-
ment of the Law of Moses. Like the sleep of Christ that is depict-
ed in the London panel, the Circumcision was also regarded as a
prefiguration of the Passion; the analogy is made explicit in the
altarpiece in the harrowing depiction of the dead Christ in the
lunette that crowned the altarpiece. We can envision that on a
central axis in the altarpiece were aligned the dead Christ of the
Pietà, the sleeping Christ in the lap of the Virgin, and Christ's first
shedding of blood.

In the Gardner tondo, Christ does not willingly submit to
circumcision but recoils from it, turning away also from the
image of Moses. So too in the London panel, the face of the sleep-
ing child covers up and renders illegible the Second Command-
ment of Moses, which in its Hebrew form makes an explicit

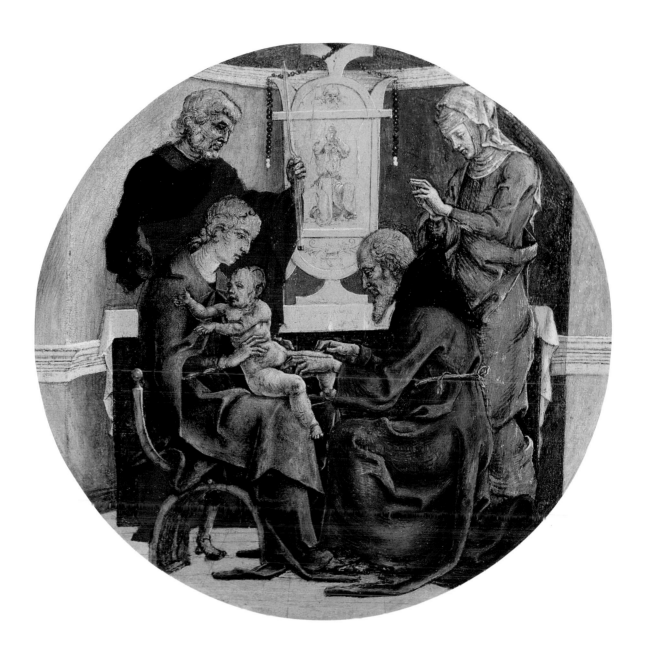

prohibition against the worshiping of God through images. The 1470s, when the altarpiece was created, was a time of considerable strife between Jewish and Christian communities across Northern Italy, including Ferrara, culminating in the notorious blood-libel of Trent in 1475 when Jews were massacred following the alleged ritual murder of a Christian child. Any suggestion of Christian triumph over Judaism in these years would have fanned the flames of a cultural tension, not only between Jews and Christians in general but between Italian princes and their Christian subjects who were encouraged by mendicant preaching to resent the protection of the Jews.

— STEPHEN J. CAMPBELL, 2002

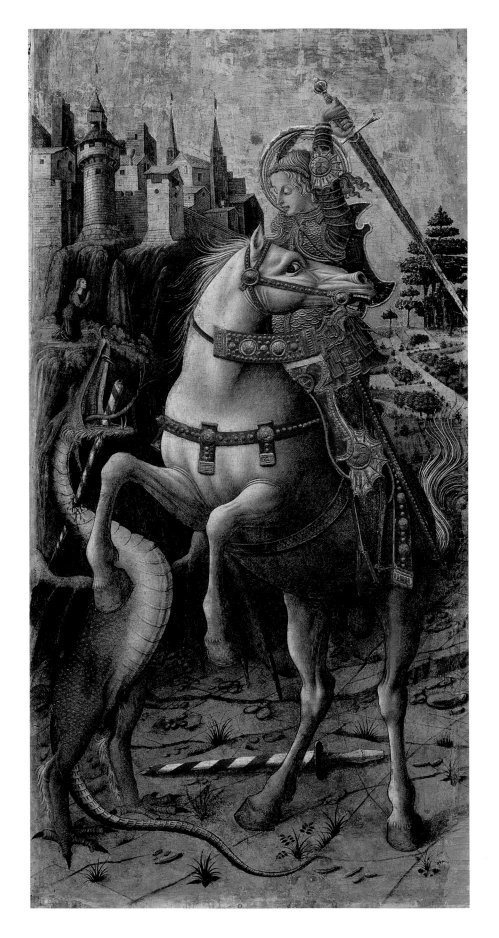

❧ *Saint George Slaying the Dragon,* 1470

CARLO CRIVELLI, Italian (Venice), 1430–1495
Gold and tempera on wood, 94 x 47.8 cm
Purchased in 1897 from Colnaghi, London, through Berenson.
Raphael Room

*Few even among Crivelli's adorable works
have so piquant a charm or display so
fairy-like a fantasy as this. There are other
pictures of his early years which show
intense feeling, but no other exists in
which the purity, the unfettered gaiety
and freakishness of his fancy is more
apparent.*

‒ ROGER FRY, 1907

*"St. George," the marvellous fairy-tale in
gold and lacquer and flaming line, [holds]
a place of honor among Mrs. J. L.
Gardner's masterpieces. Here is not an
attitudinizing page-boy, but the ever
youthful defender of eternal right against
regardless might. His face of beauty and
passion and his slim body are outlined
against the golden sky, while he bestrides a
gorgeously caparisoned steed, himself in
shining armor that can never lose the
purity of its luster. He is now hacking
away at the Dragon, already transfixed by
his lance. The young knight, too, is nearly
spent, but his victory is sure. Under the
bastion towers of the undevastated city
kneels in prayer the Princess for whom he
is fighting. Stately trees stand dark against
the sky. What a pattern ‒ and what an
allegory!*

‒ BERENSON, 1916

Charged with excitement and bristling with spiky forms, *Saint George Slaying the Dragon* is one of Carlo Crivelli's masterpieces. Although the artist worked for more than thirty years after painting it, he never produced anything quite so full of vigor and imagination. What could be more dramatic than the contrast between the rearing horse, its head distorted with fear, and the tender saint, his eyes fixed on the dragon he is about to slaughter? Crivelli's saint is no robust hero, but a slim boy who must use all his might to wield his heavy sword. The jutting shapes of his armor are echoed in the towers of the hill town in the background. On a cliff just below it, kneels the tiny figure of the princess who was to be the dragon's next victim.

Few paintings in the Gardner Museum are more self-sufficient. Yet Crivelli's *Saint George* originated as part of a large altarpiece. Crivelli made the altarpiece for the parish church of Porto San Giorgio, a village near Fermo on the Adriatic coast. It was commissioned by an Albanian immigrant, Giorgio Salvadori.

‒ EVERETT FAHY, 1978

Virgin and Child with an Angel, early 1470s

Sandro Botticelli, Italian (Florence), 1444/45–1510

Tempera and oil on wood, 85.2 x 65 cm
Purchased in 1899 from Prince Chigi, through Colnaghi, London,
and Berenson. Long Gallery

A vast number of paintings of the Virgin and Child were produced in Florence in the late 1400s to meet a new demand for devotional images on a domestic scale. Early in his career, Botticelli specialized in such works. While this painting possesses much of the calm prettiness expected from these Madonnas, it also contains unexpected elements of allegory. The angel, Virgin, and Christ Child all look down at a bowl of grapes studded with ears of grain. Grapes and wheat produce the wine and bread of the Eucharist, and allude to the blood and body of Christ's sacrifice. The Virgin carefully selects some of the wheat, to signify that she accepts her child's fate. The angled arcade adds further mystery: like a set of isolated doorways, the structure encloses the figures while it simultaneously frames the landscape beyond.

In 1899, Isabella Stewart Gardner discovered that Prince Chigi in Rome was willing to sell his painting by Botticelli, so she cabled Bernard Berenson to ask if it was worth $30,000. He replied emphatically that it was not, but she was not discouraged. A few months later, the price had risen to $70,000 and Berenson was recommending its purchase! The acquisition stirred great controversy because the press believed that the painting had been illegally exported from Italy; Prince Chigi was fined, but later cleared of impropriety. Popular interest on both sides of the Atlantic became so great that it was decided to exhibit the painting in London at Colnaghi before it was shipped to Boston.

— ALAN CHONG, 2002

People simply are losing their heads over Italian pictures…. Genuine Italian pictures are getting so despairingly rare that those who want them will now pay anything for them.

— BERENSON to GARDNER, 1899

It can claim the glory of having been smuggled out of Italy; and feats of smuggling always do appeal to the public. The picture belonged to Prince Chigi, but was so little appreciated that it remained hidden away in one of the lower halls of his Roman palace for years before it was discovered by Morelli and declared by him to be, except for the frescoes in the Sistine Chapel, the only authentic Botticelli in Rome.

– The Nation, 1901

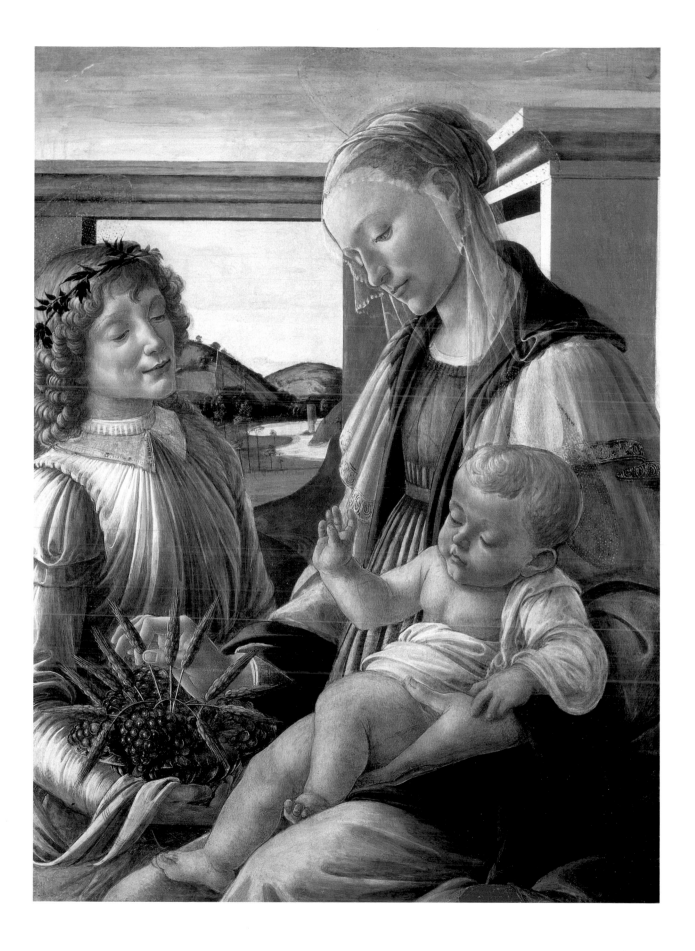

Woman in Profile, ca. 1475

MINO DA FIESOLE, Italian (Florence), 1429–1484
Marble, 33.7 x 27.9 cm
Purchased in 1899 from the Florentine dealer Elia Volpi, through
Berenson. Long Gallery

Mino da Fiesole was a brilliant marble carver, creating tombs and portraits for leading citizens of Florence and Rome. His portrait bust of Piero de' Medici of 1453–54 initiated the revival of an ancient Roman type of portraiture, the marble bust. He also carved marble portrait reliefs and reliefs representing Roman emperors. The sculpture in the Gardner Museum displays aspects of both forms – the sharp profile combined with the strongly projecting left shoulder, which breaks the boundary of the relief plane and evokes a three-dimensional bust. The relief presents a woman dressed in a simple robe that is tied in the front and back into bows. Her hair is tightly braided at the back, but loose, unruly curls fall from a knot at the top of her head. The profile is sharply undercut and traces the slight curve of her nose, her soft double-chin, and her long, columnar neck. She is splendid (as Berenson says) and powerful, her chin slightly raised and her gaze direct and steady. Yet these very qualities – her power and splendor – argue against this being a portrait of a particular Florentine woman. She wears no jewels and her dress is not rich brocade, but simple and plain. She has more in common with Mino da Fiesole's reliefs of Roman emperors than with the elegantly bedecked and bejeweled female sitters typical of Florentine portraits of the fifteenth century. She may instead represent an ancient Roman heroine or empress, a model of virtue for the contemporary Florentine woman rather than a portrait of an individual.

When Bernard Berenson wrote to Isabella Stewart Gardner to recommend this relief, he believed it represented a member of the Antinori family, since the relief came from the Palazzo Antinori-Aldobrandini in Florence.

— MARIETTA CAMBARERI, 2002

I am all aflame with the eagerness to have you buy yet another masterpiece. Seldom has anything taken such complete possession of my fancy, and few things have my more reasoned approval. This time it is a bas-relief in marble by Mino da Fiesole – not a relatively common-place Madonna, *but that singular rarity in Florentine sculpture, a portrait in relief. The photograph I enclose will give you some idea of the style, the splendour, the superb character of the lady represented. As workmanship, Mino here quite surpasses himself. You have the strength of bronze and the delicacy of ivory combined. In a word I have never seen the Renaissance marble which I rather would own.*

— BERENSON to GARDNER, 1899

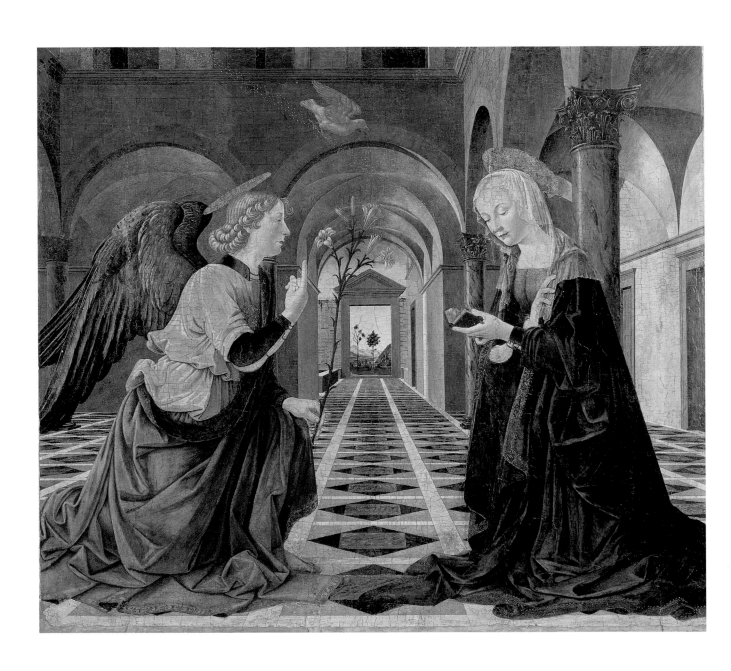

❧ *The Annunciation,* ca. 1475

PIERMATTEO D'AMELIA, Italian (Umbria), ca. 1450–1503/1508
Tempera on wood, 102.4 x 114.8 cm
Purchased (as Fiorenza di Lorenzo) in 1900 from Colnaghi,
London, through Berenson. Raphael Room

It is of a purity of quattrocentisteria simply unsurpassable. If I know you, it will simply enchant you. So be prepared with a pure heart and – a full purse.

— BERENSON to GARDNER, 1900

The subject of the Archangel Gabriel appearing to the Virgin Mary to say she will bear the son of God was often depicted in dramatic and innovative architectural settings, both in Italy and in the Netherlands during the Renaissance. Here, the sweeping recession to the central doorway is the unifying element of the composition. The perspective lines on the floor divide the figures and focus attention on the hilly landscape beyond.

Like many Italian Renaissance painters, Piermatteo d'Amelia was concerned with the principles of optical perspective. However, the painting is neither formulaic nor rigidly symmetrical. The architecture varies significantly from left to right, the open courtyard giving way to an arcade, as if to embody the Virgin's motherly embrace. In the center, a spray of lilies and the dove connect the archangel with the Virgin.

The painting was made for the main altar of the Franciscan church in Amelia, a small town in Umbria near Spoleto. Since 1900, the painting has borne many different attributions, and was long known simply as the work of the Master of the Gardner Annunciation, but documents now indicate that the artist is Piermatteo d'Amelia, a pupil and assistant of Filippo Lippi.

— ALAN CHONG, 2002

"Rare and Wonderful" Marriage Pictures

ISABELLA STEWART GARDNER did not just collect Renaissance art, but created a theater of the imagination. She identified closely with Renaissance women, especially with those alter-egos named Isabella or Elizabeth. And in her own sumptuous palazzo, she recreated the luxurious display, witty conversation, and chivalric flirtation associated with medieval and Renaissance courts of love. Fifteenth-century Tuscan cassoni, or wedding chests, were essential furnishings since they had originally been made for brides to store and transport their trousseaux. While wealthy Renaissance brides could publicly show off their richly decorated cassoni only on the day they moved into their husbands' homes, Gardner put several examples of wedding furniture on permanent display in her museum.

One complete chest (opposite page) is decorated with gilded pastiglia, or plaster relief, shaped into elaborate foliage motifs, twining garlands, and incised patterns – all calculated to catch and reflect shimmering light. Warriors hold the arms of the Piccolomini and the Spannocchi families of Siena. The ceremonial procession decorating the front of the chest evokes a Renaissance bridal procession, complete with musicians, attendants, and a richly caparisoned horse. The two figures on the left that embrace one another may represent Solomon and the Queen of Sheba, a popular pairing of lordly magnificence and feminine submission.

In characteristic fashion, Bernard Berenson paid court to his patron, complimented her discernment, and spurred her acquisitiveness and rivalry with other collectors. Gardner was indeed lucky to get the two Pesellino panels (pp. 66, 67) since in the latter half of the nineteenth century, dealers and collectors had raised the demand for Renaissance painted wedding furniture. The cassone panels feature five parade floats, forming a grand procession that culminates in a celestial vision of God at the end of time. The imagery derives from Petrarch's fourteenth-century allegorical poem, *The Triumphs of Love, Chastity, Death, Fame, Time, and Eternity*. In his letters to Gardner, Berenson singled out the final tableau for praise, but he referred to it as the triumph of Religion rather than Eternity; presumably this substitution of titles was calculated to appeal to Gardner's deepening piety. Religious sentiment mingled with courtly love proved irresistible, so it's no wonder that Berenson also deliberately tailored his

I found two cassone panels the sight of which took my breath away; for I saw at a glance that not only were they the finest, but the best preserved pictures by the Giorgione of Florence, the very rare and wonderful Pesellino…. it is for you – O Lady – to buy them…. In style Pesellino combines the refinement of Fra Angelico, the gaiety of Benozzo, with the winsomeness of Fra Filippo. The grace, the refinement of the figures, the daintiness of the golden colouring, the beauty of the line, and the naïve charm of the representation have scarcely a rival.

– BERENSON to GARDNER, 1897

Cassone: A Procession with the Arms of the Piccolomini and Spannocchi Families, 1470s

Workshop of FRANCESCO DI GIORGIO, Italian (Siena), 1439–1501

Gilded and painted gesso on wood, 59.5 x 167 x 54.5 cm
Purchased in 1894 from the dealer G. Teunissen, The Hague,
through Ralph Curtis. Raphael Room

description of the first panel to include the triumph of "Chivalry" rather than Petrarch's more conventional Fame. With such coded language, Isabella Stewart Gardner and Bernard Berenson shaped history through imagination and fantasy; they engaged with the Renaissance past through scholarship, research, and travel, but they also enjoyed the role-playing of a good costume drama!

Indeed, a highly dramatic historical scene appears on the very first picture that Berenson procured for Gardner: Sandro Botticelli's *Tragedy of Lucretia*, bought in 1894 (p. 68). Berenson's letters suggests that he offered his services in gratitude for his patron's generous funding of his postgraduate year in Europe. Whereas knights might fight jousts for their ladies, Berenson indicates his willingness to enter the hazardous fray against other connoisseurs, collectors, and dealers in order to obtain the picture for his champion. The Botticelli panel originally served as a spalliera or wainscoting in the Vespucci palace in Florence along with

FRANCESCO PESELLINO, Italian (Florence), 1422–1457

Tempera and gold on wood, 42.5 x 158.1 cm
Purchased in 1897 from Mrs. J. F. Austen, Kent, through Berenson.
Early Italian Room

its pendant, the *Story of Virginia* (now in the Accademia Carrara, Bergamo). In order to emulate the appearance of a Renaissance interior, Gardner cleverly installed the Botticelli panel above the Sienese cassone (p. 68). Botticelli illustrates the rape and subsequent suicide of the chaste Roman matron, Lucretia. Her tragic fate was recounted by the ancient writers Livy and Ovid, as well as by countless medieval and Renaissance authors who celebrated the heroine's firm resolve and manly courage. Outrage over Tarquin's callous behavior ultimately led to a civil war and to the establishment of the first Roman republic. Is it too much to imagine Gardner sympathizing with the plight of Lucretia, a woman facing accusations of impropriety and subject to intense public scrutiny? Would she not have admired Lucretia's capacity for decisive – if unconventional – action, spurring her fellow citizens to political action and social reform? Like Lucretia, Isabella Stewart Gardner became a female exemplar but unlike her Roman predecessor Gardner lived out her long life surrounded by a collection that exemplified the triumph of art.

 – CRISTELLE BASKINS, 2002

∾ *The Triumphs of Fame, Time, and Eternity,* ca. 1450

Francesco Pesellino, Italian (Florence), 1422–1457

Tempera and gold on wood, 45.4 x 157.4 cm
Purchased in 1897 from Mrs. J. F. Austen, Kent, through Berenson.
Early Italian Room

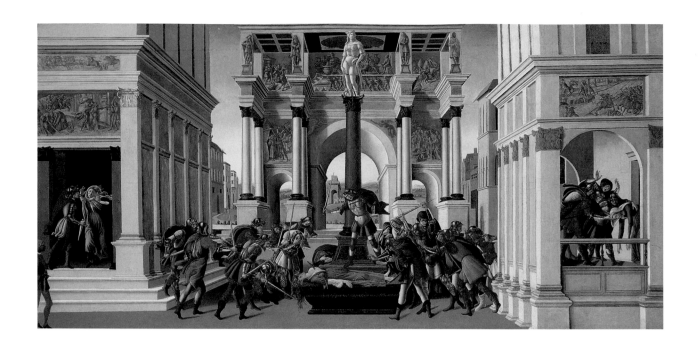

The Tragedy of Lucretia, ca. 1500–1501

Sandro Botticelli, Italian (Florence), 1444/45–1510

Oil on wood, 83.8 x 176.8 cm
Purchased in 1894 from the Earl of Ashburnham, through
Berenson. Raphael Room

The Raphael Room

The style of Botticelli's paintings from the last decade of his life, beginning with such works as the *Tragedy of Lucretia,* is dramatically different from that of his earliest career. The gentle calligraphy of his earlier drawing and the balletic grace of his figure types, derived from Filippo Lippi but perfected in his own unmistakable idiom, have given way to hard, almost engraved lines and crabbed, intensely over-wrought figures. The delicate veils of color that warmed the atmosphere and created a sense of open space as well as of surfaces and textures in paintings like the Chigi Madonna (p. 59), have become adamantine blocks of bright, unmodulated tone, lending a cold clarity to a light that defines figures and architecture with somewhat inconsistent results. In part this change may be attributable to Botticelli's shift to the fashionable medium of oil paints, a shift he was never comfortable making, having been one of the century's greatest technicians in the use of tempera paints. Scholars have also seen in the stiffening of Botticelli's late style proof of Vasari's claim that the artist was physically debilitated at the end of his life: "Finally, having become old, unfit for work, and helpless, he was obliged to go on crutches, being unable to stand upright, and so died, after long illness and decrepitude." Whether this story be fact or fiction, Botticelli's late works betray no perceptible diminution in his power of expression or in his compositional genius. The *Tragedy of Lucretia* is certainly one of the great masterpieces of Florentine painting from the last years of probably its greatest period, the golden age of the fifteenth century.

— LAURENCE KANTER, 1997

ge alla contemplatione et Danthe cioe epso appetito gli tien drieto, perche gli diuenta obbediente

CANTO SECONDO DELLA PRIMA CANTICA

1 O giorno senandaua et laer bruno
togleua glianimali che sono interra

p Ossiamo dire che elprecedente capitolo sia stato
quasi una propositione di tutta lopera p laquale
lauctore non solamente dimostra con brieue pa

∾ Dante

Illustrations to the *Inferno* by Dante (Italian, 1265–1321), in: *Comento di Christophoro Landino fiorentino sopra La comedia di Danthe Alighieri poeta fiorentino* (Florence, 1481)

Dante and Virgil with the Vision of Beatrice
(canto 2)

Virgil is describing Beatrice's coming to him to request his assistance as Dante's guide. To the right is the gate of Hell which Dante and Virgil will enter in the next canto.

The City of Dis, and the Flaming Sarcophagi of the Heretics
(canto 10)

Inside the gate of the city of Dis (lower Hell), Dante and Virgil encounter the flaming tombs of the heretics who include, as the engraved slab at the center reveals, a previous pope. To the right Dante speaks with Cavalcante dei Cavalcanti, the father of his friend Guido Cavalcanti.

The Malebolge: The Punishments of Simony
(canto 19)

Dante and Virgil are in the third ditch of the ten Malebolge that make up the circle of Fraud. In this upside-down space, the simoniac popes are punished for their greed and corruption.

Attributed to Baccio Baldini (Italian, ca. 1436–1487), based on designs by Sandro Botticelli
Engravings, each ca. 9.5 x 17.4 cm
Purchased in 1887 at the London auction of the Earl of Crawford, through Bernard Quaritch, London.

The 1481 edition of *The Comedy (La commedia)* was the first to be printed in Florence. Its printer was Nicolaus Lorenz of Breslavia (his name appears in the colophon as Nicholo di Lorenzo della Magna), a printer who was active in Florence from 1477 to 1484. This was the first printed edition to envision a continuous visual commentary, even though the complete series of one hundred projected engravings was never completed. Only nineteen engravings were made. The first engravings were printed on the same page as the text they illustrate, but the difficulty of combining engraving with printed text kept the printer from proceeding in this manner; the subsequent plates were engraved on separate sheets and then affixed to the text. Only a few copies actually contain all nineteen illustrations, and Mrs. Gardner's is one of them. Following Giorgio Vasari, scholars have generally believed that the nineteen engravings were made by Baccio Baldini working from lost drawings by Botticelli.

This edition is also important for its commentary by Cristoforo Landino (1425–1498), a major figure in Florentine cultural life with close ties to the Medici family and to the leading intellectuals of their circle. This was the first Renaissance gloss on the poem, and also the first Florentine commentary since that of Boccaccio who had lectured on the poem in 1373. Landino situates Dante within the larger perspective of Florentine civic and intellectual history, reviewing and reframing that history while giving Dante a central role within it. His interpretation of Dante is suffused with the ideals of Florentine neoplatonism, making Dante the predecessor and exemplum of avant-garde Florentine neoplatonic humanism. Landino's commentary was reprinted frequently and remained the most popular throughout the sixteenth century.

Isabella Stewart Gardner became interested in Dante through Charles Eliot Norton whose lectures she attended at Harvard. Norton, one of the founders of the Dante Society of America, encouraged Mrs. Gardner to collect rare editions. In

1886 he alerted her to the sale of a 1502 Aldine Comedy and a 1487 Bonino Brescia Comedy (the second edition to attempt a continuous visual commentary), both of which she purchased. The following year he urged her to buy the Landino Dante which he called a "treasure," and later wrote to congratulate her with admiration for her "quick and resolute" spirit in its acquisition.

— RACHEL JACOFF, 2002

Lo'nferno e'l Purgatorio e'l Paradiso di Dante Alaghieri (Venice: Aldine, 1502)

Bound book, page: 15.7 x 9.4 cm
Purchased in 1886 from the London auction of Edward Cheney, through Bernard Quaritch, London.

This first portable edition of Dante's works was made possible in large part through the use of an innovative italic type, which had been first used in 1501. The clear and neat font allowed a great deal of text to appear on a page, while remaining easily legible. The type was designed and cut by Francesco Griffo in emulation of fine Renaissance handwriting.

Binding of a Double Edition of Dante's Comedy, 1894

Tiffany Company, New York
Leather and silver, book dimensions: 19.2 x 12.7 x 8.7 cm
Given in 1894 by F. Marion Crawford.

Mrs. Gardner and her friend Francis Marion Crawford read Dante together in the winter of 1881 to 1882. Crawford, the cousin of Mrs. Gardner's friend and neighbor, Maud Howe, had been raised in Italy and spoke beautiful Italian. Their intense friendship was a source of much speculation and gossip at the time. In 1883, Crawford left Boston abruptly to return to Europe. Ten years later, on his return to America, he resumed his friendship with Mrs. Gardner. In the autumn of 1893 Crawford sent their modern copies of Dante's *Comedy* to Tiffany in New York to be interleaved and bound in an exquisite binding. The cover is dark green leather, and there are four silver mounts in the outer corners. On

Aldine edition of 1502

Come and let me whisper you
Half the things Madame can do.
She can read terrific Dante
In a manner calm and canty.
She can sit in Music Hall,
Heavenward raised at Music's call.
She can turn again to earth
At the plea of modest Worth.
She can ride and she can row,
She can dig and she can hoe,
She can dance and she can – what?
Not say flirt? she'd like it not?
Nay! then I can't tell to you
Half the things Madame can do!

> — F. MARION CRAWFORD,
> *valentine to Mrs. Gardner*

each mount, in Gothic script, is one word of the opening line of Dante's *Vita Nova:* "Hic Incipit Vita Nova" (Here begins the new life). While the outer design is Gothic, the inside cover has flowers and tendrils based on a sketch by Crawford. On each of the two silver clasps is written: "The two are one." Written on the first page are two lines from *Paradiso* (33. 86–87): "Legato con amore in un volume / ciò che per l'universo si squaderna" (Bound with love in one volume all that is scattered throughout the universe). In a letter of 1895 Crawford refers to the pleasure of reading from "the dear green Dante with its clasps and its Gothic corners."

> — RACHEL JACOFF, 2002

Cover and inside back cover of binding by Tiffany

The High Renaissance

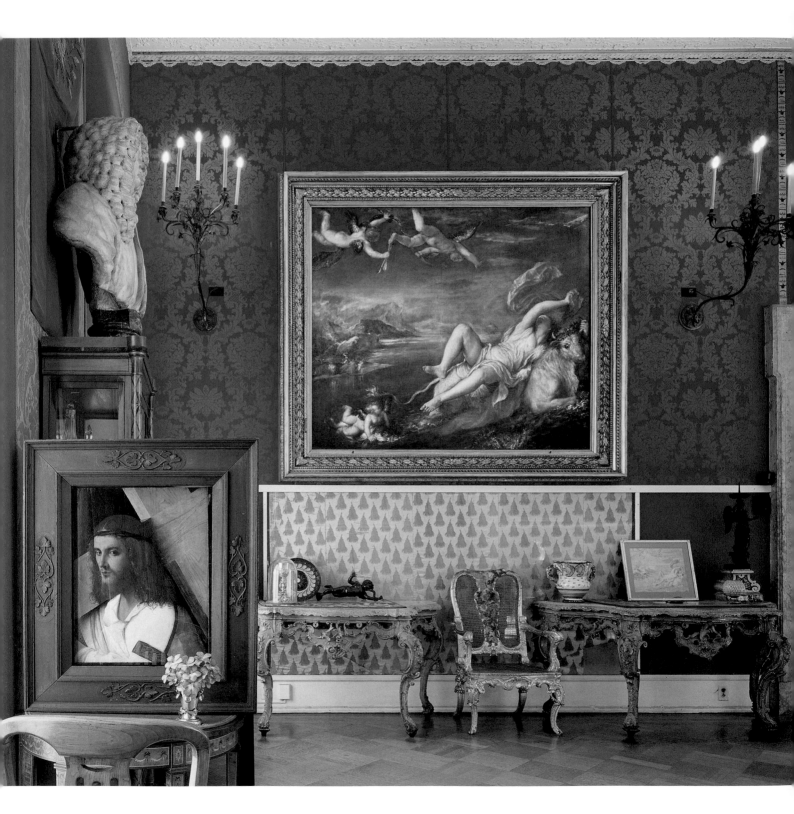

The Meeting of Christ and John the Baptist, ca. 1503–99

FILIPPINO LIPPI, Italian (Florence), 1457/58–1504

Pen in brown ink over black chalk on paper, 9.3 x 9 cm
Purchased in 1902 at the London auction of the collection of
J. C. Robinson.

The Titian Room

The drawing depicts Christ meeting John the Baptist in the wilderness, an episode not found in scripture, but described in Renaissance biographies of the Baptist and sometimes found in paintings. Filippino Lippi shows a warm and tender embrace between two figures – a theme the artist greatly favored and employed in other narrative situations. Compared with the Baptist's garb, Christ's robes are much more fully shaded and detailed, which suggests that the drawing was made in part to explore problems of drapery. In fact, Giorgio Vasari praised Filippino's innovative costumes.

Filippino Lippi's reputation was at a peak around 1900, and both Isabella Stewart Gardner and Bernard Berenson considered acquiring a work by the artist to be among their highest priorities in building a collection. In 1903, she refused to pursue the tondo that belonged to the Warren family as she felt it ought to go to the Museum of Fine Arts, Boston (it ended up in Cleveland), and as late as 1922 there was again talk of buying a painting by Filippino.

– ALAN CHONG, 2002

❧ *Pietà*, ca. 1503–5

RAPHAEL, Italian, 1483–1520

Oil on wood, 23.5 x 28.8 cm
Purchased in 1900 from Colnaghi, London, through Berenson.
Raphael Room

This small panel originally formed part of the predella of an altarpiece Raphael painted for the convent of Sant'Antonio in Perugia. The main panel depicting the Virgin and Child enthroned and surrounded by saints is in the Metropolitan Museum of Art, New York, which also owns a panel from the predella. Other parts of the predella are in the National Gallery, London, and the Dulwich Picture Gallery. The altarpiece is a youthful work by Raphael, done at a time when he was emerging as a rival to Perugino, who had been a strong influence on him.

In this painting, Raphael arranged six figures in an easily read composition, each figure varied in action but united in sympathetic attention to the dead Christ. Saint John and the Virgin Mary tenderly support Christ in the center on a slightly elevated grassy mound. Joseph of Arimathea and Nicodemus, who brought Christ down from the cross, stand behind to frame the group. At the right, Mary Magdalene kneels to kiss Christ's foot. Even in this early work, Raphael imbues his figures with the empathy and sweetness beloved in his later paintings.

When Berenson brought this painting to Mrs. Gardner's attention, she immediately bought it. A few years before, he had warned her not to buy the central panel of the altarpiece, judging it to be for the most part by Raphael's workshop (it was acquired by J. P. Morgan). Like many collectors of her time, she coveted most a Raphael Madonna, but she was never able to acquire one. The work had a series of especially distinguished owners: Queen Christina of Sweden owned it between 1663 and 1689; in 1721, it was bought by the Duke of Orléans, regent of France, who also owned Titian's *Europa* (p. 102); later it belonged to the English portraitist Thomas Lawrence.

— RICHARD LINGNER, 2002

❧ Procession of Pope Sylvester I, ca. 1516–17

R A P H A E L , Italian, 1483–1520

Colored chalks on paper, 39.8 x 40.3 cm
Purchased in 1902 at the London auction of the collection of
J. C. Robinson.

The finest drawing here. The feeling of slow movement pervades it like organ music.

— PAUL SACHS, 1935

The drawing depicts Pope Sylvester I (reigned 314–335) in the *sedia gestatoria,* the portable papal throne. He is being carried out to meet the Emperor Constantine on the occasion of the Donation of Constantine, in which the pope was given territorial possessions and broad powers. The subject, which illustrated an important source of papal authority, was chosen for a fresco in the Vatican.

Raphael used this drawing to develop the fresco's composition. Each figure has been given clarity and weight, from the pope's gesture of benediction to the several figures that turn to look out at the viewer. The paper has been squared for transfer: reproducing a design in a different scale is much easier when copying elements in the individual squares, rather than trying to copy the whole drawing at once. There are two sets of grid lines that go both under and over the design, suggesting that the drawing is just one step in an extended creative process. Raphael did not live to paint the fresco. His assistants, principally Giulio Romano, changed the motif considerably for the final painting in the Sala di Constantino.

Raphael's use of colored chalk is unusual (he used it on only one other drawing), but highly effective. The artist reworked the position and pose of the figures in black chalk; several areas have been rubbed out and redrawn. The disposition of red, orange, and yellow throughout the composition allowed Raphael to work out the massing of figures and the overall color balance. This drawing is both documentary and beautiful: we witness Raphael's creative thinking and working method.

— RICHARD LINGNER, 2002

❧ *Pietà,* ca. 1538–44

MICHELANGELO, Italian, 1475–1564

Black chalk on paper, 28.9 x 18.9 cm
Purchased in 1902 at the London auction of the collection of
J. C. Robinson.

At Vittoria Colonna's request, he made a nude figure of Christ when he is taken from the cross, which would fall like an abandoned corpse at the feet of his most holy mother, if it were not supported by two little angels. But she, seated beneath the cross with a tearful and grieving countenance, raises both hands to heaven with open arms, with this utterance which is inscribed on the stem of the cross: There they don't think of how much blood it costs.

— ASCANIO CONDIVI, 1553

Michelangelo made this highly finished drawing at the request of Vittoria Colonna, among the most accomplished women of the Renaissance. The widowed marchesa of Pescara, admired for her learning, piety, and eloquence, was active in religious circles and published acclaimed spiritual poetry. When they met about 1536, she became one of Michelangelo's few intimate friends, and the only woman among them. He too was a poet, and the pair exchanged verses and letters, which joined with the designs he gave her in a heartfelt dialogue about their mutual enthusiasms for church reform and the arts.

Though titled a *Pietà,* the drawing actually telescopes two consecutive episodes from Christ's Passion, doubling its theological and emotional impact. The venerable *Pietà* theme spotlights the Virgin alone over her prostrate son, just taken down from the cross; in this image, she mouths a grief-stricken appeal for heavenly consolation. But Mary is here upstaged by Christ, who is suspended in frontal view by two boyish angels – a group recalling the Man of Sorrows theme, a later moment that emphasizes Christ's physical sacrifice as his corpse slumps in the tomb.

Like much of Michelangelo's work, the drawing is deeply autobiographical. The key to its meanings, both public and private, lies in the verse from Dante's *Paradiso* inscribed on the (now partly-cropped) cross: "There they don't think of how much blood it costs" (Non vi si pensa quanto sangue costa). Michelangelo, who knew much of Dante by heart, quotes canto 29, where Beatrice deplores how few on earth appreciate the sacrifices martyrs make to spread the divine gospel down there, or how pleasing to God are those who cling to it. The message is conventional – the hardships of propagating the true faith – but it also held personal spiritual meaning for artist and recipient alike. Both traveled in Roman circles that preached salvation by faith, which might be achieved by prayerfully contemplating sacred events: Michelangelo's late poetry increasingly invoked the blood shed by Christ, while Colonna wrote a "Lament over the Passion" that imagined the Virgin "delighting in this pain." Michelangelo's gift thus offered consoling testimony to their shared conviction that the savior's tragic death is also a cause for joy, the climax of God's divine comedy that offers each believing soul the hope of a happy ending.

In more individual terms, Michelangelo idealized Colonna as the kind of guardian angel Dante saw in Beatrice – a spiritual guide in their joint struggle toward paradise. "A man within a woman, or rather a god / speaks through her mouth," he wrote, addressing her as "you who pass souls / through fire and water on to days of joy." The drawing celebrates their closest bond: unlike most people "down there," they do think of the divine matters he has depicted for her. The *Pietà* is thus a study of Colonna, though not in any literal sense. Michelangelo disdained painting mere likenesses: since inner beauty counts more than outer, an allegory of the beloved's devout imagination reveals more than a record of her face. This is the portrait of a soul, not a body.

Colonna received the *Pietà* as one of three presentation drawings from Michelangelo. This was a new genre – completed sketches suitable as gifts. Michelangelo gave away such drawings only as testimonials of exceptional affection, and the Gardner image (and its recipient) must have been close to his heart, since he made sure his biographer Ascanio Condivi discussed it in detail. The Colonna group of drawings followed by a few years Michelangelo's other major suite, for his greatest male love, Tommaso de' Cavalieri. The two series embody the contrasting poles of Renaissance culture: Cavalieri's drawings, all on classical mythological themes, ponder the joys and pitfalls of earthly love, while Colonna's are on Christian subjects concerned with heavenly affections. Michelangelo's infatuation with Tommaso was expressed in poems whose erotic frankness was startling for the time; his later verses to Vittoria still speak of Petrarchan longing. Condivi records Michelangelo saying that he created her *Crucifixion* drawing "for love of that lady," but Condivi then makes clear that it was her "sublime spirit he was in love with." The aging artist's personal evolution reflected the widespread sobering of Catholic culture during the Counter-Reformation: where images once kindled passion, they now aimed to arouse chaste meditation.

The drawing enjoyed a widespread and influential afterlife. It was copied by Michelangelo's assistants and adapted by artists such as Lavinia Fontana. The opportunity to fashion a symbolic pedigree no doubt appealed to Mrs. Gardner, who chose many treasures for their personal associations and conceived Fenway Court as an extended self-portrait. The grieving mother theme

would have resonated for a woman who lost her only son as a baby. And she shared Michelangelo's affinity for Dante, whose printed editions she collected; her affinity for Michelangelo himself is attested by her purchase of a painting then considered a portrait of him (actually Baccio Bandinelli, see p. 84). Most suggestively, she identified with cultured and powerful Renaissance women, adopting Isabella d'Este, the first great woman art impresario, as a patron saint and role model. She may well have felt a similar kinship with Vittoria Colonna: beyond shared artistic interests, both were childless women who raised orphaned nephews as surrogate sons, and Isabella was, like Vittoria, piously observant, with her own private chapel. We could equally conclude of Mrs. Gardner's *Pietà* what her biographer said of the acquisition of another Renaissance Madonna: "In it her love of beauty and her devotion to religion were united."

JAMES M. SASLOW, 2002

The Titian Room

✑ Self-Portrait, ca. 1545–50

BACCIO BANDINELLI, Italian (Florence), 1488–1560

Oil on wood, 142.5 x 113.5 cm
Purchased (as a portrait of Michelangelo by Sebastiano del Piombo) in 1899 from the collection of Ralph Vivian, through Colnaghi and Berenson. Titian Room

Baccio would have gained more esteem for himself and his abilities if he had possessed a more amiable and courteous disposition. But he was just the reverse, and his abusive language lost him all goodwill and obscured his talent, so that men viewed his works askance and never liked them. As he always spoke ill of the works of others, no one could endure him, and all who could returned his abuse with interest. He was always engaged in litigation, and seemed to delight in it.

— GIORGIO VASARI, 1568

What do you know about my picture "Portrait of Michelangelo" by Sebastian del Piombo? Here a doubt is raised. Is it Michelangelo? Is it by Sebastian del Piombo? Tell me what you think and know.

— GARDNER to BERENSON, 1902

Bandinelli made his career serving the Medici family. With their expulsion from Florence in 1527, Bandinelli too fled the city. After the Medici were restored to power, Bandinelli was commissioned to carve the marble group *Hercules and Caucus* (Piazza della Signoria, Florence). This self-portrait proclaims Bandinelli's status as Florence's official sculptor: he proudly holds a preparatory drawing for the *Hercules and Caucus* that secured his reputation. Around his neck is a gold chain with a shell – emblem of the Imperial Order of Santiago – that he received from Emperor Charles V.

Bandinelli and his work were often disparaged by critics, including Benvenuto Cellini and Michelangelo. Ironically, this portrait was purchased by Isabella Stewart Gardner as a portrait of Michelangelo, and it was placed next to Cellini's bust of Bindo Altoviti (p. 83). The pairing of works was originally a reminder of the close friendship among Cellini, Altoviti, and Michelangelo. Now, the juxtaposition is redolent of a bitter Renaissance rivalry.

— ALAN CHONG, 2002

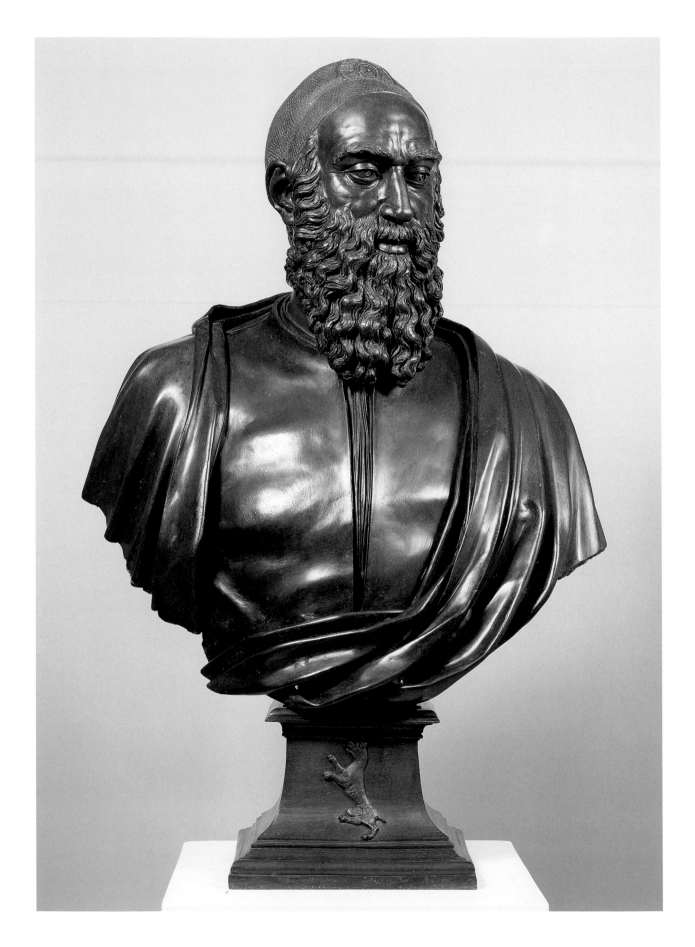

ᴄᴡ *Bindo Altoviti*, ca. 1550

ʙᴇɴᴠᴇɴᴜᴛᴏ ᴄᴇʟʟɪɴɪ, Italian, 1500–1571

Bronze, 105.4 cm high
Purchased in 1898, through Berenson. Titian Room

*I made a bust of Bindo d'Antonio Altoviti,
life-size and in bronze, and sent it to him
in Rome. He placed it in his study, which
was very richly furnished with antiques
and other beautiful things, but this study
was not suitable for sculpture, even less for
paintings, because the windows were
underneath the fine works, so the light
struck the sculptures and paintings from
the wrong direction, and spoiled the effect
they would have had in a proper light.
One day this Bindo happened to be stand-
ing at his door when Michelangelo
Buonarroti the sculptor passed by, and he
begged him to be kind enough to come in
and see his study. He led him inside, and
as soon as he was there Michelangelo said:
"Who was this artist who portrayed you
so well and in such a fine manner? You
know that this bust pleases me as much
and rather more than the antiquities,
although there are some good ones among
them."*

— ʙᴇɴᴠᴇɴᴜᴛᴏ ᴄᴇʟʟɪɴɪ, ca. 1560

*My Benvenuto, I have known you for
many years as the greatest goldsmith of
whom we have ever heard, and now I
know you equally as a sculptor. I must tell
you that Bindo Altoviti took me to see his
bust in bronze, and he told me that it was
by your hand. I was greatly pleased with
the work, but I only regret that it had
been placed in a bad light, because if it
had been given proper light, it would be
seen to be the fine work that it is.*

— ᴍɪᴄʜᴇʟᴀɴɢᴇʟᴏ to ᴄᴇʟʟɪɴɪ,
ca. 1550

The bust is a portrait of Bindo Altoviti (1491–1557) who was born into a family of Florentine bankers. He achieved considerable power as banker and administrator for the papacy; he supervised agriculture in the Papal States and managed the rebuilding of St. Peter's Basilica. Altoviti was also a remarkable patron of the arts: he owned or commissioned work from many notable sixteenth-century artists, including Raphael, Michelangelo, Cellini, Giorgio Vasari, Francesco Salviati, and Jacopo Sansovino. Around 1515, Raphael portrayed Bindo Altoviti as an elegant and beautiful young man (National Gallery of Art, Washington).

The Altoviti family had long been rivals of the Medici. Bindo's relationship with the Medici rulers of Florence was tense, although he conducted business with them and accepted honors from them. For the most part, Bindo lived in exile in Rome to avoid their authority. By 1550, the hostility between Bindo and Cosimo de' Medici, the duke of Florence, became evident. Cosimo refused to allow Bindo's son to take up his post as archbishop of Florence. Bindo financed an army to support the anti-Medici forces in Siena, and then spent much of his fortune under-writing an alliance with France intended to liberate Florence from Medici rule. These efforts failed before Bindo died in 1557.

It was at this period that Cellini produced his bust of Bindo Altoviti. Nearly sixty, Bindo is depicted as a stoic, world-weary figure, although his gaze remains alert and dynamic. The sculpture echoes ancient busts of philosophers, and indeed was displayed next to ancient Roman busts in Bindo's palace. Nearly life-size, the work presents remarkable contrasts of textures. The beard is energetically modeled and shows the repeated working of the original wax model. Very different is the careful rendering of wrinkles and details of the face, and the painstaking precision of Bindo's unusual cap (see detail).

Cellini made a bust of Bindo's hated rival Cosimo de' Medici just three years earlier (Museo del Bargello, Florence). Highly energized and aggressive, Cosimo's bust is almost overwhelming in its grandeur and dazzle. It is a public and militaristic portrait, whereas the bust of Bindo is private and humanist, both in execution and original context. It seems that Cellini and Altoviti conspired to create a portrait as different as possible from Cosimo's, although both emulate ancient prototypes and were surely meant to rival the bronzes of antiquity. Bindo Altoviti is portrayed as

republican philosopher rather than imperial general.

In the nineteenth century, several museums attempted to buy the bust from the Altoviti palace in Rome. Finally, in 1898 the work was put up for sale via Colnaghi, and Mrs. Gardner snapped it up. It is her only large sculpture in bronze, a medium that did not usually interest her.

— ALAN CHONG, 2002

Detail

∾ *Musicians,* ca. 1545

GIORGIO VASARI, Italian, 1511–1574

Fresco, 105.5 x 167 cm
Purchased in 1897 from Vincenzo Barone, Naples.
Second Floor Stair Hall

These musicians appear to be serenading a gathering in a grand salon from an upper balcony. Their instruments and sheets of music protrude over the ledge and cast shadows on the feigned architecture.

The fresco has recently been identified as the work of Giorgio Vasari. While most of his frescoes were produced for religious or civic institutions, he occasionally provided decorations for private interiors (for example, he painted frescoes for the palace of Bindo Altoviti). It is possible that this fresco was made in Naples in 1545 for Tommaso Cambi, a merchant and collector originally from Florence, who was also a close friend of Vasari. The handling of the figures resembles Vasari's other frescoes done in Naples (for example, the refectory of Monteoliveto), while similar musicians can be found in his *Marriage of Esther and Ahasuerus* of 1549 (Museo Statale di Arte Medievale e Moderna, Arezzo).

Portrait of Juana of Austria with a Young Girl, 1561

SOFONISBA ANGUISSOLA, Italian, ca. 1532–1625

Oil on canvas, 194 x 108.3 cm
Purchased in 1898 from the marchese Fabrizio Paulucci de' Calboli, Forli. Titian Room

I am now busy doing a portrait of her Most Serene Princess, our lord King's sister, for the Pope. Just a few days ago, I sent him the portrait of our lady the Queen. Therefore, my dearest Signor Bernardino, and my teacher, you see how busy I am painting. The Queen wants a great part of my time so that I can paint her portrait.

— SOFONISBA ANGUISSOLA to her teacher BERNARDINO CAMPI, 1561

One thing I can tell you quite certainly – that it is not by Titian.

— BERENSON to GARDNER, 1896

Isabella Stewart Gardner bought this painting as a Titian, although she had been warned by Bernard Berenson that the attribution was in some doubt. Perhaps reluctant to disappoint his patron, Berenson changed his mind, and helped Gardner with the purchase. She hung the painting opposite Titian's *Europa*. Although not by Titian, it was painted at precisely the same time that the *Europa* arrived at the Spanish court.

Sofonisba Anguissola was born into a minor aristocratic family in Cremona, and studied painting under Bernardino Campi. In 1560, she was appointed painter to the new queen of Spain, Isabel de Valois (1546–1568), who had become Philip II's third wife. She taught the young queen drawing and made numerous portraits of the royal family and members of the court.

The subject of the portrait, Juana of Austria (1535–1573), was a formidable politician and patron of the arts. Daughter of Charles V (she wears a cameo of the emperor in this painting), Juana married Prince Juan of Portugal. After just two years of marriage, Juan died and Juana returned to Spain to become regent while her brother Philip II was in England. Although she was celebrated for her ability in state affairs, Juana thereafter devoted her energies to religious life. In 1557, she founded a monastery, the Descalzas Reales, which became an important center of artistic patronage. This portrait was painted in 1561 for the pope, and was thus meant to show Juana's religious devotion. The child by her side is probably a young aristocrat under her protection who is being prepared to enter the religious order.

— ALAN CHONG, 2002

Portrait of a Man, 1576

GIOVAN BATTISTA MORONI, Italian, ca. 1520–1578

Oil on canvas, 173.5 x 103.5 cm
Signed lower right: IO BAT MORONUS / MDLXXVI
Purchased in 1895 from Galleria Sangiorgi, Rome. Titian Room

Among his later portraits some (e.g. Portrait of a Man in Black, Boston, Gardner Museum, dated 1576) *have a most imposing density of presence, in which the sitter seems to have been described as an object more than as a person: as elsewhere in Lombard painting of these years, there is an intimation of the way to Caravaggio.*

— SYDNEY J. FREEDBERG, 1971

Giovan Battista Moroni painted religious works and decorative schemes, but his fame derives from his portraits. The man in this work has not been identified, although he certainly exudes personality. The set of his jaw and his direct gaze demonstrate his resolve; Moroni shows him confidently stepping forward, one hand on the hilt of his sword. The neutral background, with Moroni's characteristic imaginative architectural detail, allows the figure to command all our attention – save, perhaps, for the curiously thin-limbed, ghostly shadow on the wall behind him. The shadow heightens the believability of the depiction by marking his position in illusionistic space.

— RICHARD LINGNER, 2002

∾ The Art of Venice

VENICE is the touchstone of Fenway Court. If the whimsical and idiosyncratic building can be said to have a style, it is Venetian, for the courtyard is essentially a Grand Canal facade turned inward. Venetian painting holds pride of place in the collection. Isabella Stewart Gardner first visited the city as a young woman in 1857, and returned with her husband for an extended stay in 1884. She became so enamored with Venice that the couple returned every other year for long sojourns. She regularly rented the Palazzo Barbaro, an elegant and atmospheric Grand Canal house that belonged to Daniel and Ariana Curtis, exiles from Boston. Gardner immersed herself in Venetian expatriate society; indeed

James McNeill Whistler, American, 1834–1903
Nocturne: Palaces, 1879–80
Etching, 29.6 x 20.1 cm

John Singer Sargent, American, 1856–1925
Ponte della Canonica, Venice, 1903–4
Watercolor on paper, 45.8 x 30.6 cm

John Ruskin, British, 1819–1900
The Casa Loredan, Venice, ca. 1850
Pen, watercolor, pencil, and gouache on gray
paper, 29 x 44 cm

her personal circle came to dominate it. She met Robert Browning, befriended Katharine de Kay Bronson, Henry Austen Layard, and many others. Henry James stayed with Mrs. Gardner, completing *The Aspern Papers* and beginning *The Wings of the Dove*. The painter Anders Zorn came to visit in 1894 and made a sensuous portrait of Gardner (p. 214). She gathered together distinguished artists, writers, and socialites in an evocative setting. These salons inspired the formation of the Gardner Museum.

Much of Mrs. Gardner's activity in Venice was educational: she visited hundreds of churches and palaces, and carefully filled albums with photographs that documented various aspects of Venetian art. So powerful was Venice's hold on Mrs. Gardner's imagination that she even contemplated purchasing a palace on the Grand Canal. Instead, she decided to bring Venice to Boston. Much of the decorative arts, furniture, and textiles in the collection was purchased from Venetian dealers. Eight balconies ringing the court originally adorned the facade of the Ca' d'Oro. Gardner also enthusiastically acquired evocative renderings of Venice, for example, a painting by Ralph Curtis (p. 111), etchings by James McNeill Whistler, an architectural drawing by John Ruskin, and, at the end of her life, several striking watercolors by John Singer Sargent.

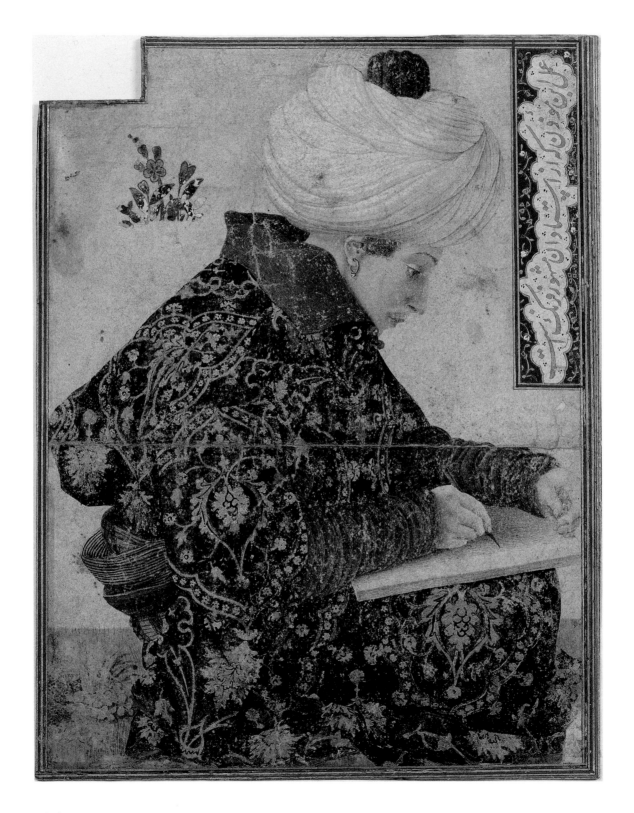

A Seated Scribe, 1479–80

Attributed to Gentile Bellini, Italian (Venice), 1430–1507

Gouache and pen with ink on paper, 18.2 x 14 cm
Purchased in 1907 from F. R. Martin, through Anders Zorn.
Early Italian Room

Such an adorable and exquisite thing. Zorn did this for me. It is joy and rapture.

— GARDNER to BERENSON, 1907

I want to talk about a drawing of a young Turkish man who appears to be about to begin drawing. But how? I could say that he seems to be an absent-minded man absorbed in his own limbo – immobile, silent, staring at something he is supposed to be doing, drawing or maybe writing. And then I think it doesn't matter what he's doing. It is an image of a man completely detached and distant. I could say that there is something elusive or that his concern seems to appear and disappear from sight. My own attention shifts from the board, where he's drawing or writing, to his hands and then to the beautiful embroidered blue gown. I could talk about absorption and the absence of the beholder – about being outside while being inside. But then all those words and concepts, that I write now in silence, and that I will read aloud to you, will not help me to understand or to re-create that instant when I first walked into a room at the Gardner Museum and contemplated a small, delicate drawing of a young Turkish man by Gentile Bellini, and in my mind, for an instant, thought it perfect.

— JUAN MUÑOZ, 1995

Curious visitors who lift the cover from the unassuming *Seated Scribe* will be richly rewarded by what they see: an intimate painting in miniature of a young member of the Ottoman court bent intently over a writing pad. Dressed in a navy velvet caftan woven with gold, the elegant youth wears bright silks on his arms and neck. The generous folds of his turban hold in place a ribbed, red taj – headgear worn in the court milieu of Ottoman sultan Mehmed II (1432–1481), who nurtured a passionate interest in portraiture and particularly in western traditions of the genre.

Striking for its gleaming tones and stunning delicacy of line, the *Seated Scribe* is spectacular not only visually, but also in historiographic terms. The painting's original dimensions have been trimmed, and a later hand has taken care not only to embellish the image, but also to frame, mount, and, ultimately, historicize it. An added inscription in Persian records the image as the "work of Ibn Muezzin who was a famous painter among the Franks." Scholars have never doubted that a European or "Frankish" artist painted the *Seated Scribe*. The pressing issue of late has been who, precisely? Whether the Venetian Gentile Bellini, a renowned portraitist sent to Istanbul in 1479, or Costanzo da Ferrara, a court artist at Naples who also sojourned at the Porte, the specificity of detail in the *Seated Scribe* leaves little doubt that the artist drew from life.

Once the debate over attribution subsides, the more intriguing issue to raise is whether one can call the work a portrait. Might western pictorial realism have been the point of the exercise? A pronounced crease just above the youth's elbow suggests the image was initially handled as a loose-leaf, autonomous work of art before being mounted (and in this way preserved) in a sixteenth-century album. Like other western-style works Mehmed II commissioned or obtained during his sultanate, the *Seated Scribe* may have been used as a pedagogic tool for rising artists of the Ottoman royal workshop. A slightly later copy of the miniature (Freer Gallery of Art, Washington) certainly affirms its value for Ottoman and Persian artists as a pictorial model worthy of imitation. If the pictured youth is not a scribe but an artist, shown in the act of drawing while he himself is being drawn according to Western pictorial practices, the *Seated Scribe* taught by poignant example – it sits indeed at the nexus of Ottoman art and European traditions of representation.

— SUSAN SPINALE, 2002

Christ Carrying the Cross, ca. 1505–10

Circle of GIOVANNI BELLINI, Italian, ca. 1431/36–1516

Oil on wood, 49.5 x 38.5 cm
Purchased in 1898 from Conte Zileri Dal Verme, Vicenza.
Titian Room

This is a very hurried word, to say merely that if our stupid and impossible Art Museum does not get the Giorgione (the Christ head, you know), please get it for me. I have seen the photographs and like it. They won't move quickly enough to get it I fear. You think it is Giorgione do you not?

— GARDNER to BERENSON, 1896

It is a sublime illustration rather than a great work of art. Moreover it is not in as good a condition as one might wish — a little fact that seems to have escaped the attention of the Boston experts. Now please do not think I am running the picture down. I adore it. Yet, it somehow is not the kind of thing I think of for you. But it is for you to decide.

— BERENSON to GARDNER, 1896

In the late fifteenth century, new types of private devotional pictures emerged in Italy. This painting is innovative in its depiction of strong emotion to aid prayer and meditation. The subject has been excerpted from narrative representations of Christ carrying the cross to Mount Calvary. However, lacking distracting details or any indication of setting, this image focuses instead on the tear-streaked face of Christ, who stares out at us melancholically, as well as the knotty wood cross over which he casts a shadow. It is an intimate and intensely personal depiction of a suffering more emotional than physical. This type of dramatic close-up was perfected by Giovanni Bellini, who was influenced by devotional images derived from the work of Leonardo da Vinci. This work is in turn based on a composition by Bellini (recorded in a painting in the Toledo Art Museum), and was made by a close follower of the artist, perhaps Vincenzo Catena (ca. 1470–1531).

When Isabella Stewart Gardner purchased the painting in 1896, it was attributed to Giorgione, who was also a pupil of Bellini and documented as a colleague of Catena. Even at that time, Gardner was unsure about its authorship, although the painting's strong quality and stirring piety led her to buy it. Bernard Berenson was frankly surprised that Gardner wanted such a strongly religious work. According to Morris Carter, the first director of the museum, the painting was Mrs. Gardner's favorite, and she often placed a vase of violets in front of it, a tradition maintained by the museum.

— ALAN CHONG, 2002

∾ *Platter*

Italian (Venice), 1500s
Brass inlaid with silver, diameter 46 cm
Purchased in 1906 from the Galleria Sangiorgi, Rome. Long Gallery

The moderns have, again in imitation of the ancients, rediscovered a way of making metal objects engraved with silver or gold, forming them into works of flat, low, or high relief, and in which they have greatly advanced. And these we have seen in steel, engraved in "tausia," also called damascene because people in Damascus, and all through the Levant, have excelled in making them in this manner.

— GIORGIO VASARI, 1568

Like the illumination attributed to Gentile Bellini, this brass platter is a Venetian response to Islamic art. The object is decorated with silver wire that has been fused to the brass in a technique called damascening, named after the city of Damascus. During the Renaissance, damascene brass was imported from the eastern Mediterranean to Italy, and by 1500 this Islamic technique had been adopted by craftsmen in Italy. Brass objects inlaid with intricate Arabesque designs in silver became especially popular in Venice. Some objects were close copies of Islamic models, while others, like this plate, mingle Italian and Eastern patterns.

๑ *The Virgin of Charity*, 1522

GIAMMARIA MOSCA, Italian, 1493–after 1574

Stone, 165 x 97.5 cm
Purchased in 1897 from A. Clerle, Venice. West Cloister

The severe image of the Virgin in this sculpture is deliberately archaic and Byzantine in style. More up to date are the swirling volutes of the throne, which echo the decorative pattern on the cloth of honor behind the Virgin. She holds the wheel of charity, symbol of the Scuola della Carità, a Venetian lay confraternity whose former headquarters is now the Accademia. The coat of arms is that of the donor, Paolo da Monte, who was a maker of rock crystal objects. The work was originally painted and gilded by a different artist, one Zuan del Verde, and it was installed on the façade of one of the Scuola's houses at San Zulian. Isabella Stewart Gardner discovered it after it had been moved to another church. According to Morris Carter, "she happened to go there and found workmen hacking it out, and said she would buy it if they would stop and let her have it taken out." Giammaria Mosca was a sculptor from Padua who worked in Venice in the 1520s, then moved to Kraków, Poland.

— GIOVANNA DE APPOLONIA,
2002

Eight Venetian ducats were paid to master sculptor Zuan Maria from Padua, who lives in San Barnaba, for carving in stone the figure of the Virgin with the sign of charity and the coat of arms of Polo Damonte.

— record of payment to the
sculptor, 1522

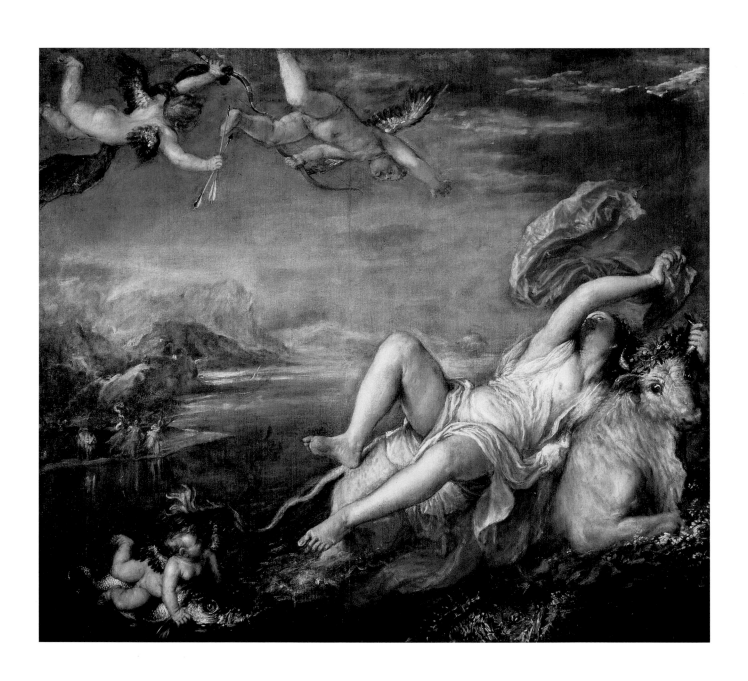

Europa, 1560–62

TITIAN (TIZIANO VECELLIO), Italian, ca. 1485/90–1576

Oil on canvas, 58 x 96 cm, signed lower left: TITIANVS. P.
Purchased in 1896 from Colnaghi, London, through Berenson.
Titian Room

I have finally, with the help of divine grace, brought to completion the two pictures that I began for Your Catholic Majesty: one is Christ in the Garden, the other the poesia *of Europa carried by the bull, which I send to you. And I can say these may set the seal of the many other works that you commissioned from me, and that I have sent to you on other occasions.*

— TITIAN to PHILIP II, 1562

Titian also painted a Europa crossing the ocean on the bull. These paintings are in the possession of the Catholic king, and they are held most dear because of the vitality Titian gave to his figures with colors that made them almost alive and natural. But it is certainly true that his method of working in these last works is rather different from that of his youth: While his early works are executed with a certain finesse and incredible diligence, and are made to be seen both from close up and from a distance, his last works are executed with such large and bold brushstrokes and in such broad outlines that they cannot be seen from close up, but appear perfect from a distance... it is obvious that his paintings are worked again, and that he has gone back over them with colors many times, making the effort evident. And this technique, carried out in this way, is judicious, full of judgment, beautiful, and stupendous, because it makes the pictures not only seem alive but also executed with great skill that conceals the labor.

— GIORGIO VASARI, 1568

Jupiter, the most powerful of the gods, is in love with the princess Europa. He has taken on the form of a beautiful white bull, and with seemingly tame behavior induced the girl to climb upon his back. As soon as she does, the bull makes for the sea and bears the terrified Europa from her native Sidon to the island of Crete, where he consummates his passion. Titian is unequivocal about the fact that this is a scene of rape: Europa is sprawled helplessly on her back, her clothes in disarray. At the same time, he conveys the mythic import of the story: that is, to be coerced by a god is no ordinary human experience of sexual violence. Rather, it is a terrifying but transformative experience of supernatural possession or ecstasy, which may have a positive outcome.

Much of what makes this painting so intriguing, and indeed disturbing for us today, is Titian's insistence on the paradoxical aspects of Europa's ordeal: the pathos of the victim also affords pleasure – hers, as well as the viewer's. Titian thus could be said to idealize rape, yet the painting is about more than sexual coercion. His artistic goal is also a psychological one. The challenge is to show a moment when a state of terror becomes a state of rapture: both are experiences of being "acted upon" – of being in the grip of forces that seem to possess one from the outside. In fact, the English language preserves the kind of association that inspired Titian's painting, in that the words *rape* and *rapture* share a common root in Latin.

Thus Europa is in the grip of a terrifying experience: snatched away from her home and family, she is precariously balanced on the back of the bull, in real danger of sliding to another terrible fate in the dark sea below. Titian has visualized the fearfulness of the deep with the two scaly, spiny ocean predators that gleam in the turbulent waters, the fanged mouth of one agape as it follows the thrashing motion of the animal. But something else is happening; the band of shadow across her upturned face makes us particularly conscious of Europa's rolling eyes, and the direction of their glance. Europa has caught sight of two cupids (*spiritelli d'amore* or little spirits of love), personifying another passion which is yet more powerful than that of fear. This notion is itself expressed by a third Cupid who rides (and, according to Renaissance visual conventions, has thus mastered) one of the monstrous fish. Titian confronts us with the perception that a person assailed by physical danger and panic can look like a per-

son in the extreme throes of·physical ecstasy: the limbs flail and the spine flexes, all modesty and self-composure are abandoned. Just as Europa scrambles desperately so as not to loose her position on the bull, so she turns her breast towards Cupid; her fear will yield to the arrows of the god of love.

She must, in fact, because she has no choice. Like the rape of Helen by Paris, this is an act of sexual coercion with historically portentous consequences: Europa's rape will literally give rise to Europe. From her union with Jupiter, Minos will be born, and the most ancient of European civilizations on the island of Crete. Her brother Cadmus, the inventor of writing, will search for her, and found the great ancient city of Thebes. The painting records no less than the birth of civilization.

It may have been these features of the myth of Europa that led Titian to select the subject for the most powerful prince in Europe, Philip II of Spain, ruler of a vast empire that included the Netherlands as well as possessions in the New World and Asia. It befitted Philip's status that he could command the services of the most celebrated painter in Europe, thereby also enhancing his own cultural prestige. The king owned no less than thirty paintings by Titian. For the most part, these were religious pictures: Philip saw himself as a champion of the Roman Catholic faith, and he is often remembered as a militant and notorious promoter of its mounting campaign to re-establish its supremacy in the face of Protestantism. Philip also supported the church's increasingly rigorous pronouncements on orthodoxy in faith and morals, which meant that the Inquisition could operate with sweeping authority within his dominions. Yet Titian also painted mythological subjects for this most austerely catholic of sovereigns. Known as *poesie* because their subject matter derived from the works of classical poets such as Ovid, these works were "pagan" both in their depiction of fables of the ancient gods and in their markedly non-Christian character. They are frankly sensuous and erotic, sometimes violent, and seem devised to highlight Titian's virtuoso treatment of the naked female body in a variety of situations and in a range of different poses. The series of *poesie* began in 1553 or 1554 with another portrayal of female forbearance in the face of divine rapacity: *Danae*, followed by *Venus and Adonis* (both in the Prado, Madrid), *Perseus and Andromeda* (1554–56, long thought to be the version in the

In this picture, oil painting has all its peculiar virtues, its power of realization, of suggesting to the imagination mass, solidity, resistance, and suggesting besides more perfectly than any other medium, the veritable surface quality of substances, the filminess of lines, the sheen of silk, and the elastic firmness of flesh....

He takes pagan mythology less seriously than in his youth. There is something of a half humorous irony in this rendering. He surely indulged a quick sense of humor in contrasting thus the magnificent forms – the heroic energy of Europa with the timid, mild-eyed bull who carries her off. Jupiter is here the nervous husband who, even in the rapture of his new amour, does not altogether forget the possibility of an explanation with Juno.

— ROGER FRY, 1907

Up to this moment Europa has not appeared; so the honeymoon delays; and I am gnawingly impatient.

— GARDNER TO BERENSON, 1896

I am breathless about the Europa, even yet! I am back here tonight after a two days' orgy. The orgy was drinking myself drunk with Europa and then sitting for hours in my Italian Garden at Brookline, thinking and dreaming about her. Every inch of paint in the picture seems full of joy. Mr. Shaw, Mr. Hooper, Dr. Bigelow, and many painters have dropped before her. Many came with "grave doubts"; many came to scoff; but all wallowed at her feet. One painter, a general sceptic, couldn't speak for all the tears! all of joy!!! I think I shall call my Museum the Borgo Allegro. The very thought of it is such a joy.

— GARDNER TO BERENSON, 1896

Wallace Collection, London, but possibly lost), *Diana and Actaeon, Diana and Callisto* (1559, Duke of Sutherland, on loan to the National Gallery of Scotland, Edinburgh), and the *Europa*, completed in 1562. As Titian told Philip in a letter of that year, the painting of Europa "set the seal" on the series of works he had made for the king.

What would Philip II want with such images? The idea that they were conceived for the king's private and purely sensual enjoyment is too simple, as is the notion that they provided him with a sexualized allegory of his own masculine authority through images of the dominated female body. Clearly they are not without an element of what one modern commentator has called "political titillation." Philip was, perhaps inevitably, compared to Jupiter by contemporaries, and stories of the power of gods – Diana or Jupiter – over mortals would have publicized an image of the irresistible mastery and unlimited prerogatives of an absolutist monarch. Yet Titian's approach to these subjects makes them no more reducible to the ends of propaganda than of pornography. There is always a dark side to his portrayal of the gods and their amorous and imperious ways that indicates a more questioning or ambivalent attitude.

The viewer is allowed no unalloyed erotic pleasure in the image of Europa; *eros* is there, but the viewer is reminded of the discomfiting proximity of the passions of eros with the perturbations of terror and of physical distress. Bravura brushwork produces a powerful sensation of air, water, and light, but also of the lurking monstrosity which materializes in the eddies of oil pigment that define the ocean waves. In her helplessness Europa evokes not only sexual enjoyment (the viewer's or her own), but the pathos of tortured martyrs and victims in Christian art, including those in Titian's own work. The head, raised right arm and upper torso are a self-quotation from the murdered wife of the *Miracle of the Jealous Husband* (Scuola di Sant'Antonio), painted a full forty-eight years before; a similar configuration occurs in the *Martyrdom of Saint Lawrence*, painted for the Venetian Church of the Gesuiti in 1548–57. Finally, viewers who knew their Ovid would know that in the *Metamorphoses* Europa is twice associated with criticism or ridicule of the almighty gods. Regarding Jupiter's bestial self-transformation, Ovid remarks that "Majesty and Love do not sit well together." In his account of the

weaving contest between the mortal Arachne and the jealous goddess Minerva, Arachne adds insult to injury by creating a superior tapestry showing the violent sexual crimes of the gods, including the stories of Danae and Europa. Ovid was also the source for the two stories of Diana in the series of *poesie* for Philip. In his account of how the goddess cruelly punished Actaeon for inadvertently stumbling upon her while she was bathing, or Callisto for the misfortune of being impregnated against her will by Jupiter, Ovid pointedly cast doubts on the justice of the gods in their relations with mortals. The Spanish court painter Diego Velázquez appears to have been struck by the analogy between Ovid's protest at divine rapacity and the tone of Titian's painting. When, seventy years later, he came to depict the story of Arachne, Velázquez reproduced Titian's *Europa* to stand for the tapestry of Arachne (see illus.).

Titian was no mere illustrator of Ovid. Instead he deliberately sought to compete with him, pitting the resources of painting against those of the word. The fact that Ovid had described Europa as the subject of a work of art only made this competitive dimension more charged. Just as classical writers had described paintings in order to illustrate the superior descriptive powers of language, so Titian responds competitively with the unparalleled vivacity of color and brushwork. Moreover, Titian did not merely draw upon easily available Italian translations of Ovid, he drew upon more rarefied texts such as that of Achilles Tatius. Titian alters some details and invents others of his own, and thus inserts his own work into a tradition of poets who had "portrayed" the story of Europa, which included not only Ovid and Tatius, but more recently the Italian poet Angelo Poliziano. In other words, Titian lays claim to the power of poetic invention on the order of these canonical ancient and modern writers.

Yet the desire to advertise artistic mastery does not preclude other concerns. In Titian's case, this encompasses a remarkable exploration of the psychology of human passion, the intertwined causes and effects of different emotional states. The viewer is asked to reflect on the consequences of unbridled expression of masculine libido on one hand (Jupiter), and on the effects of interdiction and renunciation on the other (Diana). It has been too readily assumed that the viewer only identifies with Diana and Jupiter; also available for identification are a series of emo-

The Fable of Arachne (detail), ca. 1656–58. Diego de Velázquez. Oil on canvas. Museo del Prado, Madrid.

Copy of Titian's Europa, 1628–29. Peter Paul Rubens. Oil on canvas. Museo del Prado, Madrid.

tional transformations defined by their victims: in the sixteenth century the experience of passion was an experience of being "acted upon" (*passio* meaning "I suffer," or "I undergo"). Thus Danae, Europa, Actaeon, and Callisto undergo states ranging from rapture to terror to bestializing transformation and disintegration of the self.

— STEPHEN J. CAMPBELL, 2002

Now, this story can be understood at many levels. At an exalted level, Jupiter is a god managing to, as it were, draw the soul into his embraces. After all, whatever the goings-on and the antics, Jupiter still was a kind of god. He was not, of course, God as we know him, but he was the greatest spiritual power the ancient Greeks knew. You can also take the story at a very base level: this was a virgin forcibly snatched from her life against her will. But Titian seems to take it somewhere in between. The whole set-up has the fresh scent of the salty water – the porpoises gamboling and all the little loves flying around getting excited. With those misty, unreal mountains behind, the noble and beautiful bull bears Europa out of the picture into an unknown future. All this suggests to me a young girl getting married, having her first experience of a new kind of physical love.

Where most artists show Europa either terrified of the bull or sitting there rather enjoying it, Titian shows her bewildered. The artist very cleverly does not show us her face clearly; just enough is revealed to see that she is baffled by this new experience. Her position is so ungainly: that clumsy sprawl, with legs almost thrashing about. It all seems so undignified, and of course, I think part of Titian's profundity is his depiction of a genuine coming-together in love – a lack of dignity is accepted. The exposure and the vulnerability are all part of a profound act of trust that each partner has in the other. Titian's Europa is rather baffled and uncomprehending, but goes ahead with it. This is a delightfully unusual presentation which is sensitive to both the physical and the spiritual understanding of the mystery of wedded love – shown in a glorious setting of sea and sky and adventure. All the fantasies of girlhood are left behind with her pink- and yellow-clad maidens. She moves out into real life, and now has to learn not to be a princess and stand on her dignity, but to be loving.

— SISTER WENDY BECKETT, 1998

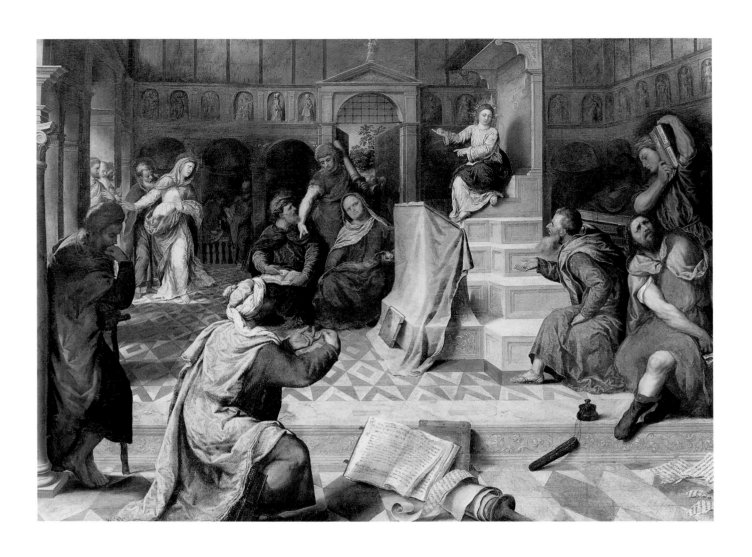

❧ *Christ Disputing in the Temple,* mid-1540s

PARIS BORDONE, Italian (Venice), 1500 1571

Oil on canvas, 163 x 229 cm, signed lower left: BORDONVS
Purchased in 1901 from J.P. Richter, through Berenson. Titian Room

It is only £1650, dirt cheap, & is a piece of Venetian colour the like of which is rare.

— BERENSON to GARDNER, 1901

But he who has imitated Tiziano more than any other is Paris Bordone, who, born in Treviso from a father of Treviso and a Venetian mother, was taken at the age of eight to the house of some relatives in Venice. There, having learned his grammar and become an excellent musician, he went to be with Tiziano, but he did not spend many years with him...

— GIORGIO VASARI, 1568

The subject of the painting is Christ Disputing in the Temple, the only event from Christ's childhood mentioned in the Gospels. The theme of religious debate offered a painter ample opportunity to portray a variety of puzzled and agitated facial expressions. Paris Bordone underscored the theme of Christianity's imminent triumph by making the brightly lit Christ Child the calm center of a composition of muscular figures in restless poses. Books and scrolls in simulated Hebrew lettering and a bell at the lower right lie in disarray. Punctuating this confusion is the very human expression of Christ's frantic parents who enter at the upper left; you can almost hear Mary whine, "We've been looking all over for you!"

A cautious painter who tended to react to developments in Venetian painting rather than initiate them, Paris Bordone trained under Titian and emulated Titian's style of the 1510s and 1520s — albeit in a more timid mode — for his entire career. This painting (which has been variously dated between the mid-1530s and 1545) seems indebted to a picture of the same subject by the young Tintoretto (Museo del Duomo, Milan), which must date from the early 1540s. Bordone's painting is typically Venetian in its layering of impasto to create a surface resonant with rich coloring, particularly in the costumes, whose folds have squirmy lives of their own. Characteristically Venetian as well is the way Paris improvised during the process of painting: major changes include shifting Christ from left of the central door to the right, altering the shape of the throne, and adding the decorated step in the foreground.

That Mrs. Gardner didn't always collect "names" confirms her status as a collector. Buying a picture by Paris Bordone would not have furthered her social position, nor the reputation of her collection. Rather, she selected this masterpiece by a second-tier artist in order to provide context for paintings by more famous artists, especially Titian's *Europa,* and also for its intrinsic beauty and drama. Gardner bought the picture from J. P. Richter, a noted scholar of Leonardo da Vinci, who also had a reputation as a dodgy dealer. Yet Richter certainly had an eye for quality; he sold Mrs. Gardner her painting by Giotto.

— FREDERICK ILCHMAN, 2002

❧ *Crucifix,* ca. 1600

FRANCESCO TERILLI, Italian (Venice), active 1596–1633

Ivory, 28 x 24 cm, signed on back: F.T.F.
Purchased in 1884, through Ralph Curtis, in Venice.
Long Gallery Chapel

Ivory is an ideal material for small devotional sculptures: its resiliency permits fine detailing while its natural translucency imparts a gleaming aura to objects. Terilli specialized in carving ivory crucifixes: at least eight survive. They date from around 1600 onwards, placing them at the beginning of the Baroque taste for ivory crucifixes, which became especially strong in Flanders and southern Germany in the course of the seventeenth century.

Ralph Curtis found this crucifix in Venice for Mrs. Gardner. She placed it in her boudoir in the Beacon Street house. At Fenway Court it was placed on the altar in the Long Gallery Chapel, in front of the Soissons window (p. 26).

The ivory Christ is a work of very rare *artistic merit, of sentiment, and execution, and also has that lovely* patina, *that bloom which only old age gives to inanimate objects, while producing contrary effects on us poor humans. It is truly a thing of beauty and I hope it will prove to you a joy forever…. The [Princess] Metternich used great seductions to induce me to pass it over to her, as you were not a Catholic "and surely in* Boston *they couldn't appreciate that chef d'oeuvre d'art." I replied, "Chez Madame altro que!" [with Madam, it would be indeed]*

— RALPH CURTIS to GARDNER,
1884

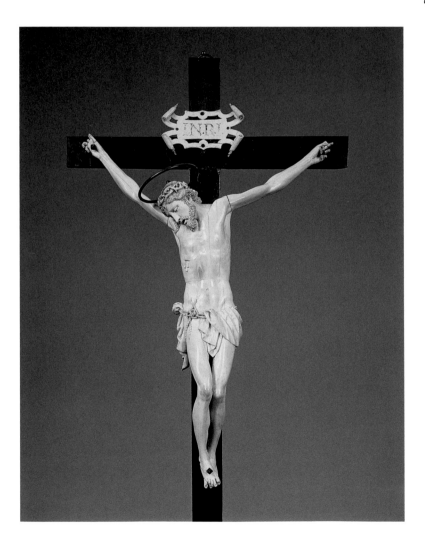

ॐ *Return From the Lido,* 1884

RALPH CURTIS, American, 1854–1922

Oil on canvas, 74 x 142 cm, signed lower right: R.CURTIS. 84.
Purchased in 1885 from the artist. Blue Room

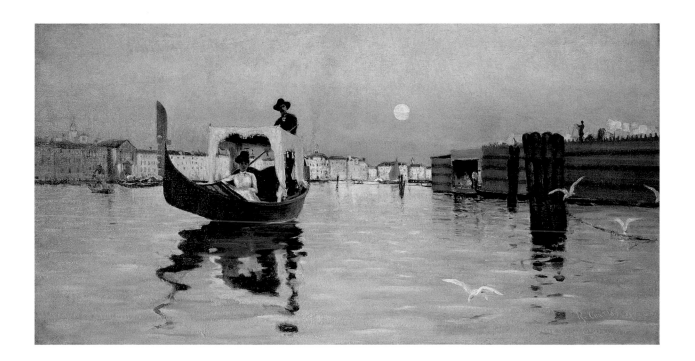

Ralph Curtis was the son of Daniel and Ariana Curtis, Bostonians who moved permanently to Venice in the late 1870s. After graduating from Harvard (where he was one of the founders of the *Lampoon*), Curtis studied in Paris at the studio of Carolus-Duran. There he met John Singer Sargent, a distant relative, who became a good friend and sometime painting companion. Curtis met Isabella Stewart Gardner in 1884, when the Gardners spent five weeks in Venice. Thereafter, they met and corresponded frequently. Curtis found works of art for Mrs. Gardner, wrote about developments in the art world, and kept her up-to-date on "gondola gossip" in Venice.

Ralph Curtis's painting of a gondola gliding through Venice must have held special meaning for Mrs. Gardner. Like the woman depicted, she and Curtis spent many hours in each other's company floating through the canals. The slight touches of purple through the sky and in the water, along with the mysterious faces of the woman and her gondolier, add the perfect tone of languid, exotic atmosphere to the scene.

— RICHARD LINGNER, 2002

❧ Strolling and Seated Lovers

Flemish (Brussels), ca. 1585–1600
Wool warp, wool and silk wefts, 470 x 429 cm
Purchased in 1903 from Mrs. Charles M. Ffoulke, Washington.
Little Salon

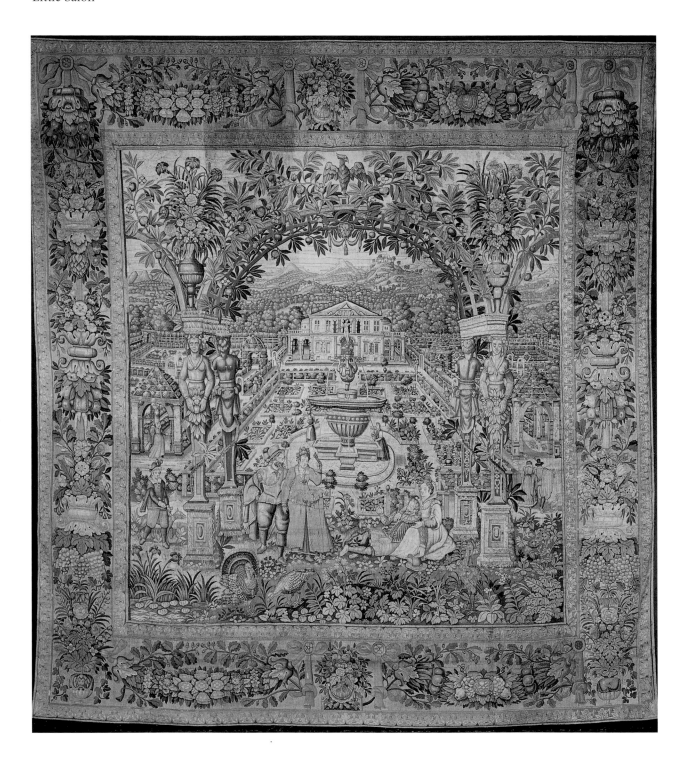

✎ Textiles

*The juxtaposition of oil painting and cou-
ture fabric in the Titian Room (p. 74)
nicely levels the distinction between high
art and fashion, and permits us to notice
that both the painting and the fabric are
flat surfaces. The presence of the Worth
silk beneath the Titian painting flattens
the Titian, reduces it to the two-dimen-
sionality of fabric, despite the painting's
claims to three-dimensionality. Similarly,
the painting raises the fabric to the status
of art, and also elevates fashion – too
often derided because of its association
with women and gay men – to the realm
of high artistic practice. The Gardner
Museum as a whole becomes a costume of
Mrs. Gardner's, a costume that the visitor
can also put on. The museum becomes a
fanciful item of apparel, a feminine
scheme intended to mesmerize and sub-
vert.*

— WAYNE KOESTENBAUM, 1996

ISABELLA Stewart Gardner's love of textiles can be felt through-
out her museum: every gallery at Fenway Court is adorned with
significant examples of tapestry, lace, embroidery, velvet, or
damask. Textiles can be found used in expected ways, such as wall
coverings, tapestries, and upholstery, but occasionally Mrs.
Gardner grandly framed fabrics, while others were casually
draped over furniture, piled up in display cases, or placed behind
paintings – adding sumptuous textures to the rooms, as well as a
sense of informality. In some galleries, fabrics were layered onto
the wall, imparting a patch-work quality. This treatment of fabric
was more typical of artists' studios than museums, and Mrs.
Gardner seems to have emulated the casual and eclectic aspect of
the Bohemian artist.

There is also an undeniable feminine quality to Gardner's
interest in textiles. Friends and acquaintances report that Mrs.
Gardner cut a fashionable figure, and was especially attentive to
the luxurious silk brocades and damasks used by the best dress-
makers. She installed one of her favorite Worth gowns under her
beloved painting by Titian (see p. 74).

Her world travels brought Gardner into contact with exotic
costumes and materials. Her journals and letters continually
describe textiles, often glimpsed in religious rites or ceremonial
processions. In Egypt, she exclaimed, "oh, their gorgeous clothes!"
– a sentiment echoed in Japan in 1883, when she noted, "their
clothes are delicious, so soft in colour and fabric," while "rainbow-
clad beings" were spotted in Beijing. Authenticity in dress was
essential: in Cambodia Gardner was shocked by "a horrible con-
trast between the 'savage' Cambodians and the dreadful
Frenchwomen in cheap finery." On these trips, like any good
tourist, Gardner bought silks, sarongs, and laces. In Boston, her
collecting interests became more serious. In 1872 she found a set
of large tapestries to decorate her house on Beacon Street; after
1896 she bought lace, embroideries, and velvets in large quantities
from dealers across Europe.

In 1905, Mrs. Gardner bought ten large tapestries that had
once hung in the Barberini Palace, Rome. Together with other
new acquisitions, this forced a large-scale reconfiguration of the
Gardner Museum, and an expansive new Tapestry Room was cre-
ated in 1915.

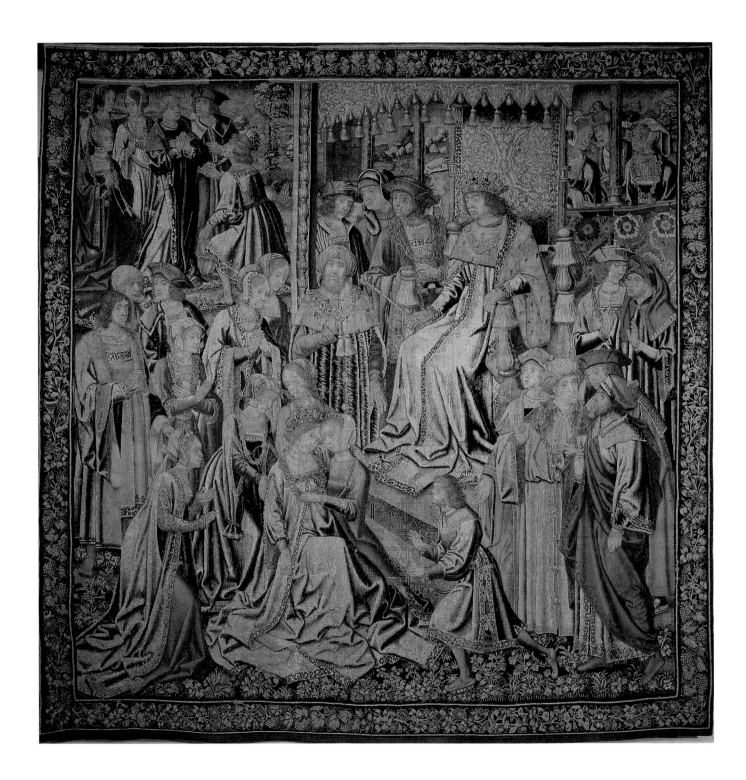

∾ Esther Fainting before Ahasuerus

Flemish (Brussels), ca. 1510–25
Wool warp, wool and silk wefts, 347 x 335 cm
Probably purchased in 1897 from Rousset, Paris.
Third Floor Stair Hall

Because the story of Esther offered rich opportunity for the representation of dramatic gesture and movement, as well as the display of sumptuous and exotic settings, costumes, and props, it made an ideal subject for tapestry designers. European weavers produced Esther hangings from at least the fifteenth through the eighteenth century; the compositions constantly changed, reflecting successive styles in the art of painting.

— ADOLPH CAVALLO, 1986

The tapestry depicts a scene from the Book of Esther (in the Apocrypha), in which Esther, the Jewish queen of Persia, pleads before her husband Ahasuerus for the repeal of his decree ordering the massacre of all Jews in his kingdom. Esther swoons on the arm of one of her handmaidens at the lower right – a reaction to the king's initial rage at seeing her before the throne, a violation of his rule that no one come to him unbidden. However, God softened his heart, and Ahasuerus holds out his golden scepter to welcome her forward. Ahasuerus had been urged to issue the decree by Haman, a courtier opposed to Esther and her people; he stands to the king's right beside the throne. In the upper left corner of the tapestry, a messenger brings news of Esther's success to a gathering of the Jewish people. The repeal of the decree, and thus the salvation of the Jews, is celebrated each year as the festival of Purim.

The tapestry is a virtuoso display of design and weaving. Thirty-three figures are depicted, all wearing different, elaborately detailed outfits. The background varies from rich landscapes to interiors adorned with patterned velvets and brocades. The borders are equally elaborate; the stalks of fruits and flowers are typical of tapestries woven in Brussels at this time.

— RICHARD LINGNER, 2002

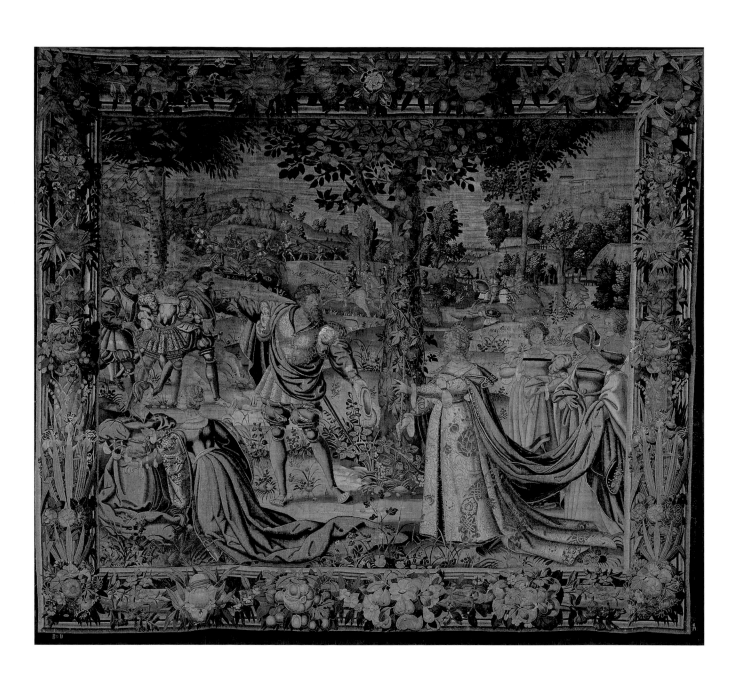

Queen Tomyris Learns that Her Son Has Been Taken Captive by Cyrus

Workshop of JAN VAN DER MOYEN

Flemish (Brussels), ca. 1535–50
Wool warp, wool and silk wefts, 402 x 461 cm
Purchased in 1903 from Mrs. Charles M. Ffoulke, Washington.
Tapestry Room

When Tomyris heard what had befallen her son and her army, she sent a herald to Cyrus, who thus addressed the conqueror: "You bloodthirsty Cyrus, pride not yourself on this poor success. Restore my son to me and get you from the land unharmed.... Refuse, and I swear by the sun, the sovereign lord of the Massagetai, bloodthirsty as you are, I will give you your fill of blood."

— HERODOTUS, 5th century BC

This tapestry belongs to a series of five depicting scenes from the life of Cyrus the Great, legendary founder of the Persian empire. Herodotus tells of an attack by Cyrus on a distant land ruled by Queen Tomyris. Cyrus sacrificed a portion of his army to entrap the enemy by leaving them behind feasting on a large banquet. Tomyris's troops, led by her son Spargapises, attacked Cyrus's decoy troops, then stopped to consume the remains of the food and wine. Cyrus ambushed them and captured the queen's son. Although Cyrus freed Spargapises, he immediately took his own life.

In revenge, Tomyris led her troops against Cyrus. After defeating his army, she searched the battlefield for Cyrus's corpse and exacted her vengeance by dipping the body in blood – giving him his "fill of blood" as she had vowed. Grand gestures and elaborate costumes were frequently employed in tapestry design. The figures are expertly situated in a landscape, which serves as the setting for other elements of the story: Spargapises is held captive at the left; a battle rages farther back.

— RICHARD LINGNER, 2002

Among the most luxurious silk textiles produced in Europe, velvets are fabrics woven with an additional warp, which creates a plush pile surface. Patterns are made by leaving portions of the design free of pile (called voided velvet). Combining cut and uncut pile loops produces contrasts in both color and texture. This technique (called ciselé velvet) embellishes the design since cut pile appears darker than the uncut pile. (For Islamic velvets, see pp. 167, 171.)

Velvets made in Italy during the sixteenth and seventeenth centuries displayed unusual colors and interesting textures. Decorated velvets were often used for garments and interior furnishings such as drapery and wall hangings. In these situations, velvet catches light in various ways, revealing subtle gradations of color.

— KATHY FRANCIS, 2002

Italian or Spanish, ca. 1600–25
Silk: ciselé voided velvet, 44.4 x 39.3 cm

Italian or Spanish, ca. 1550–1600
Silk: ciselé voided velvet shot with gilt yarn, 17.8 x 74.9 cm

Italian (Genoa?), 1700–25
Silk: ciselé voided velvet, 129.5 x 51.1 cm

Italian or Spanish, ca. 1600–25
Silk: ciselé voided velvet shot with gilt yarn, 120.6 x 73 cm

➷ *Lace*

Long prized for its delicacy and open patterns, lace is produced by manipulating threads independent of a base fabric. It is usually made of linen thread, but other materials can be used. Needle lace is traditionally made by placing threads on a pattern drawn on parchment; the gaps between these guide threads are then filled with stitches using a needle and thread. The second principal type of lace is called bobbin lace, since thread is wound onto spools, or bobbins. The threads are then woven or twisted together around pins inserted onto a pillow.

The collecting of lace became popular in the late nineteenth century, and around 1900 most American museums displayed lace. For example, Thomas Wilson, an anthropologist, formed a lace collection of more than a thousand pieces, which was exhibited in 1893 at the World's Columbian Exposition in Chicago, where Mrs. Gardner must have seen it. Wilson's collection was later acquired by the Cleveland Museum of Art. Many museum leaders believed that examples of historic lace would be relevant to workers in the textile industry.

The lace panel (lower right) is a rare piece of *point de France*. The patterns allegorize Louis XIV's political and military power. The piece consists of more than nineteen individual fragments, which have been skillfully sewn together to create a continuous panel of great delicacy. Mrs. Gardner also collected examples of folk art, as seen in the drawnwork lace. Using nothing more than plain, undyed cotton and thread, the maker of this piece created a textile of great imagination and whimsy.

— BONNIE HALVORSON, 2002

Nowhere is Isabella Stewart Gardner's remarkable discernment more evident than in the collection of laces. Exercising unusual skill in selection, she chose from among the thousands of examples available to her some two hundred pieces of lace whose varied character, high quality and broad representation of the history of European lacemaking must excite the admiration (and envy) of every textile collector and the delight of every visitor to the Museum.

— ADOLPH CAVALLO, 1986

Lace case, Veronese Room

Flounce for an Alb
Flemish (Mechlin), ca. 1750–1800
Linen, 340.4 x 25.4 cm

Drawnwork Lace
Scandinavia (?), 1800s
Cotton, 30 x 95.5 cm

Lace Panel
French (Paris), ca. 1675–1700
Linen, 193 x 40.2 cm
Purchased in 1897 from Lady Kenmare.

Ida Rubinstein as Saint Sebastian, 1911

LÉON BAKST, Russian, 1866–1924

Pencil and watercolor on paper, 28.5 x 21 cm
Signed lower right: Bakst / 1911; inscribed at top: St. Sébastien II
acte / Mme Ida Rubinstein
Purchased in 1914.

Anna Pavlova in the Ballet "Oriental Fantasy," 1913

LÉON BAKST

Pencil and watercolor on paper, 31 x 24 cm
Signed lower right: Bakst / 1913; inscribed at upper right: Ballet
Hindou / Pour A. Pavlova
Purchased in 1914.

Born Lev Rosenberg to a middle-class Jewish family in Belarus, Léon Bakst studied art in St. Petersburg and Paris. His close collaboration with the dancer and choreographer Serge Diaghilev resulted in striking costumes and scenery for the Ballets Russes. Drawing on folk art, Middle Eastern, and Asian motifs, Bakst's sensuous designs caused a sensation throughout Europe.

In 1911, the celebrated dancer and actress Ida Rubinstein (1885–1960) produced a ballet in Paris called *Le Martyre de Saint Sébastien*. With a book by Gabriele D'Annunzio, music by Claude Debussy, and choreography by Michel Fokine, the ballet was one of great triumphs of the period. The top drawing is a costume study for Rubinstein, who reportedly stunned Paris audiences with her poignant acting. The drawing below is a costume design for the equally celebrated ballerina Anna Pavlova (1881–1931) in the production of *Oriental Fantasy* (also called *Ballet Hindu*), which opened in London in October 1913, and was performed later that same month in Boston.

Isabella Stewart Gardner's passion for music and dance nearly equaled her interest in the visual arts. The avant-garde dancer Ruth St. Denis performed at Fenway Court in 1906, and these drawings present further evidence of Mrs. Gardner's interest in performance. Both drawings were purchased in 1914 at a touring exhibition of Bakst's drawings held at the Boston Art Club.

— ALAN CHONG, 2002

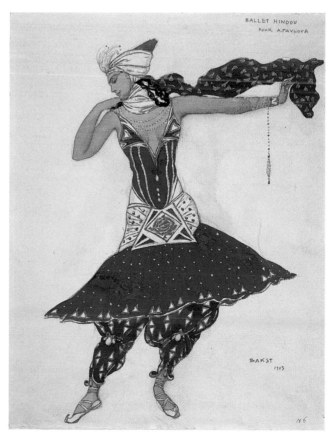

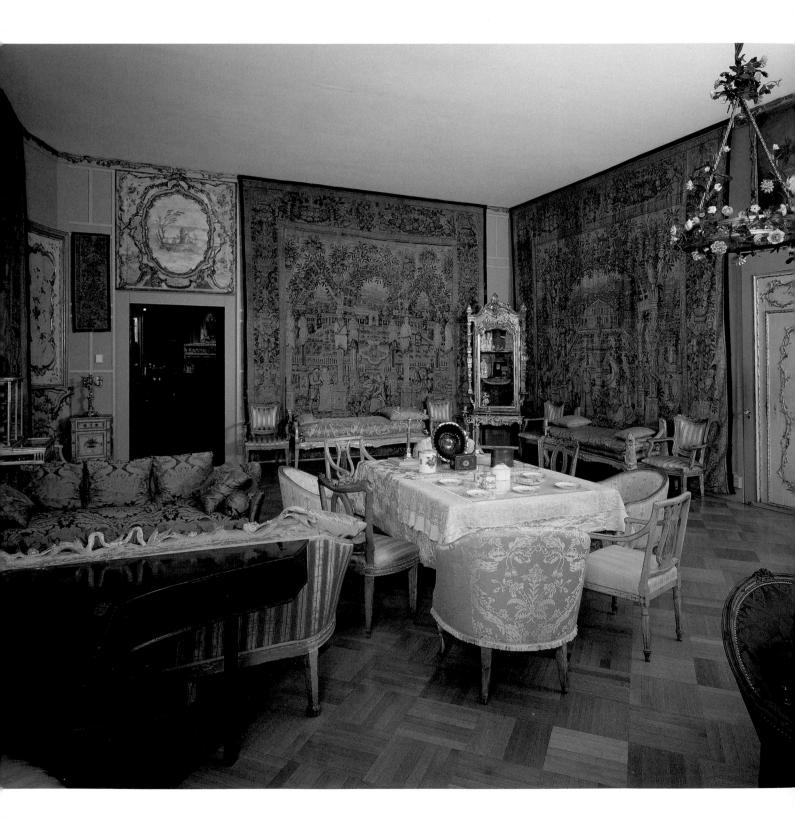

❧ *Decorative Arts*

The Little Salon

O NE of the most intimate spaces in the museum, the Little Salon combines the whimsy of the Rococo with the dense layering characteristic of Mrs. Gardner's own Victorian age. The room also evokes her roles as a society hostess and a supporter of artists. The seating arrangements seem ready to welcome interesting individuals, who might then spend an afternoon together in spirited conversation. A table set for tea, an abundance of comfortable chairs, and even an assortment of musical instruments ready to be taken up, suggest the hospitality for which the museum's founder was justly famous.

The walls of the room – covered by four large garden tapestries (see p. 112) and painted wooden panels carved with delicate floral designs – seem to dissolve into the informality of an outdoor setting. Plants and flowers curl around or sprout from most of the objects in the room, from chairs and cabinets to wall sconces, candlesticks, lamps, and clocks.

While other galleries present masterpiece paintings for quiet contemplation, the arrangement of the Little Salon provides a very different experience. The many cases in the room are filled with a range of objects that vie for the viewer's attention. The imposing upright Italian cabinet displays exquisite ceramic objects that reflect eighteenth-century French taste for bucolic images. Tucked on one of the shelves is a portrait miniature of Marie Antoinette, who typified the delights and excesses of the period.

Another small vitrine holds an array of small objects, mostly gifts from friends and admirers, as well as mementos from her world travels. Gardner's delight in juxtaposing objects from different cultures is evident here: a silver elephant from Burma, an ancient Egyptian necklace, and a series of Japanese medicine boxes. On the other side of the room, Mrs. Gardner invites the viewer to contrast the subtle luster of Japanese lacquerware with the sparkle of jewelry from India and elsewhere. The jewelry case also holds one of Mrs. Gardner's most precious personal treasures: a locket with a photograph of her infant son. The Little Salon reminds us that even the smallest object can lead the thoughtful viewer to a whole world of meaning.

— MARGARET BURCHENAL, 2002

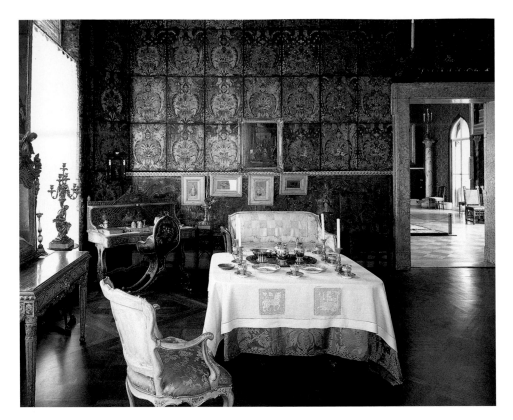

The Veronese Room

The walls of the Veronese Room are covered with an extraordinary and sumptuous type of wall hanging: gilt leather. Gilt leather was produced in many European countries from the early Middle Ages on. At first, Spain was the leading producer of decorated leather, but by the sixteenth century, Venice had become a major center of production, and in the seventeenth century, the Netherlands took the lead role. Immensely prestigious, gilt leather was made for courts, religious institutions, the nobility, and the well-to-do. Gilt leather competed with other expensive and luxurious wall hangings such as silk fabrics and tapestries.

Isabella Stewart Gardner acquired her gilt leather from various dealers between 1892 and 1901. The decoration of the Veronese Room is like a huge collage. Panels from different sources, including several altar frontals, were combined on the walls, suggesting that Mrs. Gardner found the variety of patterns, sizes, and colors more satisfying than a uniformly patterned wall covering.

— ELOY F. KOLDEWEIJ, 2002

Leather wall hangings were produced by tanning leather and cutting it into appropriately sized panels. Silver leaf was applied to the smooth side of the leather with gelatin or parchment size. The silver surface was burnished and then coated with layers of yellow-tinted varnish. It is this tinted varnish that imparts a golden appearance. Less expensive silver leaf was used to cover such large surfaces.

In the seventeenth-century Netherlands, new technologies advanced the production of gilt leather. In particular, wood embossing presses facilitated the stamping of relief ornamentation. Netherlandish leather was generally embossed after it had been silvered and varnished. The surface was then painted with designs. By contrast, most Italian and French leather was first painted freehand, then the relief decoration was applied with small heated punch tools made of iron. In all of these cases, the paints were either opaque oil paint, or more translucent paints created by mixing oil paint with varnish resins.

— VALENTINE TALLAND, 2002

Tankard: *Annunciation to the Shepherds, Nativity, and Adoration of the Magi,* late 1600s

JAKOB BECKHAUSEN, German (Danzig), active 1678–1705

Silver, partly gilded, 21 cm high, diameter of base 19.5 cm, with marks of Danzig and the maker
Purchased from the dealer A. Clerle, Venice, 1892. Dutch Room

In the seventeenth century, important works in silver were produced throughout Germany and the surrounding region, testifying to local wealth and the taste for precious objects. In the Hanseatic cities around the Baltic Sea, large covered tankards were a favorite form of silver for civic institutions. The scenes from Christ's infancy are derived from Flemish or German pictorial works.

Italian (Rome), 1760s
Gilded and painted wood, 108 cm high
Purchased in 1892 from the auction of the Palazzo Borghese, Rome.
Titian Room

These fine chairs were probably made in Rome for the Borghese family. The chairs combine a wide variety of motifs and sources, from the rich shell patterns typical of the Rococo, to the repeating discs familiar from Neoclassical furniture. The remarkable strength and intricacy of the carving in places emulates cast bronze, while details such as the brackets at the base of the back directly echo ancient Roman motifs. Some of the decorative elements anticipate the furniture designs of Giambattista Piranesi. The richly painted bouquets of flowers, enlivened with insects and small animals, are an unusual addition to gilded chairs of this type. On one chair, the painting is signed "L. Moro" – an artist not yet convincingly identified.

— FAUSTO CALDERAI, 2002

The little lady is of an energy! She showed me yesterday at Carrer's her seven glorious chairs (the loveliest I ever saw); but they are not a symbol of her attitude—she never sits down.

— HENRY JAMES, 1892

I am so glad to hear the Borghese chairs are safe. You should put those in your will for the Museum to be kept under glass. Lots of people have asked me about their health and happiness – and I learn with real joy that they escaped the baggage smasher.

— RALPH CURTIS to
JACK GARDNER, 1893

∿ *Chairs*

Italian, mid-1700s
Painted and gilded wood, 109 cm high
Early Italian Room

The slats on this set of chairs are delightfully painted with figures in exotic ancient Middle Eastern, African, or Asian garb. Although painted furniture is often connected with Venice, the chairs possess an unusual mixture of stylistic forms and decorative designs, and may have been made in central Italy, perhaps Lucca or Rome.

Isabella Stewart Gardner first placed the chairs in her Chinese Room (p. 174), where they accorded beautifully with the eclectic mixture of Japanese and Chinese objects, as well as nineteenth-century paintings. They are now arranged among painted cassone and altarpieces. Gentile Bellini's *Seated Scribe* (p. 96), displayed in the same gallery, strengthens the links between the arts of Italy and the East.

— FAUSTO CALDERAI, 2002

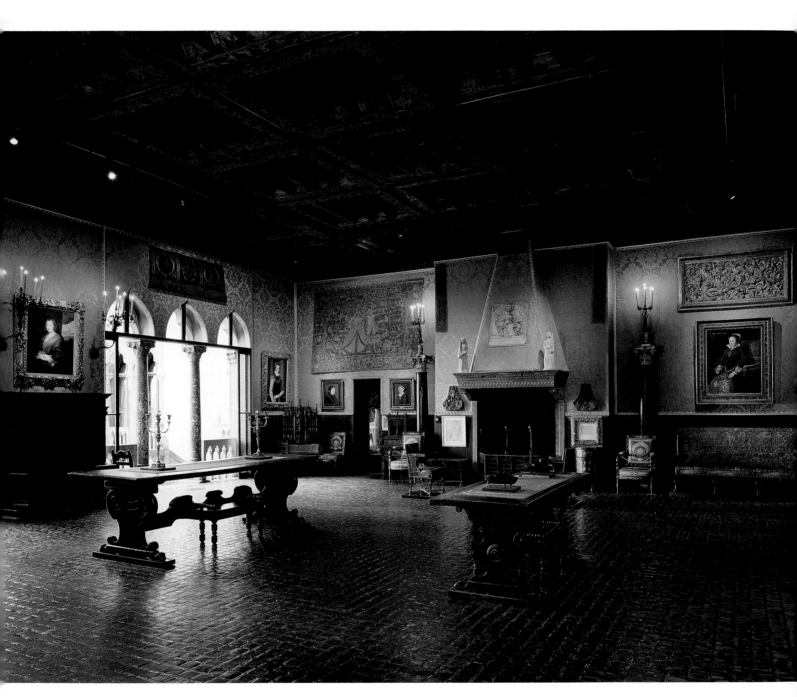

The Dutch Room

The Art of Northern Europe

The Theft

On the night of 18 March 1990, thieves dressed as policemen entered the Gardner Museum and stole thirteen works of art. These included paintings by Rembrandt, Govaert Flinck, Johannes Vermeer, and Edouard Manet; five drawings by Edgar Degas, a print by Rembrandt, and an ancient Chinese bronze vessel. The largest art theft in recent history, the event has become notorious, and has encouraged widespread speculation. However, the theft is a painful loss, not just because of the value involved, or because the museum is missing much-loved works of art, but also because their absence is so deeply felt by the entire art world. These important and beautiful works of art are truly a legacy of civilization; they have inspired visitors and creative minds for hundreds of years and are now cut off from their audiences. It would do our unruly and untidy world a great service to return them to an appreciative and loving public.

— ANNE HAWLEY, 2002

In 1892, Isabella Stewart Gardner bid on and purchased Vermeer's *Concert* at a Paris auction. We can only guess at her reasons for buying this masterpiece, as she had previously shown little interest in Dutch painting. The work had belonged to the famous critic Théophile Thoré, who wrote extensively on Dutch art and was responsible for the revival of interest in Vermeer. Mrs. Gardner happened to be in Paris at the time of the sale, and her interest may have been piqued by the celebrity of the former owner. She certainly relished the intrigue that accompanied a major auction. Years later, she told of inspecting the painting surreptitiously so as not to arouse interest, and of signaling her bidding agent with a handkerchief. Sargent and Whistler joined her for a dinner to celebrate the purchase.

Four years later Gardner bought Rembrandt's self-portrait, and her museum project was underway. By 1898, she owned paintings by Rubens and van Dyck, as well as another major Rembrandt painting. However, once these major purchases had been made, and the "Dutch Room" filled, Gardner lost interest in Netherlandish art. Surprisingly, although she had four paintings attributed to Rembrandt, she confessed that she never really loved the artist. Nor did she pursue works by other Dutch painters of seascapes, landscapes, or genre scenes (save for a work attributed to Gerard ter Borch), although these categories were greatly favored by American buyers of the time, such as Henry Frick, Peter Widener, and John G. Johnson. But Gardner had no desire to duplicate the contents of an English country house; her true interests lay elsewhere, in Italy.

The Self-Mortification of Saint Benedict, ca. 1496

Designed by ALBRECHT DÜRER, German, 1471–1528

Made in Nuremberg, Germany
Stained and painted glass, 22.5 x 16.3 cm
Purchased in 1875 from A. Pickert, Nuremberg. Spanish Chapel

This window depicts an episode from the life of Saint Benedict (ca. 480–547). Satan, in the form of black birds, flutters around the saint. The young saint overcame his sexual desires (represented by the woman seen at the right) by throwing himself into a thorn bush. Albrecht Dürer shows Benedict lying in a thicket, deep in prayer.

In 1496, Dürer made drawings for twelve stained glass panels narrating the life of Saint Benedict. Appropriately, they were made for the Benedictine abbey of Saint Aegidius in Nuremberg. Each design prominently displays the arms of the families who paid for the panels, which were probably made to celebrate a marriage. In the Gardner Museum's stained glass panel, the arms are those of the Waldstromer family.

Dürer was widely celebrated for his prints and paintings, but he also designed other objects, including sculpture, metalwork, and stained glass. His brilliance as a graphic artist shows itself in the stained glass produced from his patterns. Strong and expressive figures are set into a lively landscape of variously shaped trees and rocky forms. Dürer produced clear drawings, created with parallel or crossed lines, for the inspection of patrons, and for glass painters to trace and copy onto glass. The drawing for this stained glass panel is in Darmstadt

This stained glass panel, along with six windows from Milan Cathedral, was among the very first art objects acquired by Isabella Stewart Gardner.

— ALAN CHONG, 2002

Annunciation

The Annunciation traditionally marks the beginning of the Hours of the Virgin (Matins) and shows the archangel Gabriel explaining to the Virgin Mary that through the Holy Spirit she will be the mother of God. Typical of the artist are the porcelain-smooth, youthful faces of the Virgin and angel within a Renaissance-style domed space.

Adoration of the Magi

This image, marking the Hour of Sext of the Hours of the Virgin, shows the three magi (wise men, known as kings), who had followed the star, offering gifts – gold, frankincense, and myrrh – to the infant Christ, gently held by the Virgin. The richly dressed kings fill most of the space in the ruined stable; their gold-armored guards glower in the left background.

Book of Hours, ca. 1515

JEAN BOURDICHON, French (Tours), 1457–1521

Illumination on parchment, page size 16.7 x 10.5 cm
Purchased in 1890 from Consiglio Ricchetti, Venice.

David Penitent

David, wearing the crown as king of
Israel, and with his harp at his side,
repents his causing the death of Uriah in
order to marry Uriah's wife Bathsheba.
David looks up at an angel who holds
arrows of destruction.

Court painter to four kings of France, Jean Bourdichon was best
known for manuscript illumination of exquisite refinement and
cosmopolitan sophistication. His books of hours mark the transi-
tion from the Middle Ages to the Renaissance. Such richly deco-
rated prayer books were favored by royalty, nobility, and the rich
merchant classes who continued to prefer manuscripts to printed
books as aids to their daily devotions.

The *Book of Hours* in the Gardner Museum has remained
virtually unstudied. A late work by Bourdichon, it is characterized
by ambitious Italianate frames that enclose the main illumina-
tions. The book nonetheless remains intimate and private, the
delicately colored scenes compelling close inspection.

— MYRA ORTH, 2002

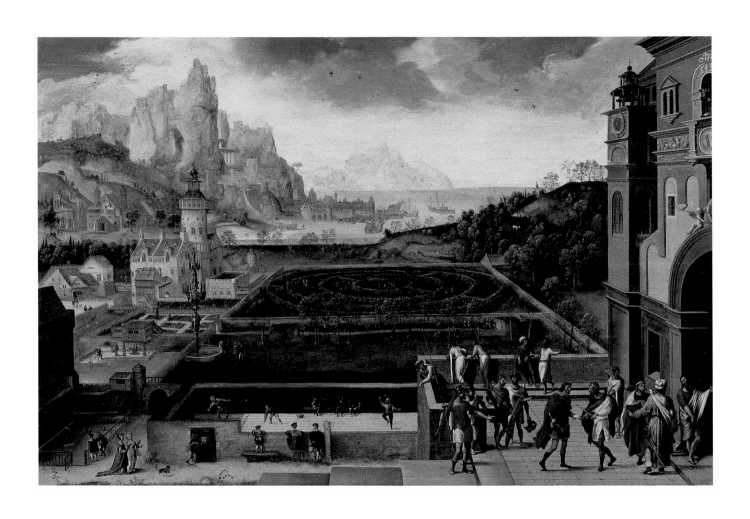

Landscape with David and Bathsheba, ca. 1535–40

HERRI BLES, Netherlandish, ca. 1510–after 1550

Oil on wood, 46.2 x 69.2 cm
Purchased in 1895 at an auction at Sangiorgi, Rome.
Veronese Room

François Rabelais concludes his famous Gargantua *(which appeared in October 1534) by describing the abbey of Thélème, an ideal community where one could freely enjoy all the pleasures of life according to the principle "Do what you want." Nearly all of the delights described by Rabelais are paralleled in this painting. The similarities are too numerous and the relationships too precise to be coincidental: a fountain with the Three Graces, a swimming pool with three levels, a pleasure garden with a maze, fruit trees, a tennis court, an archery range, falconry, and a game park. These facilities could almost be those of a modern vacation resort. Rabelais enumerates the joys of nature and of sport, while Herri Bles might have designed the resort's advertising brochure.*

— LUC SERCK, 1990

Tucked into this rich landscape are several episodes from the story of David and Bathsheba (2 Samuel). In the arched window at the upper right, King David, wearing a crown and holding a scepter, watches Bathsheba bathing in the pool at the opposite corner of the painting. On the terrace below, David appears again. He hands to Bathsheba's husband Uriah a letter sending him to his eventual death.

This biblical episode concerned with illicit love and flirtation has been set in a sixteenth-century park equally redolent of courtly love. An elaborate Renaissance palace overlooks a pleasure garden peopled with aristocrats, courtiers, and jesters. Spectators watch a game of court tennis in a walled enclosure in the foreground. In the middle distance is a topiary maze; beyond, deer are being hunted. A vibrant seaport is nestled under the distant mountains. The very complexity of this courtly landscape compels attention. Our eyes wander through the scene, searching out curious and delightful incidents. The minuteness of the details challenges us to identify the biblical narrative. Rather than overwhelming the story of David and Bathsheba, the landscape setting reinforces its significance.

— ALAN CHONG, 2002

Portrait of Thomas Howard, 2nd Earl of Arundel, 1629–30

PETER PAUL RUBENS, Flemish, 1577–1640

Oil on canvas, 122.2 x 102.1 cm
Purchased in 1898 from Colnaghi, London, through Berenson.
Dutch Room

One of the four evangelists and a supporter of our art.

— RUBENS, on the
EARL OF ARUNDEL, 1620

You never knew I think, what a pang I had long ago when I had to give up the Rubens, because I had bought the Titian. I wasn't so deep dyed then, and never thought or knew what depths debt had! Well, ever since, I have longed for that picture, and have had an eye on it; so the other day when I heard from people in England that Benson was buying it for a friend of his, I simply couldn't bear it — and you know the rest!

— GARDNER to BERENSON, 1898

Thomas Howard, 2nd Earl of Arundel (1585–1646), was one of the greatest connoisseurs and collectors of the seventeenth century. As a young man, he traveled to Flanders, where he first met Peter Paul Rubens, and to Italy, where he amassed a remarkable collection both of modern paintings and drawings, and of ancient sculpture. Arundel enjoyed a distinguished career as a diplomat and statesman in the service of Charles I until he suffered a humiliating defeat as general in 1638. He retired to the Netherlands shortly thereafter, and died in Italy in 1646.

Rubens's magisterial yet warmly observed likeness of the earl conveys the mutual respect that developed between the accomplished and erudite painter and his powerful patron. Rubens had already painted the earl's wife, Alathea Talbot, in 1620. Nine years later, when the artist came to London on a diplomatic mission, he renewed his friendship with Arundel. He was particularly eager to study the ancient sculpture and inscriptions in Arundel's collection, and wrote enthusiastically of them, "I confess that I have never seen anything in the world more rare, from the point of view of antiquity."

Much as he admired (and to some extent sought to emulate) the earl's impressive accomplishments as a collector and humanist, Rubens chose to represent Arundel as a warrior, in armor, wearing the Order of the Garter, and holding the gold baton symbolic of his role as Earl Marshal of England. In this hereditary post, Arundel presided over the country's nobility and upheld its traditions of chivalric honor. Rubens's imposing likeness conveys not only the pomp and ceremony associated with this office, but also the earl's innate reserve and haughty demeanor.

Rubens probably left this portrait unfinished when he returned to Antwerp in March 1630. Much of the figure below the waist, the background, and the area to the left were only summarily sketched in by the master, and subsequently completed by another hand. Nonetheless, Rubens's brilliant brushwork and the vivid characterization of his distinguished subject fully justify Isabella Stewart Gardner's passionate pursuit of the painting for her collection.

— MARJORIE E. WIESEMAN, 2002

Portrait of a Woman with a Rose, ca. 1635–39

ANTHONY VAN DYCK, Flemish, 1599–1641

Oil on canvas, 101.5 x 79.5 cm
Purchased in 1897 from Colnaghi, London, through Berenson.
Dutch Room

The sitter crosses her arms in enigmatic fashion, and holds a rose casually between her fingers; the flower may symbolize the pleasures and pains of love. The delicate silvery tones and the billowing drapery are typical of the elegant portraits Anthony van Dyck made in London between 1635 and 1639. Fashion and art found remarkable rapport in van Dyck's portraits of English women: strings of pearls, colorful silks, and casually worn diaphanous gauzes were favored by both the painter and his aristocratic sitters.

Van Dyck worked extensively for Charles I and his court, but also painted a wide variety of sitters. An old copy of the portrait suggests that she may be a member of the Killegrew family; van Dyck painted several other members of the family.

— ALAN CHONG, 2002

Also I am keenly anxious to see that lady, and I am ready to wave a flag of victory. And this is why. All the Boston Art Museum, soi-disant connoisseurs *are wild about a Van Dyck that Durand-Ruel has in New York that is coming on for an exhibition here and that they want the Art Museum to buy. Everybody* seems *determined that it is an amazing wonder and that owning it the Art Museum will step right to the top! So when mine comes I do want to have a little triumph; and I expect to. Of course, no one knows anything about mine.*

— GARDNER to BERENSON, 1897

Self-Portrait, Aged 23, 1629

REMBRANDT, Dutch, 1606–1669

Oil on wood, 89.7 x 73.5 cm, signed lower right: RHL […] 9
Purchased in 1896 from Lt. Col. Sawyer, through Berenson.
Dutch Room

Now I come to the special point of this letter, I am sending you a photograph of one of the most precious pictures in existence, which if not sold by Feb. 18 goes to the National Gallery. Owing to a number of fortunate accidents I am in a position to offer you the chance of buying it.

— BERENSON to GARDNER, 1896

Isabella d'Este is here [a portrait also bought in 1896]. She arrived safely and is most delightful. She and Rembrandt held quite a little reception this afternoon. I had some delicious music. When that was over, the devotees put themselves at the feet of the lady and the painter. They and the music – all three – had a great success.

— GARDNER to BERENSON, 1896

This Rembrandt may be called the cornerstone of Fenway Court, for it was the first picture – so Mrs. Gardner said – that she bought with the intention of developing a real museum collection. From now on, it was her determination that her acquisitions should be masterpieces; no difficulties daunted her, no desire seemed to her extravagant; she pursued her game with a zeal, courage, a determination, and a wisdom hitherto unsuspected – except by Mr. Gardner, who was always aware of her abilities.

— MORRIS CARTER, 1925

Rembrandt's self-portraits, made throughout his long career, served many different purposes, and these explorations of his own face and personality remain elusive in many ways. This is one of his first painted self-portraits, and unlike most of the earlier ones, it is not a study of expression or emotion. Indeed, the face, though beautifully lit with evocative shadows, is almost expressionless. The painting is all about costume: the plumed cap, silk scarf, and jacket suggest that this might be an elegant sitter, perhaps even an historic personage. The painting is large and carefully finished, almost as though it were a demonstration piece. In 1629, Rembrandt had not yet received any portrait commissions, so this work might have been done to show off his talents.

On the other hand, by 1629, the twenty-three-year-old artist had already begun to attract critical attention. Self-portraits were a desirable collectible for connoisseurs, especially since Rembrandt here wears a golden chain, which indicates the nobility of the painter's profession, although he had not received any such decoration.

— ALAN CHONG, 2002

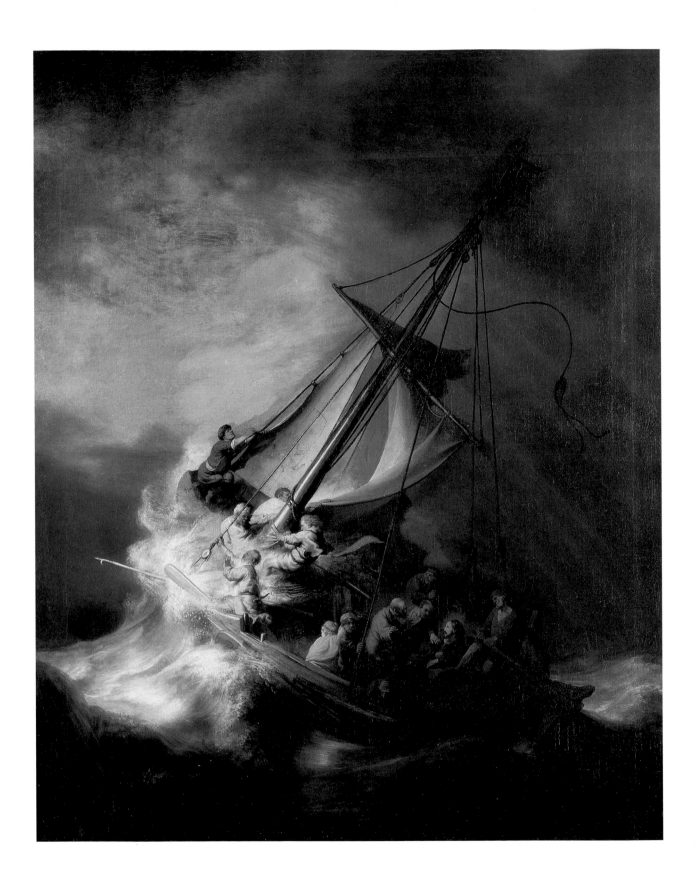

☙ *Christic in the Storm on the Sea of Galilee,* 1633

REMBRANDT, Dutch, 1606–1669

Oil on canvas, 160 x 128 cm, signed on rudder: Rembrant. f / 1633
Purchased in 1898 from Colnaghi and Wertheimer, London,
through Berenson. Stolen in 1990.

And I have noticed that in his early period he had greater patience to work out his works of art in detail than afterwards. Among various examples, this can be seen especially in the work known as Saint Peter's Ship, which for many years hung in the cabinet of Jan Jakobsen Hinloopen, the former sheriff and mayor of Amsterdam. The effects of the figures and the expressions are there executed as naturally as can be imagined, and are also more elaborately painted than one is used to seeing from him.

— ARNOLD HOUBRAKEN, 1718

Christ asleep in the storm, by Rembrandt. In this picture there is a great effect of light, but it is carried to a degree of affectation.

— JOSHUA REYNOLDS, 1781

Rembrandt's most striking narrative painting in America, *Christ in the Storm on the Sea of Galilee,* is also his only painted seascape. Dated 1633, it was made shortly after Rembrandt moved to Amsterdam from his native Leiden, when he was establishing himself as the city's leading painter of portraits and historical subjects. The detailed rendering of the scene, the figures' varied expressions, the relatively polished brushwork, and the bright coloring are characteristic of Rembrandt's early style. Eighteenth-century critics like Arnold Houbraken often preferred this early period to Rembrandt's later, broader, and less descriptive manner.

The biblical scene pitches nature against human frailty — both physical and spiritual. The panic-stricken disciples struggle against a sudden storm, and fight to regain control of their fishing boat as a huge wave crashes over its bow, ripping the sail and drawing the craft perilously close to the rocks in the left foreground. One of the disciples succumbs to the sea's violence by vomiting over the side. Amidst this chaos, only Christ, at the right, remains calm, like the eye of the storm. Awakened by the disciples' desperate pleas for help, he rebukes them: "Why are ye fearful, O ye of little faith?" and then rises to calm the fury of wind and waves. Nature's upheaval is both cause and metaphor for the terror that grips the disciples, magnifying the emotional turbulence and thus the image's dramatic impact.

The painting showcases the young Rembrandt's ability not only to represent a sacred history, but also to seize our attention and immerse us in an unfolding pictorial drama. For greatest immediacy, he depicted the event as if it were a contemporary scene of a fishing boat menaced by a storm. The spectacle of darkness and light formed by the churning seas and blackening sky immediately attracts our attention. We then become caught up in the disciples' terrified responses, each meticulously characterized to encourage and sustain prolonged, empathetic looking. Only one figure looks directly out at us as he steadies himself by grasping a rope and holds onto his cap. His face seems familiar from Rembrandt's self-portraits, and as his gaze fixes on ours we recognize that we have become imaginative participants in the painter's vivid dramatization of a disaster Christ is about to avert.

— MICHAEL ZELL, 2002

✑ *Landscape with an Obelisk, 1638*

GOVAERT FLINCK, Dutch, 1615–1660

Oil on wood, 54.5 x 71 cm, inscribed: R. 1638
Purchased (as Rembrandt) in 1900 from Colnaghi, London,
through Berenson. Stolen in 1990.

Long thought to be by Rembrandt, this landscape was recognized
in the 1980s as the work of his pupil, Govaert Flinck. The stormy
scene with a dramatically lit obelisk in the middle ground is close
to Rembrandt's own landscapes of the 1630s. Just outside
Amsterdam were two obelisks that marked territorial boundaries.
However, this scene with distant mountains and towering trees
looks nothing like Holland; rather the travelers huddled in the
foreground shadows suggest that it is some faraway place.

By 1900, Isabella Stewart Gardner's interest in Dutch paint-
ing had waned. She wrote, "I really don't adore Rembrandt. I only
like him." She already owned a Vermeer and three Rembrandts,
and had attempted to buy the celebrated *Mill*, then attributed to
Rembrandt – "the most famous landscape in the world." Peter
Widener bought it in 1911 and it is now in the National Gallery of
Art, Washington.

— ALAN CHONG, 2002

*How I wish I had got your cable about the Giotto before that about
the Rembrandt. Of course I want the Giotto – that there is no
question about! But the Rembrandt left me cold, and it was only
because you seemed so anxious about it, that I wired to get it. Of
course I feel sure that you can hand it to Bode [Wilhelm Bode,
director of the Berlin museums], that would be all right. So please
do that, and then I can have the Giotto.*

— GARDNER to BERENSON, 1900

∾ *The Concert,* ca. 1665

JOHANNES VERMEER, Dutch, 1632–1675

Oil on canvas, 72.5 x 64.7 cm
Purchased in 1892 at the Paris auction of the estate of Théophile Thoré. Stolen in 1990.

It is the nature of Vermeer that we never know for sure what's going on in his paintings. This painting feels so mysterious and haunting because the faces can't be seen clearly. I wake up some nights just thinking of that painting, and what's going on in it. It is utterly impenetrable. I think of the characters in the painting as prisoners in some mysterious world. And now I think of the stolen painting itself as a prisoner in some vault.

The woman singing is not conventionally pretty, but beautiful in a very human way. Is she singing? Is she about to sing? I believe that she is thinking about singing. Now singing, of course, is this tremendous act of release, the most complete act of release that a person is capable of. You take something from inside yourself – from your soul – and project it out into the world. This act of hurling yourself out is, as anyone knows who's ever tried it, an act of courage. It takes real courage to sing. When you sing, you yourself become a work of art. It is an ultimate act of sorting oneself out – of tuning one's self, of disciplining one's voice. Vermeer's woman is at this tense, terrifying moment: on the brink, just before her most private self goes, forever, public. In contrast, the woman at the harpsichord and the man with a lute are self-contained. The standing woman who sings is no longer self-contained; she brings a new life into the world, and that requires courage.

— PETER SELLARS, 1991

Entry from Jack Gardner's diary, 1892

In a pristine domestic parlor, two women and a man concentrate on making music. The standing woman holds a sheet of music and raises her hand to beat time for her companions. Turned enigmatically away from our gaze, the seated gentleman wears an elaborate decorated sash that indicates his membership in a civic militia. Some scholars have been tempted to interpret Dutch musical scenes like this as moral warnings against seduction and illicit sex. Indeed, hanging on the wall at the right is a painting of a procuress by Dirck van Baburen. Although the subject of this painting-within-a-painting seems to suggest that something improper is be taking place, the *Procuress* was in fact owned by Vermeer's family. Moreover, the figures in the room are intently preoccupied with their music: they do not look at each other, and seem unaware they are being observed. Their intensity does not invite interruption. Lying on the large table at left is a lute, while a viola da gamba rests on the floor. Are these instruments soon to be taken up by the trio, or are others to join the group? Vermeer crafts rather deliberately a sense of mystery: this study in social interaction is a comedy of manners open to our interpretation.

The mystery is intensified by Vermeer's famed attention to the reflections of light. It sparkles off the women's pearls (Mrs. Gardner's favorite), the gold threads of the man's sash, the white silk skirt, and even the Persian carpet heaped on the table.

Isabella Stewart Gardner may have been drawn to the painting by its elegant depiction of the domestic music-making that she herself was so fond of. The painting was her first major acquisition, and she bought it without the help of experts. It was bought at the Paris auction of the estate of Théophile Thoré (1807–1869), a prominent critic who wrote under the pseudonym William Bürger. He had been instrumental in reviving the reputation of Vermeer, which made this painting especially important.

— ALAN CHONG, 2002

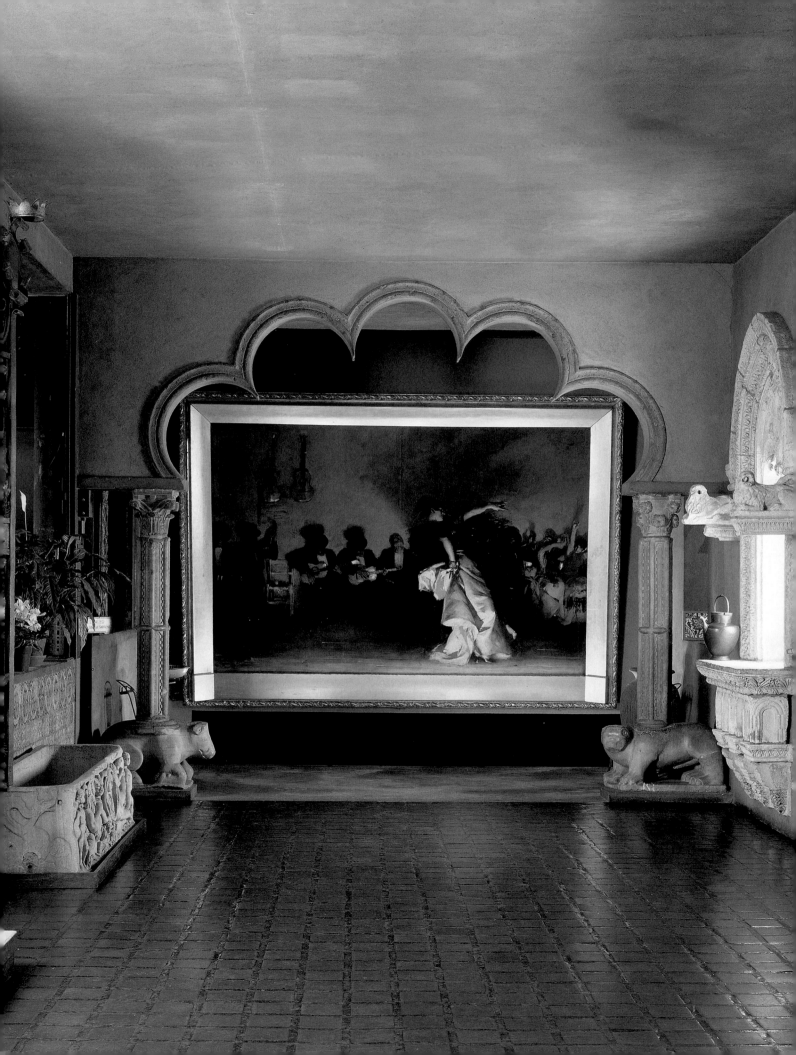

Spanish Art

The Spanish Cloister

Spanish art always played a role in Isabella Stewart Gardner's collection, but it was subordinate to that of Italian art until about 1906. Whether due to severe inflation in the art market, which essentially drove Italian painting beyond her reach, or a change in Mrs. Gardner's taste, Spanish art took on greater prominence in the final stage of the museum's formation.

Ironically, it was a modern image that introduced Spain to Mrs. Gardner: John Singer Sargent's *El Jaleo* is a vision of a Gypsy dance set in southern Spain, painted by an American artist in Paris. Although it belonged to her cousin, T. Jefferson Coolidge, Gardner greatly coveted the painting, particularly after it was exhibited in Boston in 1888, along with her own portrait by Sargent. Later that year, the Gardners went to Seville to experience first-hand the drama of Spanish life. Mrs. Gardner's first biographer, Morris Carter, described her abject terror at a bull fight. She also acquired her first old master painting there, a Virgin and Child then attributed to Zurbarán.

Mrs. Gardner's last trip to Europe in 1906 rekindled her interest in Spanish art, and she began to buy pottery, metalwork, and paintings, including several works of the 1400s as well as a full-length portrait of a lawyer by Francisco de Zurbarán. Perhaps her most important late purchase was the *Crucified Christ* (p. 22), one of the first pieces of Spanish Romanesque sculpture to enter an American museum. In 1914, a major renovation of the east wing was begun, partly to create a gallery to display a new cycle of tapestries, but also to provide a setting for Spanish art. On the ground floor, Mrs. Gardner created a Spanish Chapel and a Spanish Cloister. Lined with some two thousand seventeenth-century Mexican tiles, the Spanish Cloister replaced the old Music Hall. The new installation is permanent theater: the music and dance of Sargent's *El Jaleo* is framed by an extravagant Moorish arch. Sargent's homage to Spain became the centerpiece of the new wing.

Created in 1915, the Spanish Chapel had strong personal signifi-
cance for Isabella Stewart Gardner. Like the chapels on the third
floor and the Chinese Room, it captured her religious feelings, in
particular the devotion associated with mourning. Over the altar
hangs the *Virgin and Child* that she had acquired in 1888 and had
hung in her bedroom at the Beacon Street house. Beneath the
window is an alabaster tomb figure, and inscribed on one wall are
Spanish dedications to Jesus, Mary, and Joseph. The words "In
Memoriam" over the doorway suggested to early observers that
the room was dedicated to Mrs. Gardner's deceased infant son
Jackie. She also instructed that her body would lie just outside the
Spanish Chapel before her funeral.

Virgin and Child, with Scenes from the Lives of Saint George and Saint Martin, ca. 1395

FRANCESC COMES, Spanish (Mallorca), active 1380–1417

Tempera and gold on wood, 75.1 x 114 cm (overall)
Purchased (as northern Italian) in 1901 from Durand-Ruel, New York. Raphael Room

This small altarpiece, in its original blue and gold frame, demonstrates how the International Gothic Style reached as far as the island of Mallorca in the Mediterranean. The highly decorative patterns and graceful figures – enhanced by exceptionally long fingers – are typical of court painting throughout Europe around 1400. The scenes of Saint George slaying the dragon and of Saint Martin dividing his cloak to give to a beggar attest to the chivalric role of saints. The elegantly dressed donor who kneels before the Virgin and Child may be Juan I or Martin, kings of Aragon and Catalonia, since the double crown on the cloak was their device.

❧ *Archangel Michael,* ca. 1470

PERE GARCIA, Spanish (Catalonia), active 1445–96

Tempera and gold on wood, 184 x 144 cm
Purchased in 1916 from Paul J. Sachs, Cambridge. Tapestry Room

The archangel Michael, wearing a suit of studded armor, sits on a throne backed by an elaborate blue and gold brocade. In this painting, Michael simultaneously enacts his two principal roles: weigher of souls on Judgment Day and destroyer of Satan. On the left an angel embraces a soul, while on the right, Satan appears as a fantastic two-faced monster ready to capture another soul. Michael positions his lance over the monster. This painting was originally a side panel of a large altarpiece dedicated to John the Baptist, installed in the church of Sant Joan del Mercat in Lleida, Catalonia.

In 1916 or thereabouts she had considered the acquisition of a Spanish primitive but had not made up her mind. Meanwhile it was purchased by Paul Sachs, who had just moved to Cambridge from New York. Shortly Mrs. Gardner gave a highly select dinner party in his honor. Toward the close of the meal she remarked quietly: "Mr. Sachs, I understand you have just bought a Spanish primitive. Turn around. Don't you agree your painting would go very well over the fireplace?" Then she laid her right hand on the table and continued: "You know, this hand could hold a stiletto. If you tell me what you paid for your painting I will send you my check in the morning." Today it hangs over the fireplace and does look very well.

— JOHN COOLIDGE, 1989

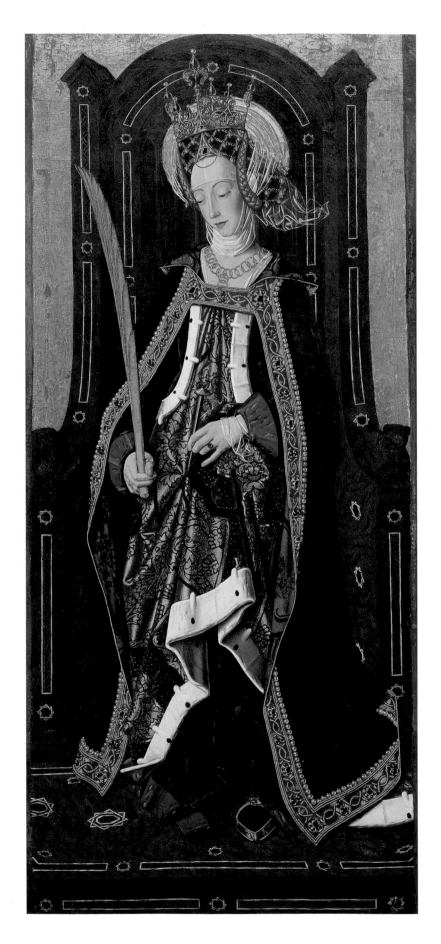

∾ *Saint Engracia*, ca. 1474

BARTOLOMÉ BERMEJO, Spanish (Aragon), ca. 1436–ca. 1498

Oil and gold on wood, 164 x 73 cm
Purchased in 1904 at the Brussels auction of the de Somzée
collection. Tapestry Room

Richly dressed in gold brocade and with a cloak trimmed in
ermine, Saint Engracia stands before a throne. Engracia was
thought to be a fourth-century Portuguese princess who was bru-
tally tortured by the Roman proconsul of the city of Zaragoza.
The cult of Engracia became especially popular in Aragon.
Bermejo depicts the saint wearing a crown and holding a nail, one
of the instruments of her torture; in her other hand is the palm
frond that signifies a martyr saint.

This painting was the central panel of an altarpiece. The sur-
rounding works illustrated episodes from the life of Engracia
(now in San Diego, Bilbao, and Daroca). The altarpiece was com-
missioned by a wealthy merchant named Johan de Loperuelo for
a chapel in the church of San Francisco in Daroca. Bermejo was
profoundly influenced by the oil paint technique of Netherland-
ish painting, which he in turn was instrumental in transmitting to
other Spanish artists.

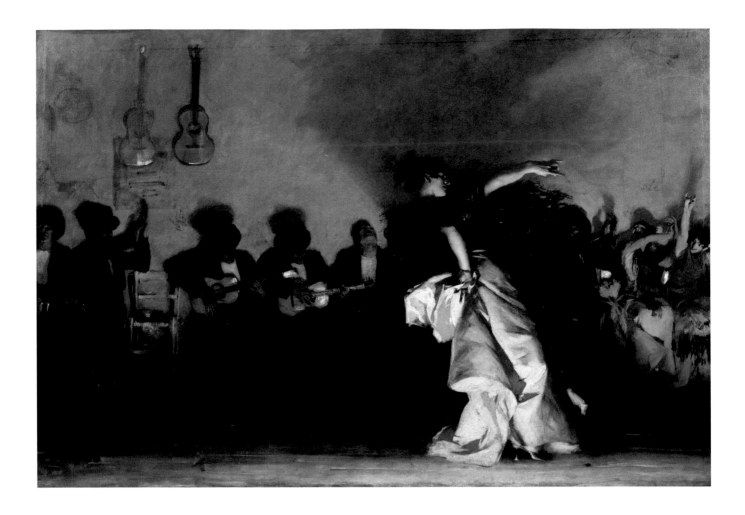

At the salon of 1882, the painting was bought by T. Jefferson Coolidge of Boston. In 1888, it was publicly exhibited in Boston, together with Sargent's portrait of Mrs. Gardner (p. 205). That fortuitous pairing led Gardner to ask that the picture be left to her in his will. In 1914, Mrs. Gardner embarked on a major renovation of her museum in order to create several new rooms devoted to Spanish art. She borrowed *El Jaleo* from Coolidge, and fashioned a Spanish cloister as a dramatic setting for the painting. Overwhelmed by this installation, Coolidge immediately gave Gardner the painting. Sargent, in his turn, made up an album of twenty-one sketches – many done years earlier in preparation for *El Jaleo* – as a special gift to Gardner.

Mrs. Gardner invited Mr. Coolidge to come see it, and he expressed great admiration for the installation, said the picture never looked so well, and so forth, whereupon Mrs. Gardner said, "If you really think it looks so much better here, would it be right for you to take it away?" And then and there Mr. Coolidge gave it to her.

– MORRIS CARTER, 1964

El Jaleo, 1882

JOHN SINGER SARGENT, American, 1856–1964

Oil on canvas, 232 x 348 cm
Gift in 1914 from T. Jefferson Coolidge, Boston.
Spanish Cloister

Studies for El Jaleo

Images like *El Jaleo* lean toward the daring, risky, unconventional, dramatic, erotically off-center, and odd. Because nomadic Gypsies were believed to ignore ethical principles and exalted superstition over orthodox religion, they endured oppression in numerous countries during the nineteenth century, but artists and bohemians idealized them as free spirits. Bizet's opera *Carmen*, first performed in Paris in 1875, scandalized the public with its tale of a proud, lusty Andalusian Gypsy torn between an army officer and a torcador.

During his travels in Spain in 1879, Sargent was mulling over a major work of art in which he could express his love of Gypsy music, dance, and picturesque costumes. On his return to Paris he set to work on a wide horizontal picture whose proportions simulated the shallow stage space of popular musical establishments. He named the painting *El Jaleo* to suggest the name of a dance, the *jaleo de jerez*, while counting on the broader meaning *jaleo*, which means ruckus or hubbub. The painting was exhibited at the Paris Salon of 1882 with the more explicit title *El Jaleo: Danse des gitanes* (Dance of the Gypsies).

The best evidence of his own excited reactions to live dance performances can be found in the pencil sketches of a Spanish woman that he included in an album assembled for Isabella Stewart Gardner. They are among his fastest, most intuitive works. In one drawing a torrent of fast hard lines suggests the twisting shawl from which a majestic neck and outstretched vamping arms emerge.

— TREVOR FAIRBROTHER, 2000

∾ Tile

Turkish (Iznik), ca. 1575–1600
Glazed pottery, 21.5 x 25 cm
Purchased in 1885 from Noyes and Blakeslee, Boston.
Spanish Cloister

*Sketch of tiles by Mrs. Gardner from her
Egyptian diary, 1874*

*The Iznik tiles of the second half of the
sixteenth century are justly famous for
their bright tomato-red color, which
together with black, blue, turquoise, and
green were painted in underglaze colors
on the flawless white ground. This tile is
unusual in several respects: it uses black in
large amounts, the most important ele-
ments of the field have been quartered in
the corners of the tile, and no other tiles
from this panel have yet come to light.*

— WALTER DENNY, 1975

❧ Islamic Art

The next day we went to Cairo, where the dream only became more colored with Eastern glow. The people had stept out of the "Arabian Nights" which were no longer tales that we had read, but were bits of real life happening with us looking on – and we had truly "come abroad and forgot ourselves."

Oh, the grace and beauty of the men, and oh their gorgeous clothes! From the Princes of Persia to the barber's son, what graceful languor and what perfect postures, as they lean against a deewan or a wall.

— GARDNER, 1874

I went up, as usual, alone after dinner and found the steersman at his prayers, his forehead touching the deck. As I lay upon the couch with the fragrance of the frankincense stealing over me, the wake of the moon was a fit path by which my thoughts went straight to Cleopatra – and I forgot it was Christmas eve.

— GARDNER, 1874

ALTHOUGH Isabella Stewart Gardner bought one or two Islamic objects early in her collecting activity, she became most active after 1912. She was deeply impressed by her travels in Egypt and the Middle East in 1874; she and her husband Jack returned to Egypt in 1884. She was fascinated not just by the tourist sites and exotic scenery, but also by the drama of daily life that swirled around her, and which she recorded in watercolors and diaries. Indeed, modern Egypt seems to have interested her more than the wonders of ancient Egypt. She visited the humble one-room house of a mule driver. She was also strongly drawn to the religious practices of other cultures.

Mrs. Gardner was not yet a collector, and she acquired only a few souvenirs on these trips. She bought commercial photographs, which she carefully pasted into a travel album with her own watercolors. Back in Boston in 1885, she bought her striking Iznik tile. In 1912, she spent a small fortune on a Kashan plate, and began to pursue Islamic manuscript illuminations. She even wrote a short catalogue of her miniatures in 1915.

Mrs. Gardner also understood that Islamic art was intimately connected with Venice. One expects to find Islamic objects in Mrs. Gardner's museum, as one might have in a Venetian palazzo. The architecture of Venice is often Arab in inspiration, and the city had always attracted merchants and artisans from the Middle East. An especially important intersection of East and West is Gentile Bellini's small illumination of a scribe (p. 96). A blend of Turkish and Italian techniques, surrounded by Arabic script, the work was probably made in Constantinople. In the same spirit, Mrs. Gardner surrounded one of her most important Renaissance paintings, Botticelli's *Virgin and Child with an Angel*, with Islamic objects.

The crew are my great delight and are so vain of their dress — I mean their turbans. They are always washing them, wringing them and helping each other to wind their heads in them. The steersman a picturesque creature who hangs on the tiller for 24 hours at a time. The crew are a very jolly set, and are always singing and find their great enjoyment in their oft repeated cups of coffee and their occasional whiffs from the hashish pipe. One of them is a beauty and with a very deep voice.

— GARDNER, 1874

Scrapbook of Mrs. Gardner's trip to Egypt in 1874

❧ *Tile*

Iranian (Kashan), 1200s
Pottery with cobalt and luster glazes, 47 x 44 cm
Spanish Cloister

Most surely in the creation of the heavens and the earth and the alternation of the night and the day there are signs for men who understand. Those who remember Allah standing and sitting and lying on their sides and reflect on the creation of the heavens and the earth: Our Lord! Thou hast not created this in vain! Glory be to Thee: save us then from the chastisement of the fire.

— Koran, 3. 190–191
(a section of this passage is inscribed on the tile)

This beautiful tile formed part of the frieze in a prayer niche of a mosque. Called a *mihrab,* this niche or arch in a wall marks the direction towards Mecca, toward which worshippers face during prayer. The inscription, in large dark blue script, is a verse from the Koran. The rich decoration consists of intertwining foliage and a patterned band at the top. Various blue glazes are balanced by copper luster glaze. Two other tiles from the frieze are in the Victoria and Albert Museum, London.

❧ *Tombstone*

Iranian or Central Asian, ca. 1475
Stone, 173 x 36 x 32.5 cm
Purchased in 1901 from Mihram Sirvadjian, Paris, through Ralph
Curtis. West Cloister

The Arabic inscription at the head of this slab informs viewers it
marks "the tomb of him whom God has exalted by the glory of
martyrdom after a life of abundance in the world through leader-
ship and the caliphate; and he is the sultan…" Although the rest
of the inscription, which would presumably have included the
name of the deceased, has been effaced, these few lines suffice to
introduce his piety and power. The splendid and meticulously
handled carving that envelopes the tombstone attests to the aes-
thetic refinement and achievements of the reign of the Timurid
dynasty (1397–1501) in Iran and Central Asia.

Historically, Islamic traditions prescribe simple and egalitar-
ian burial practices. Fearing the temptations of ancestor worship
or idolatry, the Prophet Muhammad reportedly discouraged per-
manent or elaborate tomb structures. A compromise between
religious purity, human nature, and pre-Islamic burial practices,
this tombstone nevertheless evokes Islamic values and symbols.
The decorative program excludes the representation of humans
or animals, relying instead on Arabic inscriptions in stately *naskh*
or monumental *kufic* scripts, and a profusion of arabesques.

Invoking the Day of Judgment, the Koranic phrase
"Judgment is to God" (12.66) appears in rectangular panels on
three sides of the tombstone. Most beautifully written is the
inscription in the smaller of two panels on the main side of the
tombstone. Here bold letters with interlacing ascenders trace
right angles, in contrast to the diminutive floral scroll in the back-
ground.

Lotus and peony blossoms punctuate the border channels,
evoking not only the influence of Chinese art so prized by the
Timurids, but also the Islamic concept of the after-life as a garden.
The notion that the faithful will be rewarded in an eternal garden
is perhaps also alluded to by the term *rawdat,* with which the
tombstone refers to itself. Although *rawdat* may be translated as
"tomb," it literally means "garden."

A self-contained network of vigorous and intricate
arabesques fills a long panel on the front face of the slab.
Dominating the panel is an extremely stylized arabesque in which
large heads formed of split leaves and spirals branch from elasti-
cally curling stems. Around and beneath it glides a secondary
arabesque composed of more naturalistic flowers and leaves.
Crisply and precisely carved, this multi-layered interlacing per-

fectly expresses the Timurid delight in complexity and virtuosity.

In the upper fourth of the panel, a continuous, cusping line traces the top of an arch, calling to mind a *mihrab* – the niche or arch in the wall of a mosque that marks the direction toward Mecca. A fundamental requirement of Islam is that worshipers face toward Mecca for prayer, and the *mihrab* serves as a directional symbol. Its presence on a tombstone is a reminder that in Islamic burial traditions, the body is aligned with Mecca for its final rest.

— MARY McWILLIAMS, 2002

Detail of inscription

Velvet: Foliate and Floral Lattices

Iranian, late 1500s–early 1600s
Silk and foil-wrapped silk, 56.5 x 33 cm
Purchased from Villegas, Rome, 1895. Titian Room

Approximately half of the original loom-width of this luxurious textile is preserved in Mrs. Gardner's velvet panel. In its entirety, the velvet superimposes an ogival lattice built of exuberant blossoms and buds atop a second lattice created from fanciful leaves. The arabesque design masterfully opposes the innate balance of its symmetry with the ogees' fluid rhythms. Leaves split and curl, or twist backwards, along carefully calculated curves. When properly aligned at the selvedges, the pattern can be repeated infinitely across a planar surface.

The velvet exemplifies the extraordinary expertise of and resources available to Iranian weavers during the reign of the Safavid dynasty (1501–1722). For garments and furnishings, the court demanded intricately patterned silks fabrics woven in a wide range of brilliant colors and enhanced with radiant gold and silver wefts. Although only one of several weave structures employed for the production of prestigious fabrics, Safavid velvets hold a superlative place in the history of textile arts. The French traveler John Chardin, who surveyed the arts and industries of Persia in the 1660s, singled out the "gold velvets" for particular praise.

Characteristic of Safavid velvets, this fabric presents a complex, highly wrought surface, contrasting materials, weave structures, and a wide array of colors. The design is "drawn" in pile against a shining gold background. At least twelve different colors are woven into the pile, although only the color black, which outlines all of the motifs, is employed throughout. All other colors are added and subtracted into the textile as desired through a technique invented by Safavid weavers known as "pile-warp substitution." Although highly labor-intensive, this technique freed velvet-weavers from the restrictions of the loom, allowing them to weave as many colors as the silk dyers could produce.

— MARY McWILLIAMS, 2002

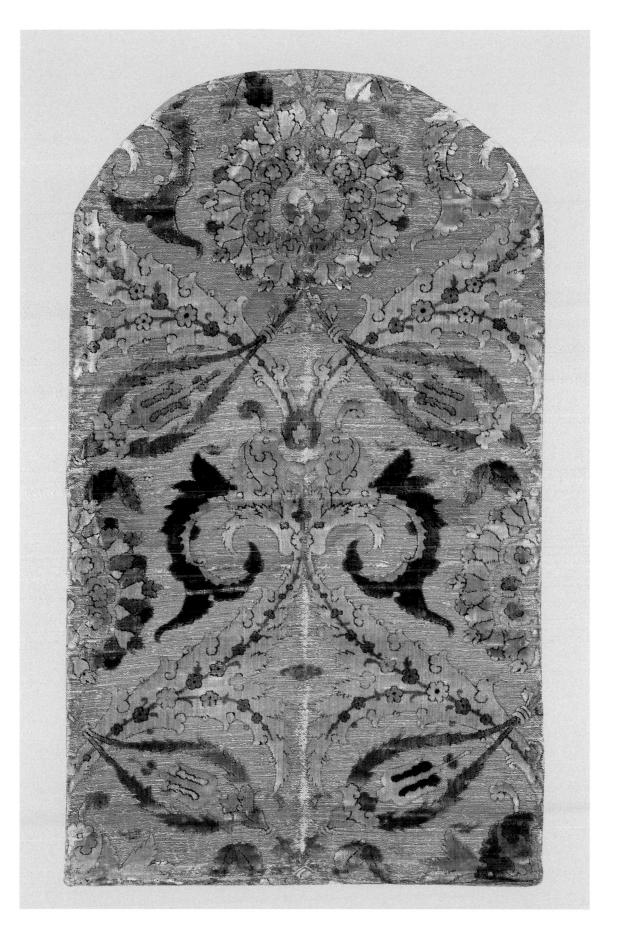

⌒ Ceramic Plate: A Courtly Couple

Iranian (Kashan), ca. 1200
Fritware with overglaze-painted luster design and splashes of
turquoise, diameter 35 cm
Purchased in 1912 from H. K. Kevorkian, New York.
Early Italian Room

The invention of luster painting – the decoration of ceramics with
a glittering, metallic film – is usually credited to ninth-century
Muslim potters in Iraq. A complicated technique in which metal
oxides are fired in a reducing kiln, luster painting passed within a
few centuries from Iraq via Egypt to Iran (Persia), presumably
through migrant potters who guarded the technique as a trade
secret. The decorative potential of luster's other-worldly irides-
cence was explored by Iranian potters during the twelfth through
fourteenth centuries, a period of brilliant innovation and prolific
production in the ceramic arts circumscribed by the reigns of the
Great Saljuqs and the Il-Khanids.

The finest painting and most ambitious decorative programs
for lusterware were produced in the central Iranian city of
Kashan. Several stylistic features of the Gardner Museum's plate
suggest an attribution to Kashan: the monumental figures set
against a luster background, the kidney-shaped leaves, the plump-
breasted bird, and the minute spirals painted and scratched
through the luster. Scholars have linked the plate to two famous
luster-painted plates in the Freer Gallery of Art and the Victoria
and Albert Museum, because their ceramic bodies seem to have
been produced from the same mold with 29 scallops in the cavet-
to. The Freer plate, arguably the most accomplished of the three,
bears a date of 1210.

At its center, the plate in the Gardner Museum presents a
vignette of courtly life in the classical period of Islamic civiliza-
tion. The elevated status of an elegantly attired couple is revealed
in their refined decorum and possessions. The serene counte-
nances of the couple betray neither the pains of separation and
romantic disappointment lamented in the concentric bands of
poetry, nor the pleasures of their musical activity. The figure on
the left plucks an ancient harp (*chang*) that rests on his knee. For
centuries, the Persian harp was one of the most prized instru-
ments in aristocratic circles, and was celebrated in poetry and
painting. The lower hand of the figure on the right holds a folded
handkerchief (*mandil*), another allusion to wealth and refined
manners. Beautiful and costly handkerchiefs were a source of
pride among the wealthier classes and an elaborate etiquette gov-
erned their usage.

 – MARY McWILLIAMS, 2002

*The heart is branded with the grief of
 your love on its soul;
Separation from you makes the world like
 a prison;
That heart that has not the patience for
 union with you,
Alas that it can suffer through separation.*

 *– inscription on the outer rim of
 the plate.*

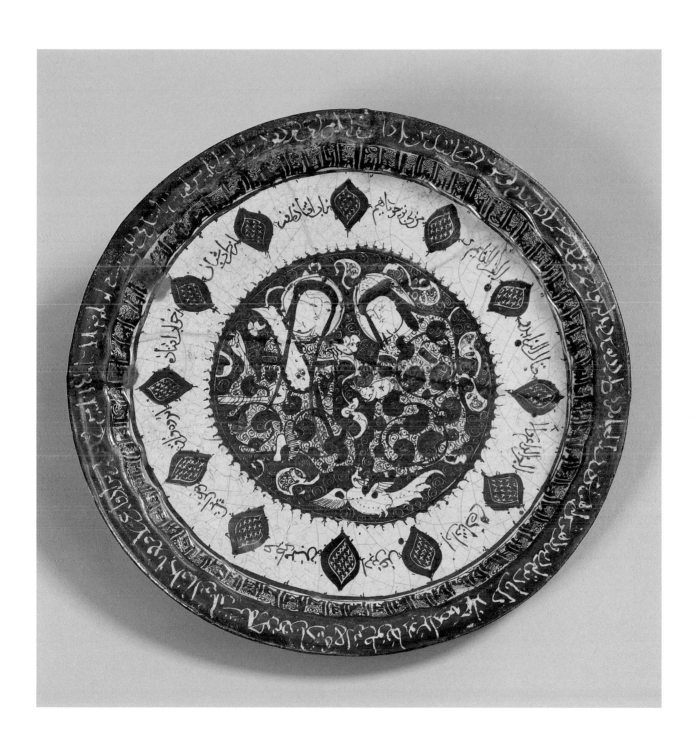

Verbena peresterion
Verbena recta

Leaves from an Arabic translation of *De Materia Medica* by
Dioscurides
Mesopotamian (Baghdad), 1224
Ink and watercolor on paper, 29.5 x 21.5 cm
Purchased in 1914 from the Berlin Photographic Company, New
York, through Berenson.

These illustrations of medicinal plants were added to a manu-
script translation of a medical treatise by Dioscurides, originally
written in the first century AD. The Greek text was frequently
translated into Arabic; this sheet is from a copy by Abdallah ibn
al-Fadl, which is dated 1224.

❧ *Ikat Velvet*

Uzbekistan, late 1800s
Silk: cut velvet, pile-warp-dyed, 683.2 x 33.9 cm

Ikat is a laborious technique in which the color and design are dyed into the yarns prior to weaving. Bundles of silk warps are tie-dyed, that is, bound tightly to resist dye; areas that have been tie-dyed may be unbound for subsequent dyeing. Some sections have been over-dyed to increase the number of colors in the finished fabric. The dyeing technique and the positioning of the colored warp on the loom produce a design with blurred, feathery edges, while the sides of the designs are sharp.

With brilliant, saturated colors, the Gardner Museum's ikat is perfectly preserved and of full loom length. This type of silk warp ikat fabric was used for the magnificent robes of Central Asia. The patterns include abstracted plant forms and triangular shapes. The bird life forms appear to be Gajak pendants, which were worn in temples.

The Taoist

She stood alone on Earth,—
an exile from Heaven. Of
all the Immortals she was
the flower.

Time receded in reverence
at her approach, space bowed
the way to her triumph. The
wind brought to her its
untrammelled grace, the air
lent to her voice the balm
of its own Summer. Blue
lightening swept in her

glances, clouds unfurled in the
train of her queenly tread.
Infinity asked of Wonder:
"Below and above in thy wanderings
amongst the stars, hast thou heard
the name of this fearless Spirit,
who laughs with the thunder and
plays with the storm, whom fire
burneth not because she is fire
itself, whom water quelleth not
for she is the Ocean herself?"
Quoth Wonder: I know not.

"The Taoist" by Okakura Kakuzō, 1911

Asian Art

Aʟᴛʜᴏᴜɢʜ Fenway Court was unlike any other house of its time, it possessed one room which could be found in many American Victorian mansions: a Chinese Room. Mrs. Gardner decorated this eclectic gallery with embroidered wall hangings from China, Japanese screens (hung on the wall, as was common display practice at the time), eighteenth-century Venetian chairs with oriental motifs, as well as a portrait of herself by Anders Zorn. She dispersed other Asian objects, including Buddhist statues, carved wood panels, snuffboxes, and porcelains, through the museum. Asian art signaled that the museum was a palace of universal beauty endowed with the riches of both East and West.

After the reopening of Japan to the West in the 1850s, many Americans and Europeans became fascinated with the arts of Japan. The Gardners were not indifferent to this trend. In 1882 Mrs. Gardner hosted a series of lectures by Edward Sylvester Morse, one of the preeminent authorities on Japanese culture. Morse triggered enthusiasm for Japan in other locals such as Ernest Fenollosa, William Sturgis Bigelow, and Percival Lowell, making Boston a lively center of Japanophiles. Inspired by Morse, the Gardners embarked on a world tour in 1883, visiting Japan, China, Cambodia, Indonesia, and India. Mrs. Gardner filled scrapbooks with photographs, notes, flowers, and assorted souvenirs. On the trip she also acquired a few works of art, including a screen bought in Yokohama and a small bronze figure of Vishnu that she was given in Angkor Thom, Cambodia.

Mrs. Gardner's friendship with the Japanese art critic Okakura Kakuzō, beginning in 1904, expanded her interest in East Asia. In 1905 she orchestrated an extravagant "Japanese Festival Village" in the Music Room of the museum. She recreated her picturesque impressions of Japan by staging a fox-god shrine festival with thatched stalls, a teahouse, and a garden. Mrs. Gardner reportedly appeared in a rickshaw. This involvement with Japanese culture presented an image of her as an adventurous patron of an exotic culture: it was even rumored that she trained in the martial art of jujitsu.

Beginning around 1910, Gardner began to acquire works of early Chinese art. She wrote to Bernard Berenson:

> It is quite true about the Oriental things. Persian above all, and *Old Chinese*. You should see some of the latter terra cottas Okakura has sent. Do the best you can for me – *not many* things, but *very* good.

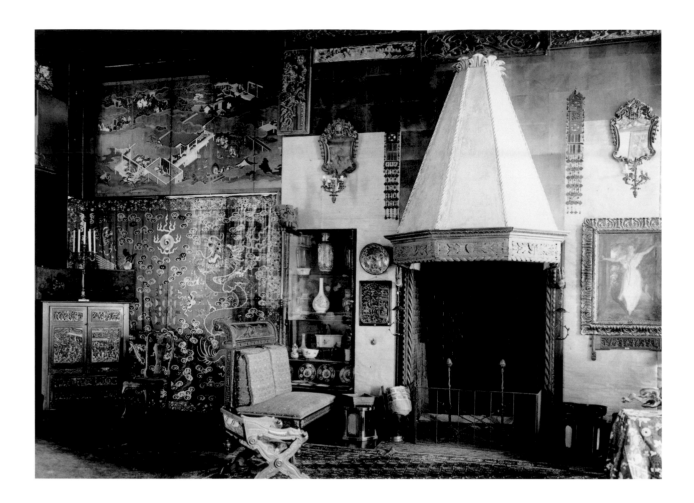

The Chinese Room (now the Early Italian Room), 1903

This renewed interest was almost certainly due to Okakura who was collecting Chinese art for the Museum of Fine Arts. Berenson had also begun to buy Chinese art for himself and offered Mrs. Gardner things he could not afford. Though small in number, these later acquisitions of Chinese art represent some of the most remarkable pieces in her collection: a Shang *ku* (ritual vessel), Han dynasty bronze bears, a Buddhist stele, and a Guanyin statue.

During 1914 and 1915, Mrs. Gardner created a new Chinese Room (also known as the Buddha Room), a subterranean chamber entered from the Chinese Loggia. This space became the new focal point of Asian art at Fenway Court. Although this room was dismantled in 1971, photographs provide insight into Mrs. Gardner's spiritualist interpretation of Asia. In contrast to the informal and random Orientalism of the first Chinese Room, this crepuscular chamber possessed a ritualistic atmosphere evoked by a triad of Buddhist statues, altar tables decorated with incense burners and candleholders, and temple ornaments hung from the ceiling. Mrs. Gardner did not buy new pieces for this room, but managed to bring out an entirely different character from her Asian collection through rearrangement.

Please don't be shocked, dear, at all the proceedings [a sumo match]. *"When in Turkey, etc." – I shall go to see the Missionaries when I go back to Osaka, to atone. And I am really interested in the work they do, for the poor Japanese sorely need help; but how beautiful are their Buddhist temples. When I get into one I never want to come away – I could lie on the mats and look forever through the dim light.*

— GARDNER *in Japan, 1885*

In the afternoon we went to the waterfall and came back late and our drive back through the palm forest by moonlight was one of the things you should have seen. Off the road, in one place, was a beautiful little Siamese temple. So I got out of the gharry and walked through the trees to it. And there, all alone, was a yellow-robed priest chanting his evensong to his gilded Buddha. I crept up softly – no light but the moon and the service lamps and the burning incense, and I stood behind the priest, who never heard or noticed me. It was exquisite—but very sad.

— GARDNER *in Malacca, 1884*

Japanese Festival at Fenway Court, 1905

The Chinese Room (Buddha Room), 1926

ꙮ *Okakura Kakuzō* (1862–1913)

Okakura was an art administrator, educator, critic, and historian who played an instrumental role in modernizing the visual arts in Japan during the Meiji period (1868–1912). Son of an ex-samurai merchant, he learned English at an early age. As a university student, Okakura became an interpreter to his Harvard-educated professor, Ernest Fenollosa, who was studying and collecting Japanese art. Under Fenollosa's guidance, Okakura began his versatile career dedicated to the preservation of artworks and the creation of a new "national" art built upon this legacy. During the 1880s, Okakura worked with Fenollosa and Japanese officials to establish the imperial museums and a national fine arts academy, of which he was appointed director in 1890. Okakura's disciples included some of the most influential artists of Nihonga, or modern Japanese-style painting.

Okakura arrived in the United States in 1904, his self-appointed mission being the promotion of Asian art – especially Japanese art – as the highest embodiment of the cultural and spiritual ideals of the East, a position he argued in his English books *The Ideals of the East* (1903) and the immensely popular *Book of Tea* (1906). In Boston, Okakura surveyed the Asian collection of the Museum of Fine Arts and eventually became its curator. From 1904 until his death in 1913, Okakura divided his time between Japan and the United States.

Introduced to Mrs. Gardner by the artist John La Farge in 1904, Okakura quickly became one of her favorite companions and benefited from her generous support. She introduced him to such cosmopolitan intellectuals as Bernard Berenson, Henry James, and John Singer Sargent, and in turn, Okakura introduced her to some of his friends, such as the Nobel laureate Rabindranath Tagore. Okakura did not directly advise Mrs. Gardner in the purchase of art, although he stimulated her interest in early Chinese objects. Okakura's charismatic persona as an Eastern aesthete greatly impressed Gardner and helped her to understand Asian art and philosophy. Okakura performed for Mrs. Gardner the Japanese tea ceremony by candlelight, and sent her a complete set of tea utensils from Japan in 1905. It was also to Gardner that he dedicated the libretto for an opera entitled *The White Fox*. On Okakura's death, Mrs. Gardner hosted an elaborate memorial service at Fenway Court. The new Chinese Room, constructed two years after Okakura's death, was a sacred space that repre-

Okakura Kakuzō, ca. 1900

And we sit under the trees, one of them sketches (not in our manner), one arranges flowers as only they can, and through it all we become far away and hear only Okakura's voice as he tells those wonderful poems and tales of the East. Perhaps tomorrow night I shall see them mistily coming up over the grass, the only light, their cigarette. It has really made the summer different.

— GARDNER, 1904

Okakura is still a great joy—so interesting, so deep, so spiritual, so feminine.

— GARDNER, 1904

[Bernard Berenson said to Mrs. Gardner] *the last day that although he had found her fascinating and wonderful before, he had never loved her until this time, for she had never been lovable. She wept at this, and said it was true, and perhaps she would have gone to her grave with her hard heart and selfish character if it had not been for a Japanese mystic named Okakura, who was attached to the Boston Museum as expert. He was the first person, she said, who showed her how hateful she was, and from him she learnt her first lesson of seeking to love instead of to be loved. She admitted that many of her bad habits remained, but said that the core of herself was quite different, and she wanted to get rid of old evils. It was really touching. She is truly one of the most astonishing personalities we have ever known, and at last we really care for her as a human being.*

— MARY BERENSON, 1914

Tea set given by Okakura to Mrs. Gardner

sented her mystical conception of the East. There she displayed Okakura's tea set, which suggests that the room also functioned to commemorate their close friendship.

— NORIKO MURAI, 2002

❧ *Mat Weights: Bears*

Chinese (Western Han dynasty), ca. 206 BC–AD 9
Bronze with remains of gilding, 15.5 cm
Purchased in 1914 from Marcel Bing, Paris, through Berenson.
Early Italian Room

Delightfully naturalistic, these two bears sit heavily and somewhat awkwardly on the ground. With one hind leg tucked under, each one opens its mouth in a friendly growl. The carefully observed depiction of the animals cannily matches their original function, for these bronzes were meant to weigh down the corners of straw or textile mats that were placed on low platforms for seating. Made in sets of four, mat weights have been excavated in aristocratic tombs of the Han dynasty. Often finely crafted, they appear to be highly prized personal possessions of daily use that were buried with their owners to represent the continuity between the living world and the afterlife.

Bears emerged as favored subjects in the art and literature of the Western Han dynasty. They may have been associated with protective nature spirits, although real bears could also have been seen in the royal zoo of the emperor Wudi (ca. 140–87 BC) at the capital Chang'an (present-day Xi'an). In fact, the bears in the Gardner Museum, which are unusually large mat weights, were found near Xi'an in 1900.

You will find them endlessly delightful, as nice as real ones, only more so.

— MARY BERENSON to GARDNER, 1914

The bears have come and are darlings – to live with, and delight in.

— GARDNER to BERENSON, 1914

Belt Buckle

Eurasian (South Ossetia, Georgia, and the north Caucasus),
ca. 1st or 2nd century
Bronze, 9.75 x 10 cm
Presented by Thomas Whittemore in 1920. Raphael Room

Framed within a border of spirals, a fantastical grouping of animals is depicted in profile on this belt buckle. The central figure is a deer with stylized antlers and mouth; sunken coils accentuate its musculature while echoing the tightly curled tail and the spirals in the border. Combined with the exaggerated proportions of its body, the overall effect is that of a rhythmically patterned decoration. A fish is located in the lower right corner, while a bird perches upon one of the deer's rear hooves. The barking dog in the upper left suggests that the buckle might depict a hunt. A raised loop and hook on the reverse side would have affixed the buckle to a textile or leather backing.

The Gardner Museum's belt buckle is closely related to objects excavated or discovered in Georgia and the Caucasus (in present-day Russia). Created as luxury items, such buckles may have drawn on earlier precedents crafted in gold or silver. The recurring appearance of deer in the material culture of the nomadic and semi-nomadic tribes stretching from the Black Sea to the steppes of Mongolia suggests that the animal had religious or totemic significance, as well as importance for the livelihood of these peoples.

— MICHELLE WANG, 2002

✌ Votive Stele

Chinese (Eastern Wei dynasty), 543
Limestone, 142.2 x 81.9 x 62.9 cm
Purchased in 1914 from Victor Goloubew, Paris, through Berenson.
Chinese Loggia

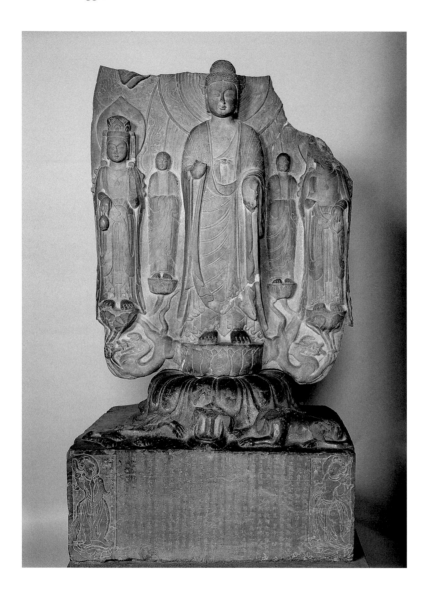

The front of the stele presents in high relief the Buddha Sākya-
muni in the center, whose right hand is held in the "fearless ges-
ture" (abhaya mudrā) and his left hand in the "charity gesture"
(vara mudrā). He is attended by the young disciple Ānanda and
the old disciple Kāsyapa, both with shaven heads and attired in
monastic robes. The Buddha is further flanked by the bodhisatt-
va Maitreya to his right, who holds a flask, and the bodhisattva
Manjusri to his left. The two bodhisattvas respectively embody
Compassion and Wisdom. The iconic ensemble as such, unique
in China, gained currency in the early sixth century. The bod-

But now that it is yours, let me tell you, that procuring it has been the greatest sacrifice I could possibly have made to my love of you, and to my interest in your collection. For this stele is incomparably the finest thing that thus far has come out of China, and the price is such a fraction of its market value that it was well within my means to get it for myself. I was not tempted not to do my best to persuade you to get it, but I retained a vague hope that you might refuse it, and that then I could in conscience keep it for myself. What a marvel it is!!!!!!

— BERENSON to GARDNER, 1914

Reverse

hisattvas exemplify Mahayana, or "Great-Vehicle" Buddhism, which is devoted to universal salvation. The monk-disciple figures are identified with Theravada, or "Small-Vehicle" Buddhism, which is preoccupied with personal salvation. Hence the bodhisattvas are shown on a larger scale than the disciples. Their aggregation suggests the Chinese Buddhist effort to subsume Theravada teachings under Mahayana Buddhism. This is partly the message conveyed by the Lotus Sūtra, which is the doctrinal basis for the stele here. The bodhisattvas Maitreya and Manjusri

are the two primary interlocutors of Sākyamuni who preaches the sūtra.

The universal salvation advocated by the Lotus Sūtra is further dramatized in the scene carved in low relief on the back of the stele, based on the chapter "The Emergence of Many-Treasure Stupa." The Buddha Sākyamuni, about to enter Nirvāna, or the "Great Extinction," joins Prabhūtaratna, the ancient Buddha from the past and distant land, in the latter's stupa, which hovers in the air. Sākyamuni then transports the entire ensemble witnessing the spectacle into Buddha's realms.

The Lotus Sūtra also urges the "voice-hearers" to practice the bodhisattva's way by transcending their self-absorbed discipline and embracing universalism and altruism. The two figures on the sides of the stele, an iconographic hybrid, visualize this moral. Their headgear suggests the attributes of a bodhisattva while their monastic robes identify them as disciple figures, sometimes equated with "voice-hearers." Their lesser standing relegates them to the sides of the stele. However, their partial possession of bodhisattva traits as symbolized by the headgear signals their eventual conversion to the bodhisattva way.

The stele base shows, on its two sides and back, ten Spirit Kings, indicated by their heads and the objects which they hold. They are, starting from the Buddha's left side, the Lion King, Bird King, Elephant King, River King, Mountain King, Tree King, Fire King, Pearl King, Wind King, and Dragon King. Drawn largely from the Nirvāna Sūtra, which was often studied in conjunction with the Lotus Sūtra in medieval China, the set of images refer to the gathering of nature gods from all quarters to attend to the Buddha's passing into Nirvāna. Having paid their final homage, they seat themselves on the sides, which explains their sitting posture in the relief carving.

On the front of the stele base is inscribed the votive, dated 543, which states that a "disciple of Buddha" named Luo Zikuan and seventy other people made the Sākyamuni statue for the emperor, seven generations of forebears, and the living beings. They hope that the sentient beings of the Dharma world will all convert to the Buddha's way. The inscription thus succinctly recapitulates the visual rhetoric of the sculptural program with its aspiration toward universal salvation.

— EUGENE YUEJIN WANG, 2002

❧ Seated Guanyin

Chinese (Song dynasty), 11th to 12th century
Wood with remains of color and gilding, 116.8 cm high
Purchased in 1919 from Parish-Watson, New York. Chinese Loggia

Bodhisattvas are enlightened Buddhist beings who have delayed entering Nirvāna in order to aid other sentient beings. The Chinese name Guanyin itself means "One who heeds the cries (of others)." Known as Avalokiteśvara in Sanskrit, Guanyin was first worshipped in India and subsequently introduced into China. As is customary, Guanyin is clad in the sumptuous garb of an Indian prince. This statue was once displayed as an icon in a Buddhist temple, and it seems fitting that Mrs. Gardner placed it over the doorway leading to her private chamber for meditation, which was filled with Buddhist icons and other Asian objects.

∾ *Pair of Folding Screens: Rice Cultivation in the Four Seasons,* ca. 1600

Japanese (Kanō school)
Six-part screens: ink and color on paper, each 171.4 x 381 cm

These finely painted screens depict the growing of rice in an imaginary Chinese village through the four seasons. Both the theme and the masterful brushwork are typical of the Kanō school, the predominant school of Japanese painting beginning in the fifteenth century. The left screen bears a seal of Kanō Motonobu (1476–1559), head of the school's second generation. The seal may be spurious, but compositional details of the screens resemble those on sliding doors at the Daisen-in, Kyoto, which are attributed to Motonobu's brother Utanosuke (ca. 1513–1575).

Reading each screen from right to left, the seasons are presented in the traditional order beginning with spring. Each scene depicts characteristic agricultural activities, with both young and old men working the fields as women and children tend to other activities. On the right of the first screen are the lush and abundant trees of spring. The overall mood is light-hearted as the fields are plowed by water buffaloes. On the left of the screen, the season shifts to summer as the first rice crop is transplanted. The autumnal harvest begins in the second screen: beneath rustling willow leaves, the grain is threshed and pounded. In the final vignette, snowy mountaintops and heavy skies frame the milling of rice.

Illustrations of rice cultivation were popular in sixteenth- and seventeenth-century Japan, and stretch back to Warring States China (481–221 BC). The subject had become popular in Japan through a handscroll attributed to the thirteenth-century Chinese painter Liang Kai, although the original is lost.

— MIDORI OKA, 2002

The Gardner screens were painted in very subdued colors, mostly black ink and sepia, in a technique called "ink painting" (suiboku-ga), based on a style of Chinese landscape that flourished in the court of the Southern Song emperors of the thirteenth century. Indeed, in the aesthetic values of the Kanō workshops, Southern Song ink painting was the classic ideal to which artists should strive, much as the nineteenth-century French academy placed Raphael at the pinnacle of artistic attainment.

Not only is the style of this painting of Chinese inspiration, but the theme itself, rice farmers living in peaceful harmony with nature through the year, reflects Chinese Confucian ideals of the tranquil society – ideals much promoted by the Japanese military government of the day.

— JOHN ROSENFIELD, 1993

❧ *Pair of Folding Screens: Scenes from the Tale of Genji,* 1677

KANŌ TSUNENOBU

Japanese, 1636–1713
Six-part screens: color and gold on paper, each 170 x 379 cm
Possibly purchased in 1883 in Japan.

Nestled amid the golden clouds in this vibrant pair of screens are depictions of twelve chapters from the *Tale of Genji,* one of the world's earliest novels. Written around the year 1000 by Murasaki Shikibu, a lady-in-waiting at the court in Kyoto, the story vividly portrays courtly customs through an intricate web of human relations. The protagonist Genji epitomizes the ideal male persona of the time: strikingly attractive and a master of all the arts, he was also a great lover. Indeed much of the long novel revolves around his liaisons with women of the court.

The earliest illustrations of the *Tale of Genji* are handscrolls of the early twelfth century. These paintings not only set the stylistic standards of the *yamato-e* (pictures of *yamato,* or Japan), but also influenced later renditions of the novel. This influence is apparent here in the bird's-eye–view perspective and thick layering of pigment. The diagonal lines that run through the architectural elements heighten the emotional intensity of the scenes.

Although convention dictated that characters from the *Tale of Genji* should be shown devoid of emotion or individualization, the screens contain many interesting details. The musicians dis-

Genji and Tō no Chūjō danced "Waves of the Blue Ocean." Tō no Chūjō was a handsome youth who carried himself well, but beside Genji he was like a nondescript mountain shrub beside a blossoming cherry. In the bright evening light the music echoed yet more grandly through the palace and the excitement grew; and though the dance was a familiar one, Genji scarcely seemed of this world. As he intoned the lyrics, his listeners could have believed they were listening to the Kalavinka bird of paradise. The emperor brushed away tears of delight, and there were tears in the eyes of all the princes and high courtiers as well.

— MURASAKI SHIKIBU, ca. 1020

play an unusual range of facial expressions: some converse with one another, while one puffs out his cheeks to play a wind instrument. Such expressive displays can be seen in other Genji illustrations by the seventeenth century, but they are usually reserved for commoners and not the nobility who were considered composed at all times.

Also remarkable are the monochromatic ink landscapes drawn on the sliding doors and screens in the palace interiors depicted in the screens. These meticulously painted landscapes, dragons, birds, and flowers contrast sharply with the colorful screens themselves. This disparity might be intended to emphasize that the screens were a product of the Kanō school, whose painting styles and techniques were derived from Chinese ink painting (the *kara-e* pictures of Tang China) as opposed to *yamato-e*.

— MIDORI OKA, 2002

The Nineteenth Century

The Blue Room

Mrs. Gardner's earliest acquisitions were contemporary paintings chosen to decorate her Beacon Street house, modest examples of the artists favored by more adventurous Boston collectors of her day. The earliest acquisition still in the collection is Charles-Emile Jacque's pastoral scene bought in 1873; later, she acquired landscapes by Corot, Courbet, and Ziem, all in 1880, and, within two years, works by Delacroix and Diaz, none of particular distinction. However, by the end of the decade, her collection contained three works by James McNeill Whistler, including a small pastel portrait of herself. And two years later, she turned to the greatest portrait painter of the day, John Singer Sargent, who created a spectacular full-length likeness and became one of her closest friends and a confidant in the development of her collections.

Given her active involvement with the musicians of Boston, Mrs. Gardner's lack of interest in the city's artists, whose placid paintings enjoyed considerable national fame, is significant in understanding her taste. The one exception was the young Denis Miller Bunker, who died when he was only twenty-nine, shortly after he had given her one of his finest works, a painting of banks of chrysanthemums in her Brookline greenhouses (p. 208). Their friendship nurtured her decision to purchase a most sensitive figural piece by the New Yorker Thomas Dewing, a work that otherwise seems quite removed from her taste.

As early as 1878, Isabella Stewart Gardner started to attend Charles Eliot Norton's lectures at Harvard, the first art history courses taught there. Norton's words unquestionably helped her develop her taste; his ideas had been greatly influenced by his friend, the revered English art critic John Ruskin. Mrs. Gardner must have been sympathetic to Ruskin's great involvement in "faith" as a factor in his judgments – and to his vividness in describing Italy, most notably Venice, a city she so loved. She owned a drawing by Ruskin of a Venetian facade. The fact that she later acquired works by J. M. W. Turner and Dante Gabriel Rossetti, two artists greatly admired by Ruskin, suggests the continuing strength of that influence.

The immense effort Ruskin invested in painting details of architecture and sculpture, as well as of nature, came to influence Harvard's philosophy of teaching, which encouraged copying works of art as the best means of understanding them. A number

of the Boston artists who most interested her were closely allied with this approach, among them Joseph Lindon Smith, whose nuanced painting of the bust of Akhenaton in the Louvre hangs in the Blue Room (p. 188). Elsewhere in the museum hang works by others who carried on this tradition in their teaching, for example Arthur Pope, who was also one of her first trustees, and Martin Mower, who painted a telling portrait of Mrs. Gardner. The one other collector in Boston who challenged her in stature, Denman Ross, was very much of this circle; his various gifts, including a charming beach scene, which hangs in the Blue Room, may surely be seen as tokens of his great respect.

In 1884, visiting Venice for the first time since her youth, she rediscovered the delights of the city and for some time thereafter she would spend considerable time there. She bought a lovely Venetian scene by Ralph Curtis that epitomized the city's nostalgic charm. Curtis also advised her, negotiating the following year her purchase of Mancini's dazzling *Standard Bearer*.

However, once she had formulated her "big" idea – the creation of this great collection and its spectacular setting – and when she could act because of the fortune she inherited from her father, she would pursue far more ambitious goals. While henceforth she concentrated upon the arts of the past, there were a few more modern acquisitions, ones that happily enlarged the impact of her earlier achievement in this area, notably two much finer Whistlers and handsome portraits by Degas and Manet. The spontaneity of judgment that characterized her collecting was clearly evident in her decision, on the spot, to purchase Anders Zorn's *Omnibus*, a work by an artist then totally unknown to her, when first she saw it at a preview of the 1893 World's Columbian Exposition in Chicago.

— EVAN H. TURNER, 2002

∾ The Roman Tower, Andernach, 1817

J. M. W. TURNER, British, 1775–1851

Watercolor on paper, 20 x 28 cm
Purchased in 1890 at the London auction of the collection of Walter
Fawkes. Yellow Room

After the defeat of Napoleon, Europe was again open to travel and in 1817 J. M. W. Turner visited the battlefield of Waterloo and journeyed up the Rhine River. On his return to England, he produced a large number of watercolors based on graphite sketches he had made of the Rhine. Fifty-one of these drawings, including this one, were acquired by Walter Fawkes of Farnley Hall, one of Turner's most important patrons as well as a close friend. Although not made on the spot, this drawing preserves a freshness and spontaneity. Throughout his career, Turner adjusted his watercolor technique to the scenery he encountered, and as a result, each set of drawings possesses an individual style.

When Mrs. Gardner acquired this watercolor, she was still feeling her way as a serious collector. She was initially interested in British art, and the purchase of this watercolor by Turner, as well as a painting by Dante Gabriel Rossetti – both bought at auctions of famous collections at fairly high prices – shows her determination to start at the top. However, despite talk of buying Gainsborough's celebrated *Blue Boy*, her interest in British pictures soon fizzled.

— ALAN CHONG, 2002

Portrait of Madame Auguste Manet, 1863

EDOUARD MANET, French, 1832–1883

Oil on canvas, 98 x 80 cm, signed lower right: Manet
Purchased in 1910 from Wallis and Son, London, through Berenson.
Blue Room

This portrait of the artist's mother, Eugénie-Désirée Fournier Manet, shows her dressed in mourning for her husband, who had died the year before. The thick swatches of black and dark gray paint that form the dress resonate against the lighter, flat paint of the face and hands. The painting is essentially monochromatic and possesses a solidity reminiscent of Manet's beloved Velázquez. Bernard Berenson called the work "a colossal thing."

Manet's mother had encouraged his painting from the beginning, and she remained a close confidante. His stepson described the relationship between Manet and his mother as more than close: "Edouard Manet did not have just an ordinary filial affection for his mother, but rather a real obsession."

In 1909, Isabella Stewart Gardner asked Berenson to find her a portrait by Manet, perhaps to accompany her portrait of Madame Gaujelin by Degas (p. 194). Both sitters present severe personalities, and both painters found an underlying sympathy beneath these formidable exteriors.

— RICHARD LINGNER, 2002

◌ *Portrait of Joséphine Gaujelin*, 1867

EDGAR DEGAS, French, 1834–1917

Oil on canvas, 61.2 x 45.7 cm, signed upper left: Degas. 1867
Purchased in 1904 from Eugene Glaenzer and Co., New York.
Yellow Room

Monsieur Degas has a very pretty little portrait of a very ugly woman in black, with a hat and a cashmere shawl falling from her shoulders. The background is a very light interior, showing a corner of a mantelpiece in half tones; it is very subtle and distinguished.

— BERTHE MORISOT, 1869

Even a veteran may feel with the joyful recognition of a masterpiece a moment of repulsion. This woman is disquieting. How strangely an almost sullen discontent contrasts with the milieu.

— FRANK J. MATHER, 1907

For the portrait is, if one may say so, an intimate one, and is a most astounding revelation of character. The steady gaze of the controlling eyes above the quiet but resolute mouth is so astonishing as to mark the picture as something absolutely unique, something almost haunting in the perseverance of its impression. The person who might speak and who does not, whose lips and deeds are controlled by the mind, is told here in this astonishing way.

— JOHN LA FARGE, 1907

Joséphine Gaujelin (or Gozelin) was a dancer at the Opéra in Paris and later an actor at the Théâtre du Gymnase. Degas used her as a model on several occasions, for example as a ballerina in his *Classe de danse* (Metropolitan Museum of Art). In this portrait, she appears in street clothes, sitting in her dressing room. Wrapped entirely in black, she sits rigidly, with arms clenched to her sides. The dour expression and reserved demeanor belie her reputation as a charismatic beauty. The portrait is almost deliberately unglamorous, although the intensity of the sitter's gaze is compelling, if not disconcerting to some viewers. Gaujelin, who had commissioned the portrait, rejected it. However, Degas exhibited it in the Paris Salon of 1869 (titled *Portrait de Mme G…*). Mrs. Gardner heard that Gaujelin was angry that it was coming to America.

Isabella Stewart Gardner was not a collector of Impressionism, but Degas was an exception, undoubtedly because of his serious attention to historical painting. She may have seen his paintings at the Chicago World's Columbian Exposition in 1893. In addition to this portrait, Mrs. Gardner also owned a drawing of a ballet dancer and four other drawings by Degas.

— RICHARD LINGNER, 2002

Isabella Stewart Gardner and James McNeill Whistler enjoyed a long relationship that began as patron and artist, but gradually grew into a warm friendship. Whistler was one of the first contemporary artists from whom Mrs. Gardner bought art, and she seemed to crave the entrée he provided into the European art world. The relationship benefited both: Mrs. Gardner acquired fine examples of his work; Whistler gained an enthusiastic client.

Henry James introduced Mrs. Gardner to Whistler in 1879, while the Gardners were in London with their three nephews. This was shortly after Whistler's bankruptcy, so he must have relished the opportunity to cultivate a new, rich American patron. In 1884, Whistler invited her again to his studio, and later that year sent Mrs. Gardner a hand-written copy of his "Proposition," which elaborated his famous art-for-art's-sake argument. By 1886, the Gardners were visiting Whistler's studio frequently and dining together regularly. Isabella sat for a portrait (*The Little Note in Yellow and Gold,* p. 197) and bought two other small works – her first purchases from him. Over the next several years, she acquired complete sets of the Venice etchings and a large number of his London and Paris prints.

In 1892 in Paris, Gardner visited Whistler again and bought *Harmony in Blue and Silver: Trouville.* The Gardners and Whistlers twice went to see the Folies Bergère. Afterwards, Mrs. Gardner was eager to see drawings Whistler made of a dancer there.

Mrs. Gardner understood that Whistler was a major force in the art world, and equally conceived of herself as an important philanthropist. Beginning in 1893, she attempted to buy Whistler's celebrated Peacock Room to give to the Boston Public Library. John Singer Sargent supported her efforts and wrote, "I have often thought that there ought to be an attempt to incorporate the peacock room into the library." He wrote again to Gardner in 1895, "How can you let the peacock room belong to anybody else!" In 1897, Violet Paget, a childhood friend of Sargent and an accomplished author who wrote under the name Vernon Lee, urged her, "Certainly the Peacock Room is one of the greatest things modern art has produced, and if you can 'pick up its pieces' or cause them to be re-created, you will have done a fine thing for the future." Unfortunately, these efforts were fruitless: Charles Freer bought the room in 1904.

To Mrs Gardner – Whose appreciation of the work of Art is only equalled by her understanding of the Artist!

— WHISTLER to GARDNER, book dedication, 1899

Mrs. Gardner's final purchases from Whistler were a nocturne – a nice complement to her early seascape – and another pastel. In a final act of friendship, Whistler presented Mrs. Gardner with his bamboo walking stick as a token of his affection.

— RICHARD LINGNER, 2002

The Little Note in Yellow and Gold, 1886
James McNeill Whistler
Chalk and pastel on brown paper, 27 x 14 cm
Purchased in 1886 from the artist in London.
Veronese Room

Harmony in Blue and Silver: Trouville, 1865

JAMES McNEILL WHISTLER, American, 1834–1903

Oil on canvas, 49.5 x 75.5 cm
Purchased in 1892 from the artist in Paris. Yellow Room

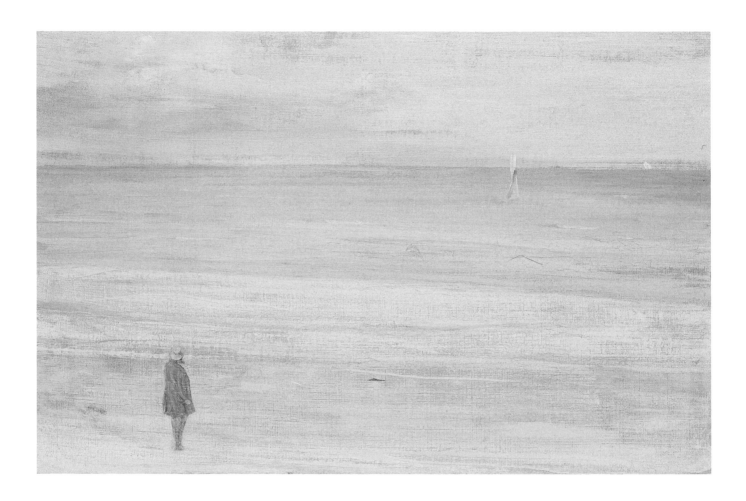

This picture, painted in the autumn of 1865 when Whistler worked alongside the artist Gustave Courbet at Trouville, marks an important moment in the development of Whistler's art. In the late 1850s and early 1860s, Courbet's defiantly unconventional paintings and persona had provided an important model for Whistler. *Harmony in Blue and Silver* is at once a tribute to Courbet's influence and an assertion of the younger artist's move toward more exclusively aesthetic concerns and an independent painting style. Titled by Whistler in 1866 as *Courbet – on sea shore*, the painting echoes the composition of Courbet's *Les bords de la mer à Palavas* (1854). Yet, while it refers to that picture and represents the figure of Courbet within its composition, *Harmony in Blue and Silver* is a turning point in the emergence of what would come to be Whistler's mature painting mode, a radical reduction

of painting to thin veils of color brushed across canvas. Whistler's growing commitment to the purely formal elements of painting is apparent in the way in which the calm expanses of sand, sea, and sky approach the abstraction of pure bands of color; yet at the same time, thin washes of a pale lavender color suggest shifting lights and depths in the water and the air.

In this painting, a dynamic tension between surface pattern and the evocation of expansive space is reinforced by the ambiguous direction of the gaze of Courbet's small figure at the lower left. If the figure's head is turned toward the right, then he gazes diagonally across the sands, with his "Assyrian" beard visible in profile, though wearing his hat at an oddly precarious angle. Alternatively, the figure might be looking straight out to sea, as the hat's placement tends to suggest. The ambiguous direction of the figure's gaze may be taken to relate to the picture's suspension between flat immediacy and expansive depth: in one reading, the figure directly confronts the flat bands of color; in the other reading, the figure gazes across a sea that recedes toward a vanishing point defined by a sailboat in the middle distance and a second boat on the far horizon.

Whistler remained attached to this painting, and after he sold it, he bought it back a few years later. He was loathe to part with it once it had been returned to his studio in 1892. One version of the story of Mrs. Gardner's acquisition of the painting goes as follows: She fell in love with the picture when she saw it in Whistler's Paris studio. The artist reluctantly agreed that she could have it, but showed no signs of relinquishing it to her. Impatient, Mrs. Gardner returned with a friend whom she had coached in advance. She told the artist: "That's my picture… you've said many times I could have it, Mr. Whistler, and now I'm going to take it." Her companion took the painting and started out, followed by Mrs. Gardner, who blocked the way as Whistler followed, complaining that the picture was not finished because he had not signed it. Mrs. Gardner refused to listen, inviting the artist to lunch at her hotel, where he could then sign the picture.

— AILEEN TSUI, 2002

Nocturne, Blue and Silver: Battersea Reach, ca. 1872–78

JAMES MCNEILL WHISTLER, American, 1834–1903

Oil on canvas, 39.4 x 62.9 cm
Purchased in 1895 from the artist in Paris. Yellow Room

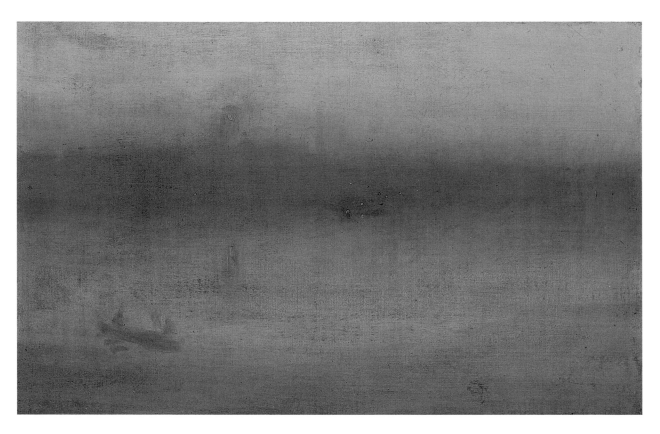

Whistler was living in Chelsea, across the Thames from Battersea, when he painted this nocturne. He brushed thinned pigment across the canvas in bold, sweeping strokes, modulating the tone of the blue only slightly to create the subtle gradations that separate river, shore, and sky. Specks of orange and yellow mark the position of boats on the water, lights on the shore, and a clock tower in the distance.

Whistler's paintings represent impressions and sensations. And in their devotion to rendering sensation, images like this one appealed to a generation of sexual radicals like Oscar Wilde, who sought not the accurate, imprisoning depiction of desire found in Victorian novels but an oblique art that would provoke irresponsible reveries, that would act as a sort of narcotic, hypnotizing the viewer. Whistler depicts sexual sensation and identity without seeming to. I see in these paintings evidence of Mrs. Gardner's Wildean sensibility and I see the entire museum as a correlative to these shadowy tone poems.

— WAYNE KOESTENBAUM, 1996

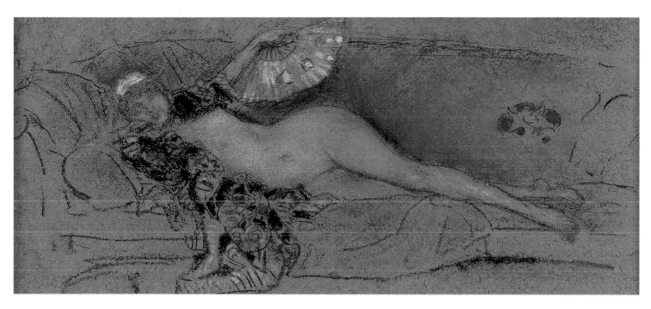

The Violet Note, 1885–86
James McNeill Whistler
Chalk and pastel on brown paper, 26 x 18 cm
Purchased in 1886 from the artist in London.
Veronese Room

Lapis Lazuli, 1885–86
James McNeill Whistler
Chalk and pastel on brown paper, 13 x 26 cm
Purchased in 1895 from the artist in Paris. Veronese Room

Forgive the shortest and most abrupt note that was ever written by ill mannered man – but I live now in a whirl of hurry, and so have only the moment to say that I shall be delighted to dine with you on Friday night at 7:30 – Of course to paint the little picture will be a joy.
— WHISTLER to GARDNER, 1886

Your visit has been most charming to me – and I only wish you carried away a more brilliant proof of my apreciation – However you rather beat me in the hurry of things this time! – but you must give me my revanche when I come to Boston.
— WHISTLER to GARDNER, 1886

Isabella Stewart Gardner hung these little works together, in their original frames, against the gilt leather of the Veronese Room. The overt sensuality of *Lapis Lazuli* and *The Violet Note* were surely meant to be linked with her own portrait in *The Little Note in Yellow and Gold* (p. 197).

Lady in Yellow, 1888

THOMAS WILMER DEWING, American, 1851–1938

Oil on wood, 50.2 x 40 cm, signed lower right: 88 / T. W. Dewing
Purchased in 1888 from the artist. Yellow Room

Full yet subtle in color, charming in slender elegance of form, lovely in the dainty characterization of the head, yet with a sufficient concession to the average idea of reality to offend no one.

— KENYON COX, 1902

Dewing's little portrait of a young girl in lemon-colored tulle, seated on a yellow chair, was one of the sensation's of this year's Academy – a harmony of colors and effect Whistler might have envied. The little study in an oriental frame shows how a plain, pale-faced woman can be painted firmly and quietly with reserve rather than any attempt at effect, and yet, with what distinction. Mr. Dewing is possessed of a most remarkable and original turn of genius, and ought certainly to do great things.

— *Chicago Journal*, 1888

Dewing created a striking contrast between the precisely modeled face and arms, and the very free, feathery brushstrokes of the dress. The painting was exhibited in 1888 at the Boston Art Club, where it was purchased by Isabella Stewart Gardner with the help of Denis Miller Bunker. The painting was then exhibited to considerable acclaim at the National Academy of Design and at the Paris Universal Exposition of 1889. Mrs. Gardner hung the painting in the Yellow Room, a setting perfectly attuned to the hue of the woman's dress.

∾ *Madame Gautreau Drinking a Toast*, 1882–83

JOHN SINGER SARGENT, American, 1856–1925

Oil on wood, 32 x 41 cm, signed upper right: à Me Avegno
témoignage d'amitié / John S. Sargent.
Purchased in 1919 from the collection of Samuel Pozzi, Paris.
Blue Room

Madame Gautreau's profile shines against a darkened interior. Raising a glass in a toast, her arm stretches laxly over a sumptuous arrangement of pink flowers. Sargent dedicated this painting to the sitter's mother, Madame Anatole Avegno. At a later date it was acquired by Dr. Samuel Pozzi, reputedly the sitter's lover. Mrs. Gardner purchased it, along with the equally sensuous watercolor, Incensing the Veil, *at Pozzi's estate sale in 1919.*

— TREVOR FAIRBROTHER, 1994

Madame Pierre Gautreau, born Virginie Avegno (1859–1915), was Madame X, the statuesque sitter in Sargent's most notorious portrait (Metropolitan Museum of Art, New York). Critics considered the portrait in scandalously bad taste, and the sitter's mother asked Sargent to withdraw the painting, which he refused to do. This much smaller and more intimate painting was done a year earlier, and was given by Sargent to Madame Gautreau's mother. By purchasing this painting at the end of her life, Mrs. Gardner acquired an important document of Sargent's career, and also a slice of her own history, since she had wanted her portrait by Sargent to rival the sensuous impact of the infamous *Madame X.*

Portrait of Isabella Stewart Gardner, 1888

JOHN SINGER SARGENT, American, 1856–1925

Oil on canvas, 190 x 80 cm, signed upper left: John S. Sargent; upper right: 1888
Commissioned in 1888 from the artist. Gothic Room

Mrs. Gardner sat for Sargent during his visit to Boston in January 1888. He was paid $3000 for the portrait, which was exhibited to great acclaim at Boston's St. Botolph Club. The work also inspired gossip and legend: someone jokingly titled it "Woman: An Enigma," while others believed that the sensuous display of flesh deliberately echoed the scandal recently created by Sargent's *Madame X*. Mrs. Gardner herself said that she rejected eight renderings of the face before she was satisfied. Jack Gardner seems to have asked his wife not to publicly show the portrait again while he was alive, and indeed the portrait was placed in the Gothic Room, which remained private until Mrs. Gardner's death. In its gallery, surrounded by altarpieces, stained glass, and religious statuary (p. 16), the sacramental quality noted by nineteenth-century reviewers is even more pronounced.

The most dashing of fashion's local cynosures, who can order the whole symphony orchestra to her house for a private musicale, was presented in a demure though décolleté black dress, with her head enclosed as by an aureole, in the Oriental arabesque of a dado, against which she stands, as if in testimony of her devotion to the fashionable Hindoo cult. The mystic smile – if smile it be – upon the quivering lips of this portrait was the prime tour de force of the whole exhibition, and the discussion is still hot as to what that smile signified or what it concealed.
– The Art Amateur, 1888

The artist and his forty-seven-year-old sitter conspired to concoct a sensation. The symmetrical composition and decorative background evoke an enshrined deity; the rather severe, tight, décolleté Parisian gown silhouettes her figure and sets off her rubies and pearls; and the unusual pose helps transform a rather plain woman into a complicated, glamorous, and iconic presence. The picture challenges viewers with its ambiguous double characterization of dominating femme fatale and gracious queen of cultural life. It proved to be the most modern and quirky portrait painted in Boston in the nineteenth century.
— TREVOR FAIRBROTHER, 2000

The canvas might be called "The American Idol." Rubies, like drops of blood, sparkle on her shoes. Her slender waist is encircled by a girdle of enormous pearls, and from this dress, which makes an intensely dark background for the stony brilliance of the jewels, the arms and shoulders shine out with another brilliance, that of flower-like flesh – fine, white flesh, through which flows blood perpetually invigorated by the air of the country and the ocean. The head, intellectual and daring, with a countenance as of one who has understood everything, has, for a sort of aureole, the vaguely gilded design of one of those Renascence stuffs which the Venetians call sopra-risso. It is a picture of an energy at once delicate and invincible, momentarily in repose, and all the Byzantine Madonna is in that face, with its wide-open eyes....

This woman can do without being loved. What she symbolizes is neither sensuality nor tenderness. She is like a living object of art, the last fine work of human skill, attesting that the Yankee, but yesterday despairing, vanquished by the Old World, has been able to draw from this savage world upon which fate has cast him a wholly new civilization, incarnated in this woman, her luxury, and her pride.

— PAUL BOURGET, 1895

It looks like h--l but it looks just like you.
— JOHN L. GARDNER, 1892

❧ *A Tent in the Rockies,* 1916

JOHN SINGER SARGENT, American, 1856–1925

Watercolor on paper, 39.2 x 53.2 cm, signed lower left: John S. Sargent
Purchased in 1916 from Sargent's Boston exhibition of Rocky
Mountain landscapes. Blue Room

*No more paughtraits whether refreshed or
not. I abhor and abjure them and hope
never to do another especially of the
Upper Classes.*

— JOHN SINGER SARGENT, 1907

*I am camping under that waterfall that
Mr. Denman Ross gave me a post-card of
– it is magnificent when the sun shines
which it did for the two first days. I began
a picture – that is ten days ago – and since
then it has been raining and snowing
steadily – provisions and temper getting
low – but I shall stick it out till the sun
reappears.... Your handkerchiefs are in
constant use and still hold out in spite of a
dripping nose and cold feet.*

— JOHN SINGER SARGENT to
GARDNER, 1916

In 1916, Sargent came to Boston to continue work on murals for
the Boston Public Library; he also accepted a new commission for
the Museum of Fine Arts. In July 1916, almost as an escape from
these large-scale figural projects, he headed off to the Rocky
Mountains to paint landscapes. He spent much of his time in
Yoho Falls, British Columbia. As a going-away gift, Isabella
Stewart Gardner presented Sargent with some Japanese handker-
chiefs, and she in turn was promised a painting from the
expedition.

Around this period, Sargent was seeking to free himself from
the confines of society portraiture. He was unprepared, however,
for the physical demands of life in the wilderness. With a guide
and servant, Sargent braved the elements to sketch and paint out-
doors. In this watercolor, the gleaming white tent — Sargent's own
abode – fascinated the artist as much as the surrounding dark
forests.

*It was raining and snowing, my tent flooded, mushrooms sprouting
in my boots, porcupines taking shelter in my clothes, canned food
always fried in a black frying pan getting on my nerves, and a fine
waterfall which was the attraction to the place pounding and thun-
dering all night. I stood it for three weeks and yesterday came away
with a repulsive picture...I am off again to try the simple life (ach
pfui) in tents at the top of another valley...It takes time to learn
how to be really happy.*

— JOHN SINGER SARGENT, 1916

∾ *Chrysanthemums,* 1888

DENIS MILLER BUNKER, American, 1861–1890

Oil on canvas, 90 x 121 cm, signed lower right: DENIS BUNKER / 1888
Purchased in 1889 from the artist. Blue Room

Bunker made this picture after returning to Boston from a summer spent in England painting with John Singer Sargent. Sargent and Bunker had been experimenting with Impressionism, and under the influence of Claude Monet, they worked outdoors and used a bright palette applied in broken brushstrokes. Bunker struggled at first and complained to Mrs. Gardner that he had "ruins of numerous works, for I've not been idle," but he continued with the style. Bunker adopted elements of Impressionism in this painting of blooming flowers in the greenhouse at Green Hill, the Gardners' summer residence in Brookline.

Despite the painting's importance as one of the earliest examples of American Impressionism, Mrs. Gardner was not much interested in Impressionist landscapes. In the early 1890s, John Singer Sargent alerted her to the upcoming sale of a famous Monet painting, but she never pursued it. She acquired portraits by Degas and Manet, and in 1906 visited Claude Monet at Giverny, an event she found "perfect in every way." She was aware of contemporary art movements: she lent pictures to the 1893 World's Columbian Exposition in Chicago and even served on the organizing committee of the 1913 Armory Show. One must conclude that Bunker's work appealed to her more for its subject and personal associations than for its style.

— RICHARD LINGNER, 2002

*Please let Violet and me know when the
Chrysanthemums are out.*

— JOHN SINGER SARGENT to
GARDNER

❧ *A New York Blizzard,* probably 1890

CHILDE HASSAM, American, 1859–1935

Pastel on gray paper, 35 x 24 cm, signed lower left:
Childe Hassam. N.Y. Blue Room

In *A New York Blizzard* Childe Hassam evoked with vivid calligraphy a few well-dressed pedestrians buffeted by blowing snow. So hastily did he draw the scene that one can even imagine his working outdoors during a blizzard! This lively sheet signals Hassam's role as the principal American Impressionist interpreter of New York City, announces his command of the then popular pastel medium, and includes some of his favorite devices.

Born in Dorchester, Massachusetts, Hassam studied in Boston, worked as an illustrator, and by 1885 was painting urban scenes unprecedented in America. Following a path familiar to aspiring American artists, he went to Paris in 1886 and enrolled in the popular Académie Julian. More nourishing than formal study in Paris was Hassam's exposure there to a banquet of works by Academics, by conservative realists whose canvases had inspired his Boston cityscapes, and by Impressionists. Hassam was exceptional for his sympathy to Impressionism during the late 1880s; most of his compatriots would adopt the style only in the 1890s.

Rather than returning to Boston, Hassam settled in New York in 1890 and began a pattern of alternating winters in the city with summers in various New England locales. "I believe the man who will go down to posterity is the man who paints his own time and the scenes of every-day life around him," he insisted in 1892. Yet, confronting a bewildering time when agrarian values gave way to urbanization and industrialization, he portrayed urban and rural America as if through rose-colored glasses. In New York, for example, he ignored the new heterogeneity and hardships, romanticized symbols of modernism such as skyscrapers, and emphasized fast-fading Gilded Age gentility.

A New York Blizzard reiterates motifs that had appeared even in Hassam's earliest Boston scenes. Figures are challenged by, but do not suffer in the snow, which Hassam often depicted to soften sharp edges of buildings and muffle urban clatter. A nostalgic note is provided by the prominent gas lamp, a vestige of older technology that would soon give way to electricity. The monochromatic triad of silhouetted black coats and umbrellas, white snow, and gray paper suggests Hassam's interest in flat pattern and design, which accords with his selective – not journalistic – interpretation of "his own time."

— H. BARBARA WEINBERG, 2002

Isabella Stewart Gardner met the Swedish painter Anders Zorn at the 1893 World's Columbian Exposition in Chicago. She had lent her painting by Paul Helleu, and Zorn was the commissioner of the Swedish pavilion. They happened to meet in front of Zorn's painting, *Omnibus*, which Isabella bought on the spot. They immediately became friends: she brought him to Boston, lined up portrait commissions, sat for an etched portrait herself, and even held a small birthday concert in his honor. Gardner acquired five of his paintings and numerous etchings.

Zorn grew up in Mora, a small town in central Sweden. After studying at the royal academy in Stockholm, he worked in London in the early 1880s, painting society portraits, and then lived in Paris between 1888 and 1896. Many Swedish artists moved to Paris at the time to escape the rigidity of the Swedish academy, although they were dedicated to preserving the special character of Swedish society, especially the traditions of the countryside. While Zorn painted portraits to great acclaim, he also depicted the rural traditions of Sweden. Zorn's paintings of nudes in landscapes were popular in Sweden, but almost totally unknown in America, making Gardner's example of the genre particularly important.

— RICHARD LINGNER, 2002

The Morning Toilet, 1888
Anders Zorn
Oil on canvas, 60 x 36 cm, signed lower right: Zorn / 88
Probably purchased in 1894. Veronese Room

My Model and My Boat, 1894
Anders Zorn
Etching, 23.8 x 15.8 cm, signer lower center: Zorn / 1894; lower right: Dalarna
The impression is inscribed: Souvenir of my last summer 1894 incomplete
proof to Mrs. Isabella Gardner aff[ectionately] Zorn

❧ *Omnibus,* 1892

Anders Zorn, Swedish, 1860–1920

Oil on canvas, 126 x 88 cm, signed lower right: Zorn – Paris 1892
Purchased in 1893 from the artist. Blue Room

Why was Mrs. Gardner so drawn to this work when she saw it in Chicago? It is a thoroughly modern painting: the subject is contemporary urban life – people sitting on a Paris trolley – and the style is Impressionist, although the Impressionists never really painted the dreary aspects of public transportation. Zorn depicts the isolation and sadness that comes with industrial progress, even as people are more crowded together.

It has been reported that Mrs. Gardner rode the streetcars of Boston, and thus could have identified with the well dressed women riders. And, if a bit of speculation is allowed, the woman in the foreground, apprehensive yet eager, leaning and looking forward, mirrors the aspect of Mrs. Gardner at this moment in her life – about to embark on a serious career of collecting.

— RICHARD LINGNER, 2002

Isabella Stewart Gardner in Venice, 1894

ANDERS ZORN, Swedish, 1860–1920

Oil on canvas, 91 x 66 cm, signed lower left: Zorn – / Venezia 1894
Given in 1895 by the artist. Short Gallery

The other is a portrait of me – astounding! A night scene, painted at night. I am on the balcony, stepping down into the salone pushing both sides of the window back with my arms raised up and spread wide! Exactly like me.

— GARDNER to JOSEPH LINDON
SMITH, 1894

I have, as you told me, tried hard to keep up to your portrait, but alas all my subjects are not Mrs. Gardner and the backgrounds not Canale Grande.

— ANDERS ZORN to GARDNER,
1896

While visiting the Gardners in Boston in February 1894, Anders Zorn made an etching of Mrs. Gardner, which neither of them considered to be a complete success. Later that year Zorn and his wife visited the Gardners in Venice, staying for several weeks as their guests in the Palazzo Barbaro. He attempted again to make a portrait of Mrs. Gardner, but continued to struggle with the task. One evening, Mrs. Gardner stepped out onto the balcony to see what was happening outside, and as she came back into the drawing-room, pushing the French windows open, Zorn exclaimed (according to Morris Carter): "Stay just as you are! That is the way I want to paint you." He went instantly for his materials, and then and there the portrait was begun.

— RICHARD LINGNER, 2002

A final emblem of Mrs. Gardner's Blanche DuBois-like penchant for self-dramatization is Anders Zorn's portrait of Gardner in Venice, which shows her like a flame burning brightly. With her long neck and flamboyantly outstretched arms, she is surely a woman who took performance seriously and who felt an affinity with the dancer in El Jaleo. *Standing at the edge of a balcony, she invites her guests to watch the display of fireworks at a Venetian festival. But she, not the fireworks, is on display. She stands in our way as if to say: look at me, not at the more traditionally exciting spectacle outside. She distracts us and puts forward her own glamour as art – not an intervention in the cause of art, but as a worthy spectacle in its own right. She reminds us, in other words, to listen to the complexities of female performance, and not to take it as subordinate to works of artifice such as painting.*

— WAYNE KOESTENBAUM, 1996

Portrait of Isabella Stewart Gardner, 1894
Anders Zorn
Etching, 25 x 21 cm, signed lower left: ZORN
[monogram] Boston 13 febr. 1894
Commissioned in 1894.

Silver Box, 1897

CHRISTIAN ERIKSSON, Swedish, 1858–1935

Silver, 7.2 x 16.5 x 9.5 cm, signed: Chr. Eriksson Paris 97
Commissioned in 1895 through Anders Zorn; delivered in 1897.
Dutch Room

Christian Eriksson studied in Stockholm, worked as a furniture maker in Hamburg, and then lived in Paris between 1883 and 1897 before returning to Sweden. He made portraits and large-scale sculptures for Swedish public buildings, including two monumental sandstone reliefs for the facade of Stockholm's opera house (1907).

Much of Eriksson's early work consists of small-scale vases and vessels in silver and bronze. This delicate hinged box shows a girl partly submerged in a stone tub – almost a travertine fountain. She ripples the water, an effect beautifully rendered in the worked surface of the silver. Two figures (her parents, according to Anders Zorn) decorate the sides of the tub. Playful in design and finely crafted, the object combines Swedish themes with the spirit of Parisian art nouveau.

The painter Anders Zorn arranged for Eriksson to make the box for Mrs. Gardner. He may also have helped select the theme, since bathing was one of Zorn's favorite subjects, and Gardner already owned Zorn's painting of a mother and child bathing in a stream (p. 212). Zorn had earlier offered to make a jewelry box for Mrs. Gardner. Zorn's completed object (Zorn Museum, Mora) is very similar in style and concept to Eriksson's box, but Zorn was loathe to part with it, and Gardner never received it.

Eriksson described his idea like this: papa and mama forming handles on each end and washing themself, and the little daughter on the cover or top stepping into water which thus in motion forms rings and so on – It does sound lovely and I don't know if it is commenced or not – Some time since I saw him. Anyhow don't hurry him but let him have his time.
— ANDERS ZORN tO GARDNER, 1895

I am delighted you like the soap box.
— ANDERS ZORN tO GARDNER, 1897

The Standard Bearer of the Harvest Festival, ca. 1884

ANTONIO MANCINI, Italian, 1852–1930

Oil on canvas, 165 x 85 cm, signed lower right: A. Mancini / Roma. Purchased in 1884 through Ralph Curtis in Venice. Blue Room

While a head is drying, Mancini is frequently tempted to indulge in veritable orgies of still life in the background, executed with a brio which suggests mental intoxication. An apparent chaos of pigment is squeezed from the tubes, smeared with the fingers, scratched with the wrong end of the brush, troweled with the palette knife, until his canvas becomes a bas-relief of paint.

— RALPH CURTIS, 1907

While bearing the standard of the shrine, the oil for the lamp, the natural sadness of his face is lessened by his joy at his newly bought red waistcoat and the piece of satin destined to make a jacket for his sister. All which serves even for luxury is first offered to the Madonna. The subject would have been superb had I been able to treat it outdoors, not in my cold, dirty studio where I was obliged to curtail the grandiose surroundings of endless plains of wheat representing immense space of peasant happiness.

— ANTONIO MANCINI, 1884

Isn't that fine! But when he writes he becomes fearfully involved, and ink and genius splash and splatter – blots, erasures, exclamation points – often 10 pages of it. Fearful!

— RALPH CURTIS, 1884

✑ Henri Matisse

As younger artists in the early twentieth century began to emulate the crudeness and abstraction of so-called "primitive" arts and to explore non-representational styles, Isabella Stewart Gardner observed their radical experimentations with interest but did not go so far as to purchase their works. Through many of her Boston friends, she was introduced to the energetic figure studies of Henri Matisse and, to a lesser extent, the brilliantly colored oils that earned him the title of leader of the Fauves. Never one to be labeled timid, she welcomed the early oil painting, five drawings, and two etchings by Matisse that were given to her by three friends: Thomas Whittemore, Matthew Prichard, and Sarah Choate Sears.

Gardner probably first heard about Matisse from Bernard Berenson, who bought a Matisse landscape in 1907 and published a glowing defense of his "magnificent draftsmanship" in *The Nation* while visiting Boston in November 1908. In 1909, he described to her his visit to the Steins (Leo, Gertrude, Sarah, and Michael), whom she did not personally know but whose "cornering" of the Matisse market she acknowledged. The same year, she began to receive effusive descriptions of Matisse's works from Matthew Prichard, the English classicist who had served as secretary and assistant director of the Boston Museum of Fine Arts between 1902 and 1906. Prichard, studying philosophy in Paris, wrote in January 1909 that he had seen Matisse's paintings: "He is a man working toward a scale, is most emotional, a free draughtsman, but is coarse, is shortsighted, and perhaps has some other optical trouble." Within a few months, Prichard became an enthusiastic supporter and friend of the artist, and in 1920 gave Mrs. Gardner one of Matisse's etched portraits of himself (1914) and a Matisse letter for her autograph collection. He may also have sent her a sheet of studies Matisse made of the Algerian girl Zorah in preparation for his 1912 Tangiers series.

Another Boston art historian, Thomas Whittemore, had also become enamored of Matisse. Whittemore had known Gertrude Stein in 1895 while she was a student at Harvard and he was taking graduate courses there, and he kept in touch with her after she settled in Paris. Through the Steins, Whittemore met Matisse and in the fall of 1907 consulted Leo about purchasing a small version of his recently completed painting *Madras* (both versions are in the Barnes Collection), that he had seen at Bernheim jeune. The

The Terrace, St. Tropez, 1904

HENRI MATISSE, French, 1869–1954

Oil on canvas, 72 x 58 cm, signed lower right: Henri-Matisse
Given in 1922 by Thomas Whittemore (on loan since 1911).
Yellow Room

Female Nude Seated on the Ground, ca. 1906–7
Henri Matisse, French, 1869–1954
Pencil on paper, 30 x 21.5 cm, signed lower right:
Henri-Matisse
Given around 1910 by Sarah Choate Sears.

Savages, or Three Studies of Bevilaqua, ca. 1900–1902
Henri Matisse
Pen and brush in black ink on paper, 33 x 24 cm
Given in 1922 by Thomas Whittemore (on loan since 1911).

following year he returned to Europe and traveled to Moscow to
see the outstanding modernist collection of Shchukin, as well as
the Byzantine architecture that he was researching. In February
1910, Whittemore visited the Matisse exhibition held at the
Thannhauser Gallery in Munich, where he may have finally
acquired a Matisse oil, the 1904 view of a terrace painted while the
artist was staying with Neo-Impressionist Paul Signac at his sum-
mer house at St. Tropez. When he returned to Boston later that
year, he brought with him the painting as well as a group of
Matisse drawings, including the early pen sketch after the hirsute
Italian model known as Bevilaqua.

Gardner's Back Bay neighbor and rival for the title of leading art patroness in Boston, Sarah Sears also had her eye on Matisse as a "comer." Sears was an accomplished watercolorist who had taken up photography in the early 1890s and been accepted into Alfred Stieglitz's Photo-Secession. After the death of her husband in 1905, she spent an extended period in Paris where she amassed cutting-edge works by Manet, Cézanne, Degas, and her friend Mary Cassatt, and met Matisse through the Steins. Whether she acquired the scrawled, almost caricatural drawing of a reclining nude that she gave Mrs. Gardner from the artist, from his Parisian dealers, or from the shows that Stieglitz mounted in 1908 and 1910 cannot be determined. In any event, this modest study evinced the radical rupture with classical ideals of female beauty that shocked early viewers of Matisse's work and undoubtedly appealed to Gardner's self-image as an opponent of prudishness and hypocritical morality.

Bostonian interest in Matisse culminated in the showing of six Matisse drawings loaned by Sears to the Annual Exhibition of the Watercolor Club in February 1911. There may have been an initial attempt to display Matisse works in the newly reinstalled Museum of Fine Arts. In late January 1911, the museum received on loan one painting and three drawings from Whittemore, a drawing from Gardner (probably the one she had received from Sears), and nine drawings and a painting from George Of, Stieglitz's framer and assistant. (This painting, which had been bought via Sarah Stein in 1907, was the first Matisse oil to be exhibited in the United States when it was shown at Stieglitz's 291 Gallery in 1908.) The drawings lent in Of's name may have been leftovers from a Matisse exhibition which Stieglitz held in the spring 1910, and Sears may have been helping to publicize the works and find buyers in her hometown. In late January 1911, en route to Europe, Whittemore asked the Museum of Fine Arts to deposit his Matisses with Mrs. Gardner, where they remained until he formally gave them to her in 1922.

— ANNE MCCAULEY, 2002

Study for Chiron and Achilles, ca. 1922
John Singer Sargent
Charcoal on paper, 63.1 x 48 cm, signed: John
S. Sargent
Given by the artist, ca. 1922.

Study for Phaeton, ca. 1922
John Singer Sargent
Charcoal on paper, 47.9 x 63.2 cm, signed:
John S. Sargent
Given by the artist, ca. 1922.

∾ Studies by Sargent

In 1922 Sargent began work on murals over the stairway of Boston's Museum of Fine Arts. Shortly afterwards, he gave Mrs. Gardner nine beautiful charcoal studies of nudes connected with the project. The selection of drawings seems to have been made with some care, as it contains female as well as male figures, and some group studies.

The Gardner Museum possesses two compositional studies for Chiron and Achilles. Half man, half horse, Chiron was entrusted with the education of the young hero Achilles. The sketch of two intertwined males, one seemingly a smaller version of the other, possesses a charged eroticism lacking in the finished mural, which rather staidly shows the figures from the side. Indeed, like many of Sargent's late studies of nudes, these drawings reveal Sargent's deep fascination with the physicality of male bodies.

Sargent's gift to Gardner was a private, personal gesture, like the artist's last portrait of Gardner. No early record of them survives and they remained outside the museum's official collection. Made at the end of the lives of both artist and patron, the drawings testify to their intimacy and love of the sensuous.

— ALAN CHONG, 2002

❧ *Mrs. Gardner in White*, 1922

JOHN SINGER SARGENT, American, 1856–1925

Watercolor on paper, 43 x 32 cm
Inscribed at upper right: To my friend Mrs. Gardner / John S.
Sargent. Given by the artist, 1922. Macknight Room

It is very nice of you to be willing to let me try a water-colour – Will you propose an afternoon of next week?

 – JOHN SINGER SARGENT to
 GARDNER, 1922

Sargent made a little sketch of me yesterday, a water-colour, not meant, I hope, to look like me, but just a sketch, and amusing. I was entirely in white, with a veil wrapped round me leaving only my nose and eyes out, and they were vaguely done. Sargent was a perfect dear, and is always a very delightful human being. He was quite delightfully amused with the symphony in white, which my maid called "a fleecy cloud from heaven."

 – GARDNER, 1922

As it was utterly unpremeditated both by him and by me, I think that is its main reason for being so good.

 – GARDNER, 1922

Made just two years before her death, this watercolor depicts Gardner after she suffered a debilitating stroke at the age of eighty-two. Swaths of fabric envelope her figure, but cannot disguise her physical frailty. On the other hand, the piercing gaze attests to Gardner's resilient spirit and curiosity. Sargent's sensitivity to his subject no doubt stemmed from his long and close friendship with Gardner. Sargent made the portrait in the Macknight Room at Fenway Court on 14 September 1922 and presented it to her twelve days later.

❧ Coda: The Collection as Inspiration

ISABELLA Stewart Gardner loved the company of artists. She had befriended John Singer Sargent, James McNeill Whistler, and Denis Miller Bunker long before she began to collect old master paintings and sculpture. Indeed her contact with these painters may have inspired her wider collecting ambitions. In the past decade, living artists have returned to work in the Gardner Museum through an Artist-in-Residence program, which has built on Mrs. Gardner's legacy. The museum has nurtured a remarkable range of creative minds. Poets, writers, storytellers, composers, performers, as well as visual artists have lived on site and have interacted with the Gardner Museum in extraordinary ways. Inspired by the collection, the architecture, the gardens, the institution, the staff, or by Isabella Stewart Gardner herself, these artists have furthered their practice. These pages illustrate a small selection of these responses, in a variety of media.

Juan Muñoz
Portrait of a Turkish Man Drawing, 1995
Sulpture, 61 x 91 cm
Installation in the special exhibition gallery

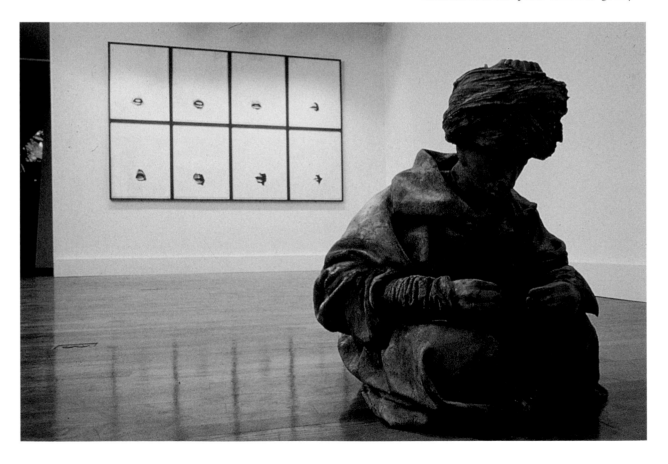

Dayanita Singh
Gardner Museum Staircase, 2002
Photograph, 21.6 x 21.6 cm

Abelardo Morell
Relief, Gardner Museum, 1998
Photograph, 22.3 x 17.8 cm

Josiah McElheny
Halo After Botticelli, 1998–99
Glass, 27.9 x 0.6 cm

Olivia Parker
The Little Salon, 1997
Photograph, 40.8 x 29.4 cm

Elaine Reichek
Sampler (Perhaps No Life), 2001
Cotton, 94 x 51 cm

Manfred Bischoff
Or Son, 2002
Gold and coral, 8.3 x 10.2 x 2.5 cm

I believe that the essence of this Museum does not reside merely in its architecture and objects, but also in its staff and extended family, who make this place function as a living organism on a day to day basis. By carrying on the organic process of sharing and entertaining, the Museum regains its role as more than a mausoleum for inanimate, exotic objects.

— LEE MING-WEI, 2002

❧ Chronology

1840
14 April, Isabella Stewart born to David and Adelia Stewart in New York.

1856
Isabella Stewart attends a finishing school in Paris and tours Italy the following year with her parents.

1859
Isabella is introduced to John Gardner by his sister Julia (a school friend of Isabella's); they soon become engaged.

1860
10 April, Isabella marries Jack Gardner in Grace Church, New York.

1862
The couple moves into 152 Beacon Street, Boston, a gift from Isabella's father.

1863
Birth of a son, Jackie (John L. Gardner 3rd). He dies two years later.

1867–68
Isabella and Jack tour Germany, Scandinavia, Russia, and Austria; extended stay in Paris.

1874–75
Tour of Egypt, the Holy Land, Turkey, Greece, Germany, and Paris.

1875
Jack Gardner's brother dies; Isabella and Jack take charge of his three orphaned sons.

1878
Isabella attends lectures by Charles Eliot Norton at Harvard College.

1879
Extended tour of England and France. Meets Henry James and James McNeill Whistler.

1880
The house adjacent to 152 Beacon Street is purchased for expansion.

1881
Jack and Isabella tour the western United States.

1882
Edward Morse lectures on Japan at the Gardner house.

1883–84
Jack and Isabella travel around the world, visiting Japan, China, Cambodia, Thailand, Indonesia, India, Egypt, Venice, Paris, and London.

1885
Isabella attends the inauguration of Grover Cleveland in Washington. Joins the Dante Society.

1886
Isabella's mother dies. Isabella visits Florida and Havana and later travels to Europe. Meets John Singer Sargent.

1887
Isabella supports research trip of Bernard Berenson, a Harvard student.

1888
Isabella sits for Sargent. Travels to Spain, Venice, and London.

1890
Travel to London, Paris, Holland, Germany, and Venice.

1891
Isabella's father David Stewart dies, leaving her $1.6 million.

1892
Jean and Edouard de Reszke and Ignace Paderewski perform at the Gardner residence. Jack and Isabella travel to Paris, London, Germany, and Venice. Isabella purchases works at the Leyland auction in London, and buys Vermeer's *Concert* in Paris.

1893
Isabella visits the Columbian Exposition in Chicago where she meets Anders Zorn.

1894
Berenson sends his first book, renewing his correspondence with Isabella. Later that year, she buys Botticelli's *Tragedy of Lucretia* with Berenson's help.

1894–95
During extended stay in Venice, Isabella meets Joseph Lindon Smith and hosts Anders Zorn.

1896
Buys Rembrandt's *Self-Portrait* and Titian's *Europa*. Willard Sears is asked to design a museum on the site of the Gardners' Beacon Street houses.

1897–98
Extended stay in France, Germany, and Venice.

1898
10 December, John Gardner dies at age 61.

In December, Mrs. Gardner buys lands on the Fenway, and asks Willard Sears to design a museum building.

1899
Construction on Fenway Court begins in June.

Isabella travels to Venice, Paris, and London to buy objects and architectural elements for the new museum.

1900
A charter is drawn up for a museum incorporated "for the purpose of art education, especially by the public exhibition of works of art."

1901
In December, Mrs. Gardner moves into Fenway Court where she celebrates Christmas.

1902
Mrs. Gardner installs her collection in the building.

1903
On 1 January, gala opening of the museum.

23 February Museum opens to the public; admission: $1.00. Sargent works in the Gothic Room in February. Bernard Berenson visits in October.

1904
Mrs. Gardner travels to Chicago, New York, and New Haven. Meets Okakura Kakuzō.

1906
Mrs. Gardner travels to Europe for the last time. She visits Berensons outside Florence, and spends time in Paris and Madrid.

1914
The east wing of the museum is entirely rebuilt to include the Tapestry Room and the Spanish Cloister where Sargent's *El Jaleo* is installed.

1919
Mrs. Gardner suffers a stroke.

1922
Sargent paints a watercolor portrait of Isabella.

1924
17 July Isabella dies. Her funeral is held 21 July, and she is buried in the Mount Auburn Cemetery, Cambridge.

1925
The museum re-opens to the public in February.

❧ Contributors

HENRY ADAMS (1838–1918),
American historian

SOFONISBA ANGUISSOLA (ca. 1532–1625),
Italian painter

CRISTELLE BASKINS, associate professor
of art history, Tufts University

SYLVESTER BAXTER (1850–1927),
American journalist

SISTER WENDY BECKETT,
British art historian

BERNARD BERENSON (1865–1959),
American connoisseur and
art historian

MARY BERENSON (1864–1945), art
historian and wife of Bernard Berenson

PAUL BOURGET (1852–1935),
French novelist

DAVID ALAN BROWN, curator of
Renaissance painting, National Gallery
of Art, Washington

DENIS MILLER BUNKER (1861–1890),
American Impressionist painter

MARGARET BURCHENAL,
curator of education, Isabella Stewart
Gardner Museum

FAUSTO CALDERAI, art historian based in
Florence

MARIETTA CAMBARERI, assistant curator
of decorative arts and sculpture,
Museum of Fine Arts, Boston

ROBERT CAMPBELL, architecture critic,
Boston Globe

STEPHEN J. CAMPBELL, professor of art
history, Johns Hopkins University

MORRIS CARTER (1877–1965), first director
of Isabella Stewart Gardner Museum,
1925–1955

GIOVANNI BATTISTA CAVALCASELLE
(1819–1897), Italian connoisseur and
museum administrator

PIERANNA CAVALCHINI,
curator of contemporary art, Isabella
Stewart Gardner Museum

ADOLPH CAVALLO, textile historian,
retired curator of textiles, Museum of
Fine Arts, Boston

BENVENUTO CELLINI (1500–15/1), Italian
goldsmith and sculptor

ALAN CHONG, curator of the collection,
Isabella Stewart Gardner Museum

ASCANIO CONDIVI (1525–1574), Italian
biographer and pupil of Michelangelo

JOHN COOLIDGE (1913–1995), architectural
historian and director of the Fogg Art
Museum

KENYON COX (1856–1919),
American painter and critic

F. MARION CRAWFORD (1854–1909),
American novelist

JOSEPH A. CROWE (1825–1896), British
journalist, diplomat, and art historian

RALPH CURTIS (1854–1922),
American painter

GIOVANNA DE APPOLONIA, co-curator, *Art
of the Cross* (2001)

WALTER DENNY, professor of art history,
University of Massachusetts

JOSEPH DUVEEN (1869–1939),
British art dealer

EVERETT FAHY, chairman
of European paintings, Metropolitan
Museum of Art

TREVOR FAIRBROTHER,
art historian based in Boston

KATHY FRANCIS, textile conservator,
Isabella Stewart Gardner Museum

SYDNEY J. FREEDBERG (1914–1997),
American art historian

ROGER FRY (1866–1934),
British critic and painter

ISABELLA STEWART GARDNER (1840–1924)

JOHN L. GARDNER JR. (1837–1898)

HENRY LOUIS GATES JR.,
W.E.B. Du Bois Professor of the
Humanities, chair of Afro-American
Studies, Harvard University

HEINRICH GEBHARD (1878–1963),
German–American pianist

BONNIE HALVORSON, textile conservator,
Isabella Stewart Gardner Museum

ANNE HAWLEY,
Norma Jean Calderwood Director,
Isabella Stewart Gardner Museum

HERODOTUS (ca. 484–between 430 and
420 BC), Greek historian

IDA AGASSIZ HIGGINSON (1837–1925),
childhood friend of Isabella Stewart
Gardner

MEGAN HOLMES, assistant professor of art
history, University of Michigan

ARNOLD HOUBRAKEN (1660–1719),
Dutch painter and historian

FREDERICK ILCHMAN, assistant curator of
paintings, Museum of Fine Arts,
Boston

RACHEL JACOFF, Margaret E. Deffenbaugh
and LeRoy T. Carlson Professor in
Comparative Literature and professor
of Italian, Wellesley College

HENRY JAMES (1834–1916),
American writer

DEBORAH KAHN, associate professor of
art history, Boston University

OKAKURA KAKUZŌ (1862–1913),
Japanese art historian and philosopher

LAURENCE KANTER,
curator of the Lehman Collection,
Metropolitan Museum of Art

EDWARD M. KENNEDY, U. S. Senator from
Massachusetts, first elected in 1962.

WAYNE KOESTENBAUM, professor of
English, City University of New York

ELOY F. KOLDEWEIJ, curator, Rijksdienst
voor de Monumentenzorg, Ziest, The
Netherlands

JOHN LA FARGE (1835–1910),
American artist and critic

JANE LANGTON, author of *Murder at the
Gardner: A Novel of Suspense* (1988)

LEE MING-WEI, artist-in-residence,
Isabella Stewart Gardner Museum, 1999

RICHARD LINGNER, assistant curator,
Isabella Stewart Gardner Museum

ANTONIO MANCINI (1852–1930),
Italian painter

FRANK J. MATHER (1868–1953),
American art critic

ROBERT MAXWELL, assistant professor of
art history, University of Pennsylvania

ANNE MCCAULEY, professor of art
history, Princeton University

MARY MCWILLIAMS,
Norma Jean Calderwood Associate
Curator of Islamic Art, Harvard
University Art Museums

MICHELANGELO (1475–1564), Italian artist

BERTHE MORISOT (1841–1895),
French painter

Charles Merrill Mount,
biographer of John Singer Sargent

Lewis Mumford (1895–1990), American
cultural historian

Juan Muñoz (1953–2001), Spanish artist

Noriko Murai, scholar-in-residence,
Isabella Stewart Gardner Museum,
2002

Murasaki Shikibu (978?–?1026),
Japanese author of *The Tale of Genji*

Charles Eliot Norton (1827–1908),
scholar and professor of art history,
Harvard College

Richard Norton (1872–1918), son of
Charles Eliot Norton and director of
the American School of Classical
Studies in Rome

Midori Oka, curatorial assistant,
Museum of Fine Arts, Boston

Myra Orth (d. 2002),
art historian based in Boston

Violet Paget (1856–1935), British author
who wrote as Vernon Lee

Harold Parsons (1882–1968), art agent

Giovanni Previtali, art historian
based in Italy

Matthew Prichard (1864–1936),
assistant to the director, Museum of
Fine Arts, Boston

Joshua Reynolds (1723–1792),
British portrait painter

John Rosenfield, emeritus professor of
art history, Harvard University

Peter Paul Rubens (1577–1640),
Flemish painter

Paul Sachs (1878–1965), professor of fine
arts, Harvard University, collector,
assistant director of the Fogg Museum

John Singer Sargent (1856–1925),
American painter

May Sarton (1912–1995),
American poet and essayist

James M. Saslow, professor of art
history, Queens College

Willard T. Sears (1837–1920),
American architect

Peter Sellars, theater and opera director

Luc Serck, art historian based in Brussels

Joseph Lindon Smith (1863–1950),
American artist

Susan Spinale, Ph.D. candidate,
Harvard University

Valentine Talland, objects conservator,
Isabella Stewart Gardner Museum

Augusta Tavender (fl. 1925–1959),
art historian based in Boston

Titian (ca. 1485/90–1576), Italian painter

Aileen Tsui, lecturer and Mellon post
doctoral fellow, Columbia University

Evan H. Turner, emeritus director of the
Philadelphia Museum of Art and the
Cleveland Museum of Art.

Giorgio Vasari (1511–1574),
Italian artist and historian

Cornelius Vermeule, emeritus curator
of ancient art, Museum of Fine Arts,
Boston

Eugene Yuejin Wang, assistant professor
of art history, Harvard University

Michelle Wang, Ph.D. candidate,
Harvard University

H. Barbara Weinberg, Alice Pratt Brown
Curator, American Painting and
Sculpture, Metropolitan Museum of
Art

Edith Wharton (1862–1937),
American novelist

James McNeill Whistler (1834–1903),
American artist

Sarah Whitman (1842–1904),
American artist

Thomas Whittemore (1871–1950),
American archaeologist, art historian,
and collector

Marjorie E. Wieseman, curator of
European painting and sculpture,
Cincinnati Art Museum

Carl Zahn, designer,
Museum Publishing Partners

Michael Zell, associate professor of art
history, Boston University

Anders Zorn (1860–1920), Swedish artist

Sources

General references

Further information on objects in this volume can usually be found in the collection catalogues listed below. The correspondence between Isabella Stewart Gardner and Bernard and Mary Berenson has been published in Hadley 1987. All letters, documents, manuscripts, and photographs are in the Isabella Stewart Gardner Museum unless otherwise noted. All letters to Mrs. Gardner are available on microfilm from the Archives of American Art (Washington and other repositories). Some letters have been edited for consistency.

John La Farge and August Jaccaci, eds. *Noteworthy Paintings in American Private Collections.* New York, 1907. Vol. 1. New ed., 1979.

Morris Carter. *Isabella Stewart Gardner and Fenway Court.* Boston, 1925. Various later editions.

The Isabella Stewart Gardner Museum. Boston, 1978. By Rollin Hadley, Deborah Gribbon, Walter Cahn, et al. Reprinted from *Connoisseur* (May 1978).

Rollin Hadley, ed. *The Letters of Bernard Berenson and Isabella Stewart Gardner, 1887–1924, with Correspondence by Mary Berenson.* Boston, 1987.

Hilliard Goldfarb. *The Isabella Stewart Gardner Museum: A Companion Guide and History.* New Haven, 1995.

Collection catalogues

Philip Hendy. *European and American Paintings in the Isabella Stewart Gardner Museum.* Boston, 1974. [1st edition, 1931]

Oriental and Islamic Art in the Isabella Stewart Gardner Museum. Boston, 1975. By Yasuko Horioka, Marylin Rhie, and Walter Denny.

Sculpture in the Isabella Stewart Gardner Museum. Boston, 1977. By Cornelius Vermeule, Walter Cahn, and Rollin Hadley.

Adolph Cavallo. *Textiles: Isabella Stewart Gardner Museum.* Boston, 1986.

The Art of the Cross: Medieval and Renaissance Piety in the Isabella Stewart Gardner Museum (exh. cat. Isabella Stewart Gardner Museum, 2001). By Alan Chong, Giovanna De Appolonia, Richard Lingner, et al.

IX
Years ago Gardner to Edmund C. Hill, 21 June [1917].

X
James: *The American Scene* (New York, 1907), ed. New York: Penguin, 1994, pp. 188–89.

Higginson to Gardner, Rome, 8 March 1923. Ida Agassiz had taken Italian with Gardner.

XI
I have not one cent Gardner to Berenson, 18 August 1896.

Europa and Philip Gardner to Berenson, 8 February 1897.

Shan't you and I Gardner to Berenson, 19 July 1896.

If you cared about it Berenson to Gardner, London, 1 August 1894.

felt at times almost suicidal Mary Berenson wrote in her diary on 23 June 1898: "business complications with Mrs. Gardner – Bernhard was simply awfully worried and felt at times suicidal"

For a discussion of the controversy around Berenson's reputation, see Ernest Samuels, *Bernard Berenson: The Making of a Connoisseur* (Cambridge, Mass., 1979), pp. 298–306. It is known that Berenson received a 25% commission from Duveen after 1912; Colin Simpson, *Artful Partners: Bernard Berenson and Joseph Duveen* (New York, 1986), pp. 265–71 (see pp. 72–92 for another interpretation of Berenson's dealings with Mrs. Gardner).

XII
Giorgione Gardner to Berenson, 8 February 1897: "kill the Giovanellis [owners of Giorgione's *Tempest* now in the Accademia, Venezia] for me. They are quite right, if they are speaking the truth. Of course I think *it* ought never to leave Italy, unless it comes to me!"

in my Platonic idea Berenson to Gardner, 19 January 1896.

Norton to Gardner, London, 14 September 1898. Berenson was not allowed to see the *Portrait of Tommaso Inghirami* attributed to Raphael, at Agnew's, London.

Gardner to Berenson, 31 May 1899.

XIII
Baxter: "An American palace of art," *Century Magazine* 67: no. 42 (1903), p. 372.

Gardner to Berenson, Madrid, 9 July 1906.

She wanted me to keep the matter secret Willard Sears, diary, 1 September 1896.

XIV
Sears: a transcription of the diary is in the Gardner Museum. The passages are from: 10 August 1900, 13 September 1900, 23 October 1900, 5 June 1901, 4 September 1901, 14 October 1901, 28 October 1901.

XV
Gardner to Mrs. John Jacob Glessner, 6 August, 1901; Chicago Architecture Foundation.

Gardner to Mary Berenson, 22 November 1902.

Prichard to Gardner, Bologna, 24 February 1908.

XVI
Wharton to Sara Iselin, Boston, 1 May [1903] The letter is in a private collection; transcription courtesy of Michael Bliss, James Cummins Bookseller, New York.

XVII
Prichard to Gardner, Bologna, 14 October 1908.

Mumford: *The Golden Day: A Study in American Experience and Culture* (New York, 1926), pp. 215–16. Used by permission.

Mount: *John Singer Sargent: A Biography* (New York, 1955), p. 241.

Mary Berenson to her family, Boston, 24 December 1920; *Mary Berenson: A Self Portrait from Her Letters and Diaries* (London, 1983), p. 237.

Beckett: lecture at the Gardner Museum, 1998.

XIX
La Farge 1907, p. 3.

XXI
Norton to Samuel Gray Ward, 2 March 1902; extract by Ward sent to his granddaughter Mrs. William C. Endicott.

XXII
Koestenbaum: lecture at the Gardner Museum, 1996.

XXIII
The Outlook 74: no. 4 (23 May 1903), p. 220.

La Farge 1907, p. 2.

2
Hawley: lecture at the University of Venice, 1999.

Gates: lecture at the Gardner Museum, 1993.

5
Vermeule: "Perceptions of the Trojan Wars in the Fenway: the Creeping Odysseus," *Fenway Court*, 1984, p. 29.

Parsons: undated note.

7
Vermeule: in *Isabella Stewart Gardner Museum*, 1978, p. 44.

Norton to Gardner, 18 May 1901.

8
Vermeule: in *Isabella Stewart Gardner Museum*, 1978, p. 44.

11
Vermeule: in *Isabella Stewart Gardner Museum*, 1978, p. 48.

Sarton, *Selected Poems of May Sarton* (New York, 1978), p. 160. First published in 1967; used by permission.

12
Vermeule: in *Isabella Stewart Gardner Museum*, 1978, p. 46.

Norton to Gardner, Rome, 5 December 1897.

15
Tavender: typescript.

16
Whitman to Gardner, 10 January 1902.

19
See *The Art of the Cross*, 2001, pp. 20–21, no. 2.

23
See ibid, no. 1.

27
Adams to Gardner, Paris, 23 October 1906. See Madeline Caviness, et al., "The Gothic window from Soissons: A reconsideration," *Fenway Court*, 1983, pp. 7–25.

31
See the essay on the work by William B. Keller, written for Columbia University, 1980.

34
Gardner to Berenson, 2 December 1895.

Berenson to Gardner, 20 December 1898 (reproduced on p. 35).

Gardner to Berenson, 23 December 1902.

37
Smith to Gardner, London, 18 May 1903.

Fahy: in *Isabella Stewart Gardner Museum*, 1978, p. 31.

39
Gardner to Berenson, 11 February 1900.

Duveen: letter of 16 February 1927.

Fahy: in *Isabella Stewart Gardner Museum*, 1978, p. 29.

41
Previtali: "Introduction to issues of Simone Martini's workshop: the Boston polyptych and its derivations," *Fenway Court*, 1988, pp. 33–43. Burton Fredericksen, in *Burlington Magazine* 128 (1986), pp. 592–97, shows that the painting belonged to the church of the Servites, where it was recorded in 1671. See also manuscript catalogue entry by Laurence Kanter.

43
Kanter: manuscript catalogue entry. See Miklós Boskovits, in *Arte cristiana*, no. 713 (1986), pp. 76–77.

45
La Farge: in La Farge 1907, p. 38.

49
Gardner to Berenson, 17 August 1908. See manuscript catalogue entry by Laurence Kanter.

50
Brown: *Virtue and Beauty: Leonardo's Ginevra de' Benci and Renaissance Portraits of Women* (exh. cat. National Gallery of Art, Washington, 2001), pp. 112–14.

53
Beckett: lecture at the Gardner Museum, 1998.

Creighton Gilbert, "The Hercules in Piero's house," *Artibus et historiae*, no. 45 (2002), pp. 107–16, suggests that the Hercules may have been paired with a full-length portrait of the artist, known only through a copy.

54
See Stephen J. Campbell, *Cosmè Tura: Painting and Design in Renaissance Ferrara* (exh. cat. Isabella Stewart Gardner Museum, 2002).

57
Fry: in La Farge 1907, p. 117.

Berenson: *Venetian Painting in America: The Fifteenth Century* (New York, 1916), p. 22.

Fahy: in *Isabella Stewart Gardner Museum*, 1978, p. 35.

58
Berenson to Gardner, 23 May 1899.

The Nation 73 (5 December 1901).

60
Berenson to Gardner, 12 March 1899.

See Shelley Zuraw, "The Medici portraits of Mino da Fiesole" in *Piero de' Medici "il Gottoso" (1416–1469): Art in the Service of the Medici*, edited by A. Beyer and B. Boucher (Berlin, 1993), pp. 317–39.

63
Berenson to Gardner, 19 March 1900. See manuscript entry by Laurence Kanter.

64
Berenson to Gardner, St. Moritz, 27 August 1897.

65
We are grateful to Laurence Kanter for the attribution of the cassone and the identification of the Spannocchi arms.

69
Kanter: *Botticelli's Witness* (exh. cat. Isabella Stewart Gardner Museum, 1997), pp. 58–60.

72
a treasure Charles Eliot Norton to Gardner, 4 June 1887.

quick & resolute Charles Eliot Norton to Gardner, 23 June 1887.

73

Crawford: undated valentine sent to Mrs. Gardner.

the dear green Dante Crawford to Gardner, Santagnello di Sorrento, 20 July 1895.

See also Maureen Cunningham, "The Dante quest," *Fenway Court*, 1972, pp. 18–25.

75

See *The Drawings of Filippino Lippi and His Circle* (exh. cat. Metropolitan Museum of Art, New York, 1997), p. 296.

77

J. A. Crowe and G. B. Cavalcaselle, *Raphael: His Life and Works* (London, 1882), vol. 1, p. 238.

79

Sachs: comment of March 1935.

81

Condivi: *The Life of Michelangelo*, translated by Alice Sedgwick Wohl (Baton Rouge, 1976), p. 103.

83

See also: *Vittoria Colonna: Dichterin und Muse Michelangelos* (exh. cat. Kunsthistorisches Museum, Vienna, 1996), edited by Sylvia Ferino Pagden. Joseph Gibaldi, "Vittoria Colonna: Child, woman, and poet" in *Women Writers of the Renaissance and Reformation* (Athens, Georgia, 1987). Charles de Tolnay, "Michelangelo's *Pietà* composition for Vittoria Colonna," *Record of the Art Museum of Princeton University* 12 (1953), pp. 44–62. Alexander Nagel, "Gifts for Michelangelo and Vittoria Colonna," *Art Bulletin* 79 (1997), pp. 647–68.

85

Vasari: *Le vite de' piu eccelenti pittori, scultori, e architettori* (Florence, 1568: online text: biblio.cribecu.sns.it), vol. 5, p. 276.

Gardner to Berenson, 27 February 1902.

87

Cellini: *Vita*, edited by E. Camesasca (Milan, 1995), p. 576.

Michelangelo: E. H. Ramsden, *The Letters of Michelangelo* (Stanford, 1963), vol. 2, p. 212.

89

The attribution was made by Pierluigi

Leone de Castris, *Pittura del cinquecento a Napoli: 1540-1573, Fasto e devozione* (Naples, 1996), pp. 108, 127.

91

Anguissola to Bernardino Campi, Madrid, 21 October 1561; Maria Kusche in *Sofonisba Anguissola e le sue sorelle* (exh. cat. Cremona, 1994), p. 97. On the attribution of the portrait, see ibid., p. 128.

Berenson to Gardner, 16 February 1896.

93

Freedberg: *Painting in Italy, 1500 to 1600* (The Pelican History of Art; Harmondsworth, 1971), p. 409.

97

Gardner to Berenson, 3 October 1907.

Muñoz: lecture at the Gardner Museum, 1995

99

Gardner to Berenson, 11 September 1896.

Berenson to Gardner, Vienna, 22 September 1896.

David Alan Brown kindly provided advice on this painting.

100

Vasari: *Le vite de' piu eccelenti pittori, scultori, e architettori* (Florence, 1568; online text), vol. 1, pp. 168–69; translated by Mario Pereira.

101

See Anne Markham Schulz, *Giammaria Mosca called Padovano: A Renaissance Sculptor in Italy and Poland* (University Park, Penn., 1998), 2 vols. The document quoted of 6 October 1522 is published on p. 205; see also pp. 46–48.

103

Titian: Clemente Gandini and Celso Fabbro, eds., *Tiziano: le lettere* (Pieve di Cadore, 1977), p. 212.

Vasari: *Le vite de' piu eccelenti pittori, scultori, e architettori* (Florence, 1568; online text), vol. 6, p. 166.

104

Fry: in La Farge 1907, pp. 170–71.

105

Up to this moment Gardner to Berenson, 18 August 1896.

I am breathless Gardner to Berenson, 19 September 1896.

107

Beckett: lecture at the Gardner Museum, 1998.

See also *Titian and Rubens: Power, Politics and Style* (exh. cat. Isabella Stewart Gardner Museum, 1998).

109

Berenson to Gardner, near Haslemere, 11 August 1901.

Vasari: *Le vite de' piu eccelenti pittori, scultori, e architettori* (Florence, 1568; online text), vol. 6, p. 170.

110

Curtis to Gardner, Venice, 19 December 1884. See *The Art of the Cross*, 2001, no. 16.

113

Koestenbaum: lecture at the Gardner Museum, 1996.

Mrs. Gardner's comments are drawn from her journals and albums kept on her world tour, 1883–84.

115

Cavallo 1986, p. 38.

117

Herodotus: *History*, 1. 212; translation by George Rawlinson (New York, 1862).

120

Cavallo 1986, p. 12.

128

James to Ariana Curtis, Venice, 10 July 1892; Henry James, *Letters from the Palazzo Barbaro*, edited by Rosella Mamoli Zorzi (London, 1998), p. 122.

Ralph Curtis to Jack Gardner, Rome, 4 March 1893.

133

See *Painting on Light: Drawings and Stained Glass in the Age of Dürer and Holbein* (exh. cat. J. Paul Getty Museum, Los Angeles, 2000), by B. Butts and L. Hendrix, pp. 92–105.

137

Serck: "Herri Bles et la peinture de paysage dans le Pays-Bas Meridionaux avant Breugel" (dissertation, Louvain, 1990), vol. 2, pp. 222–26.

139

One of the four evangelists Rubens's comment was relayed to the earl by Francesco Vercellini, a member of Lady Arundel's retinue; Mary Hervey, *The Life, Correspondence & Collections of*

Thomas Howard, Earl of Arundel (Cambridge, 1921), p. 175.

Gardner to Berenson, 12 January 1898.

I confess that I have never seen Rubens to Pierre Dupuy, 1629; Ruth Saunders Magurn, *The Letters of Peter Paul Rubens* (Cambridge, Mass., 1955), p. 322.

See also Marjorie E. Wieseman, in *The Age of Rubens* (exh. cat. Museum of Fine Arts, Boston, 1993), pp. 294–97.

140
Gardner to Berenson, 3 March 1897.

143
Berenson to Gardner, 19 January 1896.

Gardner to Berenson, 25 April 1896.

Carter: Carter 1925, pp. 156–57.

145
Houbraken: *De groote schouburgh der Nederlandtsche konstschilders en schilderessen*, vol. 1 (Amsterdam, 1718; reprint of 1753 edition: Amsterdam, 1976), p. 260.

Reynolds: A Journey to Flanders and Holland, edited by Harry Mount (Cambridge, 1996), p. 101.

147
I really don't adore Rembrandt Gardner to Berenson, 19 February 1900.

the most famous landscape Berenson to Gardner, 7 February 1897.

How I wish Gardner to Berenson, 11 February 1900.

See Cynthia Schneider, "A new look at The Landscape with an Obelisk," *Fenway Court*, 1984, pp. 7–21.

149
Sellars: lecture at the Gardner Museum, 1991.

Jack Gardner: diary entry for 5 December 1892.

153
See Judith Berg Sobré in *The Artistic Splendor of the Spanish Kingdoms: The Art of Fifteenth-Century Spain* (exh. cat. Isabella Stewart Gardner Museum, 1996), no. 1.

155
Coolidge: *Patrons and Architects: Designing Art Museums in the Twentieth Century* (Fort Worth, 1989), p. 10, reporting a story told to him by Paul Sachs.

158
Carter: *Reminiscences of Morris Carter* (Boston, 1964), p. 53.

159
Fairbrother: *John Singer Sargent, The Sensualist* (Seattle Art Museum, 2000), pp. 97, 99, 101–2 [edited text].

See also: Mary Crawford Volk, *John Singer Sargent's El Jaleo* (exh. cat. National Gallery of Art, 1992).

160
Denny: *Oriental and Islamic Art*, 1975, p. 118. Mary McWilliams provided generous advice in cataloguing all the Islamic works.

161
The next day Gardner: travel journal, Egypt, p. 1, 10 December 1874.

I went up Gardner: travel journal, Egypt, p. 19, 24 December 1874.

162
The crew Gardner, travel journal, Egypt, p. 22, 27 December 1874.

163
Scripture translation is from M. H. Shakir, *Koran: English and Arabic* (New York, 1982).

168
Sunil Sharma and Matthew Smith kindly transcribed and translated the poem on the dish.

173
It is quite true Gardner to Berenson, 22 August [1910]. On 30 July 1910, Gardner had written to Berenson, "I am crazy about oriental art and Gentile Bellini! Particularly the 1st."

174
Photograph by Thomas Marr, 1903.

175
Please don't be shocked dear Gardner to Maud Howe Elliot, Kyoto, 24 August 1883; Carter 1925, p. 62.

In the afternoon Gardner to Maud Howe Elliot, en route to Burma, 7 January 1884; Carter 1925, pp. 80–81. Gardner's letters to Maud Howe cannot be traced, but they were partly transcribed by Morris Carter for use in his book, Carter 1925. Photographs by Thomas Marr.

177
And we sit Gardner to Berenson, 2 August 1904.

Okakura is still a great joy Gardner to Berenson, 24 October 1904.

Mary Berenson to her family, Montreal, 10 January 1914; *Mary Berenson: A Self-Portrait from Her Letters and Diaries* (London, 1983), p. 194.

178
Mary Berenson to Gardner, New York, 7 February 1914.

Gardner to Mary and Bernard Berenson, 27 March 1914.

179
Whittemore to Gardner, ["Monday, spring"] 1920.

We are grateful for the assistance of Emma C. Bunker of the Denver Art Museum. See J. E. Curtis, "Some Georgian belt-clasps," in *Arts of the Eurasian Steppelands*, edited by Philip Denwood (London, 1978), pp. 88–120.

181
Berenson to Gardner, 7 May 1914.

183
See Chün-fang Yü, *Kuan-yin: The Chinese Transformation of Avalokiteśvara* (New York, 2001). We are grateful for the assistance of Michelle Wang and Elinor Pearlstein of the Art Institute of Chicago.

185
Rosenfield: "Japanese painting workshops and the Gardner Museum collections," *Fenway Court*, 1992, p. 13.

187
Murasaki: *The Tale of Genji*, translated by Edward Seidensticker (New York, 1978), p.132.

See Rosenfield 1992, pp. 14, 15, who notes that in 1677, the date of this screen, Kanō Tsunenobu was working in Kyoto. This may explain the form of his signature, Fujiwara Tsunenobu, since court artists were sometimes granted honorary membership in the aristocratic Fujiwara family. For Genji illustrations, see Miyeko Murase, *Iconography of the Tale of Genji* (New York, 1983).

193
A colossal thing Berenson to Gardner, 9 April 1909.

195
Morisot to her sister Edma, 5 May 1869; *Correspondance de Berthe Morisot*, edited by Denis Rouart (Paris, 1950), p. 28.

Mather: in La Farge 1907, pp. 247–48.

La Farge: in La Farge 1907, p. 80.

196
I have often thought Sargent to Gardner, London, 2 November 1893.

How can you let Sargent to Gardner, London, 29 August 1895.

Paget to Gardner, Venice, 21 September 1897.

197
Whistler: inscribed in a copy of his *Eden versus Whistler: the Baronet and the Butterfly; a Valentine with a Verdict* (Paris, 1899).

199
Gardner to Whistler, Paris, 4 December 1892; University of Glasgow [Special Collections: GB 0247 MS Whistler G8].

Whistler to Jack Gardner, Paris, 20 December 1892.

The account of Mrs. Gardner taking the painting from Whistler's studio is from Carter 1925, pp. 135–36.

200
Koestenbaum: lecture at the Gardner Museum, 1996.

201
Forgive the shortest Whistler to Gardner, London, 1886.

Your visit has been most charming Whistler to Gardner, London, 1886.

202
Cox: "Some American figure painters," *Cosmopolitan Magazine* 32 (March 1902), p. 594.

Chicago Journal, 26 May 1888.

See Susan A. Hobbs, *The Art of Thomas Wilmer Dewing: Beauty Reconfigured* (exh. cat. Brooklyn Museum, 1996), no. 30.

203
Fairbrother: *John Singer Sargent* (New York, 1994), p. 49.

204
Fairbrother: *John Singer Sargent, The Sensualist* (Seattle Art Museum, 2000), p. 65.

"Art in Boston," *The Art Amateur* 18: no. 5 (April 1888), p. 110.

205
Bourget: *Outre-Mer: Impressions of America* (New York, 1895), pp. 107–9; translation of *Outre-Mer (notes sur l'Amérique)* (Paris, 1895), vol. 1, pp. 147–50. Bourget stated that he did not know the name of the sitter.

John Gardner: The painter Theodore Robinson recorded in his diary on 24 June 1892 [Frick Library, New York, vol. 1, p. 30]: "Apropos of Sargent's portrait of Mrs. Jack Gardiner, Mr. G is reported to have said to his wife, 'It looks like h--l but it looks just like you.'"

207
No more paughtraits Sargent to Ralph Curtis [ca. 1907?]; Evan Charteris, *John Sargent* (London, 1927), p. 155.

I am camping Sargent to Gardner, "Camping somewhere in the Yoho Valley, British Columbia," 20 August 1916.

It was raining Sargent to Mary Hale, 30 August 1916; Charteris 1927, pp. 204–5.

209
Bunker to Gardner [1889].

Sargent to Gardner [n.d.].

211
I believe the man Hassam, quoted by A. E. Ives, "Talks with artists: Mr. Childe Hassam on painting street scenes," *Art Amateur* 27 (October 1892), p. 116.

In 1890, shortly after his return from Paris, Hassam exhibited several pastels at the fourth (and last) exhibition of the group "Painters in Pastel," held at the Wunderlich Gallery, New York. Hassam's only non-French subject was a pastel entitled "New York Blizzard" which is the title given in old handwriting on the back of the Gardner Museum's pastel. This may indeed be the work exhibited in 1890, and therefore one of the first works Hassam made after his return from Europe.

213
See Michelle Facos, *Swedish Impressionism's Boston Champion: Anders Zorn and Isabella Stewart Gardner* (exh. cat. Isabella Stewart Gardner Museum, 1993).

215
Gardner to Joseph Lindon Smith, Venice, 4 November 1894; Archives of American Art, Washington.

Zorn to Gardner, New York [1896].

Stay as you are Carter 1925, p. 147.

Koestenbaum: lecture at the Gardner Museum, 1996.

216
Zorn to Gardner, Paris [1895?].

Zorn to Gardner, 23 December 1897.

217
Curtis: in La Farge 1907, pp. 87–91.

Mancini: quoted by Ralph Curtis to Gardner, Venice, 5 December 1884.

Curtis to Gardner, Venice, 5 December 1884.

218
He is a man working towards a scale Prichard to Gardner, Paris, 2 January 1909.

220
Berenson: "De gustibus," *The Nation* (12 November 1908).

Prichard to Gardner, Paris, 11 April 1909.

225
Sargent to Gardner, Boston, 6 September 1922.

Sargent made a little sketch Gardner to Charles Loeffler, 15 September 1922.

As it was utterly Gardner to Berenson, 24 October 1922. The note begins: "Did I tell you of Sargent's wonderful sketch in water-colour of me which keeps every one's tongue busy wagging? Even I think it is exquisite."

226
Edited by Pieranna Cavalchini.

∽ Index

Artists, titles, and contributors

Adams, Henry, 27
Adoration of the Magi (Bourdichon), 134
Aldine Press, 72
Altar Frontal Relief (Italian), 18
Angelico, Fra, 45
Anguissola, Sofonisba, 91
Anna Pavlova in the Ballet "Oriental Fantasy" (Bakst), 122
Annunciation (Bourdichon), 134
Annunciation (Piermatteo d'Amelia), 63
Annunciation to the Shepherds, Nativity, and Adoration of the Magi (Beckhausen), 127
Archangel Michael (Garcia), 155
Arm Chairs (Italian), 128
Arundel, earl of, 139

Bakst, Léon, 122
Baldini, Baccio, 71
Bandinelli, Baccio, 85
Baskins, Cristelle, 64–66
Baxter, Sylvester, viii
Beacon Street house, xii
Bears (Chinese), 178
Beckett, Sister Wendy, xxii, 53, 107
Beckhausen, Jakob, 127
Bellini, Gentile (attributed to), 97
Bellini, Giovanni (circle of), 99
Belt Buckle (Eurasian), 179
Berenson, Bernard, xi–xii, 34, 57, 58, 60, 63, 64, 91, 99, 107, 109, 143, 181, 218, 221
Berenson, Mary, xi, xvii, 177, 178
Bermejo, Bartolomé, 157
Bindo Altoviti (Cellini), 87
Bird Attacking a Rabbit (Italian), 29
Bischoff, Manfred, 229
Bles, Herri, 137
Book of Hours (Bourdichon), 134–35
Blue Room, 188
Bordone, Paris, 109
Botticelli, Sandro, 58, 65–66, 69, 71
Bourdichon, Jean, 134–35
Bourget, Paul, 205
Brown, David Alan, 50
Bunker, Denis Miller, 209
Burchenal, Margaret, 125

Calderai, Fausto, 128, 129
Cambareri, Marietta, 60
Campbell, Robert, xxi–xxiii
Campbell, Stephen J., 54–55, 103–7
Carter, Morris, 143, 158
Casa Loredan, Venice (Ruskin), 95
Cassoni, 64–66
Catalonian (ca. 1150), 23
Cavalchini, Pieranna, 226

Cavallo, Adolph, 115, 120
Cellini, Benvenuto, 87–88
Centaur with a Raised Sword (Italian), 29
Central Asian, 164–65, 171
Ceramic Plate: A Courtly Couple (Kashan), 168
Chairs (Italian), 129
Chinese, Eastern Wei, 180–82; Song, 183; Western Han, 178
Chinese Room, 174, 175
Chong, Alan, ix-xviii, xix, 17-19, 31, 37, 45, 53, 58, 63, 75, 85, 87–88, 91, 99, 122, 133, 137, 140, 143, 147, 149, 155, 191, 223
Christ Carrying the Cross (Bellini), 99
Christ Disputing in the Temple (Giovanni di Paolo), 47
Christ Disputing in the Temple (Bordone), 109
Christ Entering Jerusalem (Parthenay), 21
Christ in the Storm on the Sea of Galilee (Rembrandt), 145
Chrysanthemums (Bunker), 209
Ciartius, Lasus, 15
Cinerarium (Roman), 15
Circumcision (Tura), 54–55
City of Dis (Baldini), 71
Comes, Francesc, 153
Commedia, La (Dante), 71–73
Concert (Vermeer), 149
Condivi, Ascanio, 81
Coolidge, John, 155
Courtyard, vi, xx, 2
Courtly Couple (Kashan), 168
Cox, Kenyon, 202
Crawford, F. Marion, 72, 73
Crivelli, Carlo, 57
Crowe and Cavalcaselle, 77
Crucified Christ (Spanish), 23
Crucifix (bronze), 19
Crucifix (Terilli), 110
Curtis, Ralph, 110, 111, 128, 217

Dante (Dante Alighieri), 71–73
Dante and Virgil with the Vision of Beatrice (Baldini), 71
David Penitent (Bourdichon), 135
De Appolonia, Giovanna, 18, 101
Death and Assumption of the Virgin (Fra Angelico), 45
Decorative Roundels (Italian), 29
Degas, Edgar, 195
Denny, Walter, 160
Dewing, Thomas Wilmer, 202
Dionysos (Roman), 14
Dioscurides, 170
Dürer, Albrecht (design), 133
Dutch Room, xvi, 131
Duveen, Joseph, 39

Dyck, Anthony van, 140

Early Italian Room, 32–33
El Jaleo (Sargent), 151, 158–59
Eriksson, Christian, 216
Esther Fainting Before Ahasuerus (tapestry), 115
Eurasian (belt buckle), 179
Europa (Titian), 103–7

Fahy, Everett, 37, 39, 57
Fairbrother, Trevor, 159, 203, 204
Farnese Sarcophagus, 12
Female Nude Seated on the Ground (Matisse), 220
Fenway Court, construction of, xiii
Flemish, tapestries, 112, 115, 117; lace, 121
Flinck, Govaert, 147
Foliate and Floral Lattices (velvet), 166–67
Fra Angelico, 45
Francesco di Giorgio, workshop of, 64–65
Francis, Kathy, 118
Freedberg, Sydney J., 93
French (ca. 1205), 27; (ca. 1425), 28; (ca. 1675–1700), 121
Fry, Roger, 57, 104
Furniture, 128–29

Garcia, Pere, 155
Gardner, Isabella Stewart, letters on works of art, xii, 39, 47, 85, 97, 99, 105, 139, 140, 143, 147, 178, 199, 215, 225; letters on the museum, ix, xi, xv, 34; letters while traveling, 161, 162, 175; letters about Okakura, 177; drawings and albums, viii, 160, 162; portraits of, 197, 204–5, 214, 215, 225
Gardner Jr., John L., 149, 205
Gardner Museum Staircase (Singh), 227
Gates Jr., Henry Louis, 2
Gaujelin, Joséphine, 195
Gautreau, Madame Pierre, 203
German (ca. 1496), 133; (ca. 1500), 31
Gilt leather, 126
Giotto, 39
Giovanni di Paolo, 47
Giuliano da Rimini, 37
Goddess, 7, 8
Gothic Room, xviii, 16
Grave Altar, 15
Greek, 8; after Greek, 5, 7
Griffin (Italian), 29

Halo After Botticelli (McElheny), 228
Halvorson, Bonnie, 120
Harmony in Blue and Silver: Trouville (Whistler), 198–99
Hassam, Childe, 211

Hawley, Anne, vii, 2, 131
Hercules (Piero della Francesca), 53
Herodotus, 117
Higginson, Ida Agassiz, x
Holmes, Megan, 49
Houbraken, Arnold, 145

Ida Rubinstein as Saint Sebastian (Bakst), 122
Ikat Velvet (Uzbekistan), 171
Ilchman, Frederick, 109
Inferno (Dante), 71, 72
Iranian, 163, 164–65, 166–67, 168
Iraqi, 170
Isabella Stewart Gardner in Venice (Zorn), 215
Italian (800s), 18; (ca. 1200), 25, 29; (1500s), 100; (ca. 1620), 12; (ca. 1700–25), 119
Italian or Spanish (velvets), 118–19
Iznik (tile), 160

Jacoff, Rachel, 71–73
James, Henry, x, 128
Japanese screens, Genji, 186–87; Rice Cultivation, 184–85
Juana of Austria, 91

Kahn, Deborah, 25, 28, 29
Kanō school, 184–85
Kanō Tsunenobu, 172, 186–87
Kanter, Laurence, 43, 69
Kashan (plate), 168; (tile), 163
Kennedy, Edward, vii
Koestenbaum, Wayne, xvii, 113, 200, 215
Koldeweij, Eloy F., 126

La Farge, John, xix, xxiii, 45, 195
Lace, 120–21
Landino, Christophoro, 71
Lady in Yellow (Dewing), 202
Landscape with an Obelisk (Flinck), 147
Landscape with David and Bathsheba (Bles), 137
Langton, Jane, 39
Lapis Lazuli (Whistler), 201
Leather, gilt, 122
Lee Ming-Wei, 229
Lingner, Richard, xix, 77, 79, 111, 115, 117, 193, 195, 196-197, 209, 212, 213, 215
Lippi, Filippino, 75
Little Note in Yellow and Gold (Whistler), 197
Little Salon, 125
Little Salon, The (Parker), 228
Loeffler, Charles, xviii

Maenad (Roman), 3, 9

Madame Gautreau Drinking a Toast (Sargent), 203
Malebolge: The Punishments of Simony (Baldini), 71
Mancini, Antonio, 217
Manet, Edouard, 193
Manet, Madame Auguste, 193
Martini, Simone, 41, 43
Mat Weights: Bears (Chinese), 178
Mather, Frank J., 195
Matisse, Henri, 218–21
Maxwell, Robert, 21
McCauley, Anne, 218–21
McElheny, Josiah, 228
McWilliams, Mary, 164–65, 166–67, 168
Medusa (Roman), 11
Meeting of Christ and John the Baptist (Filippino Lippi), 75
Mesopotamian (illuminations), 170
Michelangelo (Michelangelo Buonarroti), 81–83, 87
Mino da Fiesole, 60
Morell, Abelardo, 227
Morisot, Berthe, 195
Morning Toilet (Zorn), 212
Moroni, Giovan Battista, 93
Mosaic Floor: Medusa (Roman), 11
Mosca, Giammaria, 101
Mount, Charles Merrill, xvii
Moyen, Jan van der (workshop), 117
Mrs. Gardner in White (Sargent), 225
Mumford, Lewis, xvii
Muñoz, Juan, 97, 226
Murai, Noriko, 173–77
Murasaki Shikibu, 187
Music Room, Beacon Street, xii; Fenway Court, xiv
Musicians (Vasari), 89
My Model and My Boat (Zorn), 212

New York Blizzard (Hassam), 211
Nocturne, Blue and Silver: Battersea Reach (Whistler), 200
Nocturne: Palaces (Whistler), 94
Norton, Charles Eliot, xxi
Norton, Richard, xii, 7, 12

Odysseus (Roman), 5
Oka, Midori, 184–85, 186–87
Okakura Kakuzō, 173, 176–77
Omnibus (Zorn), 213
Or Son (Bischoff), 229
Orth, Myra, 134–35

Paget, Violet, 196
Parker, Olivia, 228
Parsons, Harold, 5
Parthenay, 21

Pavlova, Anna, 122
Peplophoros (Roman), 7
Persephone (Greek), 8
Persian, 163, 164–65, 166–67, 168
Pesellino, Francesco, 49, 64–65
Piermatteo d'Amelia, 63
Piero della Francesca, 53
Pietà (Michelangelo), 81–83
Pietà (Raphael), 77
Platter (Italian, 1500s), 100
Ponte della Canonica (Sargent), 94
Portrait of a Man (Moroni), 93
Portrait of a Turkish Man Drawing (Muñoz), 234
Portrait of a Woman with a Rose (van Dyck), 140
Portrait of Charles Loeffler (Sargent), xviii
Portrait of Isabella Stewart Gardner (Sargent), 204
Portrait of Isabella Stewart Gardner (Zorn), 215
Portrait of Joséphine Gaujelin (Degas), 195
Portrait of Juana of Austria with a Young Girl (Anguissola), 91
Portrait of Madame Auguste Manet (Manet), 193
Portrait of Thomas Howard, 2nd Earl of Arundel (Rubens), 139
Presentation of the Christ Child in the Temple (Giotto), 39
Previtali, Giovanni, 41
Prichard, Matthew, xv, xvii, 221
Procession with the Arms of the Piccolomini and Spannocchi Families (cassone), 65
Procession of Pope Sylvester I (Raphael), 79

Queen Tomyris Learns that Her Son Has Been Taken Captive by Cyrus (tapestry), 117

Raphael (Rafaello Sanzio), 77, 79
Raphael Room, 68
Reichek, Elaine, 229
Relief, Gardner Museum (Morell), 227
Rembrandt, 143, 145
Retable: Scenes of the Passion (French), 28
Return from the Lido (Curtis), 111
Revelers Gathering Grapes (Roman), 12
Reynolds, Joshua, 145
Rice Cultivation in the Four Seasons (Japanese), 184–85
Roman, 5, 7, 9, 11, 12, 14, 15
Romanesque, 19, 21, 23, 25
Roman Tower, Andernach (Turner), 191
Rosenfield, John, 185
Rubens, Peter Paul, 107, 139
Rubinstein, Ida, 122

Ruskin, John, 95

Sachs, Paul, 79, 155
Saint Engracia (Bermejo), 157
Saint George Slaying the Dragon (Crivelli), 57
Saint Jerome (German), 31
Sampler (Perhaps No Life) (Reichek), 229
Sarcophagus (Roman), 12
Sargent, John Singer, works, xviii, 94, 151, 158–59, 203–7, 222–25; letters, 196, 207, 209, 225
Sarton, May, 11
Saslow, James M., 81–83
Savages, or Three Studies of Bevilaqua (Matisse), 220
Scandinavian (?), 121
Scenes from the Lives of Saint Nicasius and Saint Eutropia (French), 27
Scenes from the Tale of Genji (Kanō Tsunenobu), 172, 186–87
Scenes of the Passion (French, ca. 1425), 28
Screens, Japanese, 184–87
Sears, Sarah Choate, 221
Sears, Willard, xiii, xiv
Seated Guanyin (Chinese), 183
Seated Scribe (Bellini), 97
Self-Mortification of Saint Benedict (stained glass), 133
Self-Portrait (Bandinelli), 85
Self-Portrait, Aged 23 (Rembrandt), 143
Sellars, Peter, 149
Serck, Luc, 137
Silver, 127, 216
Silver Box (Eriksson), 216
Singh, Dayanita, 227
Smith, Joseph Lindon, 37
Soissons, window from, 27
Spanish (ca. 1150), 23
Spanish Chapel, 152
Spanish Cloister, 151
Spinale, Susan, 97
Stained glass, 27, 133
Standard Bearer of the Harvest Festival (Mancini), 217
Strolling and Seated Lovers (tapestry), 112
Studies for El Jaleo (Sargent), 159
Study for Chiron and Achilles (Sargent), 222
Study for Phaeton (Sargent), 222
Stylobate Lion (Italian), 25

Tale of Genji (Kanō Tsunenobu), 172, 186–87
Talland, Valentine, 126
Tankard (Beckhausen), 127
Taoist (Okakura), 173
Tapestries, 112, 115, 117

Tavender, Augusta S., 15
Tea Set (Japanese), 177
Tent in the Rockies (Sargent), 207
Terilli, Francesco, 110
Terrace, St. Tropez (Matisse), 219
Tiffany Company, 72–73
Tile (Iranian), 163; (Turkish, Iznik), 160
Titian (Tiziano Vecellio), 103–7
Titian Room, 74, 83
Tombstone (Iranian or Central Asian), 164–65
Torso of Dionysos (Roman), 14
Tragedy of Lucretia (Botticelli), 64–65, 69
Trinity with Saint Catherine and a Bishop Saint (German), 31
Triumphs of Fame, Time, and Eternity (Pesellino), 64–65
Triumphs of Love, Chastity, and Death (Pesellino), 64–65
Tsui, Aileen, 198–99
Tsunenobu, Kanō, 186–87
Tura, Cosmè 54–55
Turkish, 160
Turner, Evan H., 189–90
Turner, J. M. W., 191
Two Elders of the Apocalypse (Parthenay), 21

Uccello, Paolo (attributed), xxii, 50
Uzbekistan, 171

Vasari, Giorgio, 85, 89, 100, 103, 109
Velázquez, Diego de, 107
Velvets, 118–19, 166–67, 171
Verbena peresterion; Verbena recta (Mesopotamian), 170
Vermeer, Johannes, 149
Vermeule, Cornelius C., 5, 7, 8, 11, 12–13
Veronese Room, 126
Violet Note (Whistler), 201
Virgin and Child (Simone Martini), 43
Virgin and Child Enthroned with Saints (Giuliano da Rimini), 37
Virgin and Child with a Swallow (Pesellino), 49
Virgin and Child with an Angel (Botticelli), 58
Virgin and Child with Saints (Simone Martini), 41
Virgin and Child, with Scenes from the Lives of Saint George and Saint Martin (Comes), 153
Virgin of Charity (Mosca), 101
Votive Stele (Chinese), 180–82

Wang, Eugene Yuejin, 180–82
Wang, Michelle, 179, 183
Weinberg, H. Barbara, 211

Wharton, Edith, xvi
Whistler, James McNeill, 94, 196–201
Whitman, Sarah, 16
Whittemore, Thomas, 179, 218
Wieseman, Marjorie E., 139
Woman in Profile (Mino da Fiesole), 60

Young Lady of Fashion (Uccello), xxii, 50

Zahn, Carl, xix
Zell, Michael, 145
Zorn, Anders, 212–15, 216